# Wildlife Artists at Work

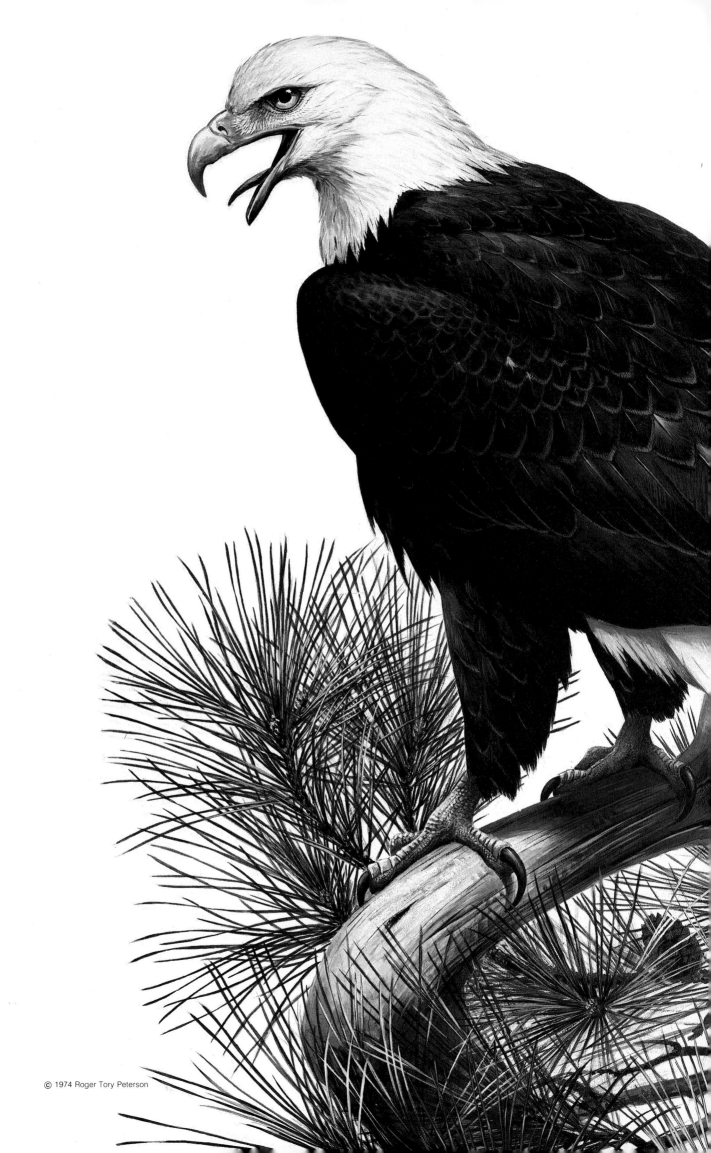

# Wildlife
# Artists
# at Work

**By Patricia Van Gelder**

WATSON-GUPTILL PUBLICATIONS/NEW YORK

*The author would like to thank Stephen Doherty of* American Artist *and Dorothy Spencer of Watson-Guptill for their encouragement and guidance; Barbara Wood for her superb editing; Madeline Aria for helping to prepare the manuscript; and Bob Fillie for his beautiful design. The publisher and the author would like to thank Robert L. Lewin and his staff at Mill Pond Press for their enthusaistic and generous support of this project.*

Frontispiece: Roger Tory Peterson, *Bald Eagle*
Watercolor and acrylic, 34″ × 28″ (86 × 71 cm)
Private collection

First published 1982 in New York by Watson-Guptill Publications,
a division of Billboard Publications, Inc.,
1515 Broadway, New York, N.Y. 10036

**Library of Congress Cataloging in Publication Data**

Van Gelder, Patricia.
  Wildlife artists at work.

  Includes index.
   1. Animal painters—United States—Biography.
2. Animals in art.   3. Painting, Modern—20th
century—United States.   I. Title.
ND1382.6.V36     758′.3′0922 [B]     81-23157
ISBN 0-8230-5749-6          AACR2

Manufactured in Japan

First Printing, 1982

6  7  8  9/87  86  85

# CONTENTS

# INTRODUCTION

The first wildlife art was probably little more than a curve scraped in the dust of a game trail as a master hunter initiated novices into the reading of spoor. We know nothing of what art may have existed on wood and bark before ten thousand years ago, or what may have been illustrated on the skins and hides that were clothes, covering, and shelter, or even what animals may have been drawn, in ochre red or charcoal black, on the bodies of the hunters themselves. We do know that human ancestors were using wild animals extensively half a million years ago, and it now seems likely that as long as five million years ago the creatures that eventually became human beings were eyeing the surrounding wildlife with something other than apprehension. We can only guess at the rich animal art that must have preceded the earliest materials that we are aware of, starting some thirty-five thousand years ago, with animal figures inscribed on bone, antler, ivory, and stone.

The skill and beauty of the animal art that has been discovered, mainly in Europe, from the Stone Ages, twelve to thirty thousand years ago, tell us of the artists' talent, love, mystery, and veneration of the subjects. The art also tells us, though the story is obscure, that these paintings were not mere hunting scenes or historical accounts, but had some much deeper-rooted symbolism in magic, religion, ritual, prayer, and initiation.

The hunters' veneration of animals carried over to their descendants who domesticated animals. In virtually every one of the earliest cultures that had domestic animals, these creatures occupied a central place in the lives and religion of the people, something that is still true today in pastoral cultures such as the Masai of Africa. The surrounding wildlife was not neglected in their art, but it eventually took on symbolism so that favorite subjects such as lions or bulls implied the authority and might of kings. Egyptian art, especially, is rich in animal themes and indicates the wide interest and involvement these people had with their domestic as well as wild animals. It also shows a synthesis of animals and humans in god form, and the development of a mythology that still exists. Myths also appear in the art of Greece and Rome, with fabulous beasts or half-beasts such as Pegasus, centaurs, and Pan, depicted in sculpture as well as in painting.

After the rise of Christianity, animal art became largely allegorical and in the subsequent theocentric world was limited mainly to domestic animals, animals mentioned in the Bible, and royal hunts. From the time of Pliny (A.D. 79) to Gesner's *Historia Animalium* in 1551, animals played only a

minor role in the thoughts of people. The art of this period includes the least sensitive depictions of animals in the whole history of humankind. With the Renaissance, however, animal art once more acquired interest, sensitivity, and feeling for the animal itself, exemplified by Dürer's hare (1502) and Leonardo's sketches of cats (1515+). During the next four centuries, animal art reigned supreme, combining both skill and sensitivity, as artists set out to document, illustrate, and translate human outlook into pictures.

The development of photography in the nineteenth century did not, initially, preempt the role of the artist as a documentary illustrator, but Eadweard Muybridge's 1887 motion analyses showed artists form and function of animal movement that their eyes had not been able to capture before. And although there have been tremendous improvements in the field of photography in the twentieth century, to which we must add the electronic photography of television, wildlife painting has neither declined nor disappeared, but instead has reached new heights of an art for its own sake that also combines deep levels of perception with pictorial accuracy.

The resources available to the modern wildlife artist are immense: still and motion pictures in color, museum study collections where each hair or feather can be analyzed and where dioramas provide a three-dimensional art form, zoos where a tremendous variety of animals can be observed and sketched at leisure, and a vast literature on the behavior and habits of animals. But what is far more obvious to the knowledgeable viewer is that today's breed of wildlife artist not only has the considerable skills that great art requires, but has a feel for and understanding of animals that can be gained only by intimate, firsthand experience with the living creatures themselves.

Thus, the history of wildlife art has completed a great circle, from the initial reverence shown in rock paintings where the animals were drawn with a love, knowledge, and feeling that were an integral part of the people's lives, through mystical and mythical depictions, to mere documentation, and once again to a position of understanding and sensitivity that seems to be an essential part of human existence. Here, in this handsome book, outstanding wildlife artists tell of their work and show that there is both an art of natural history and a natural history of art.

RICHARD G. VAN GELDER
Curator of Mammals
American Museum of Natural History

# ROBERT BATEMAN

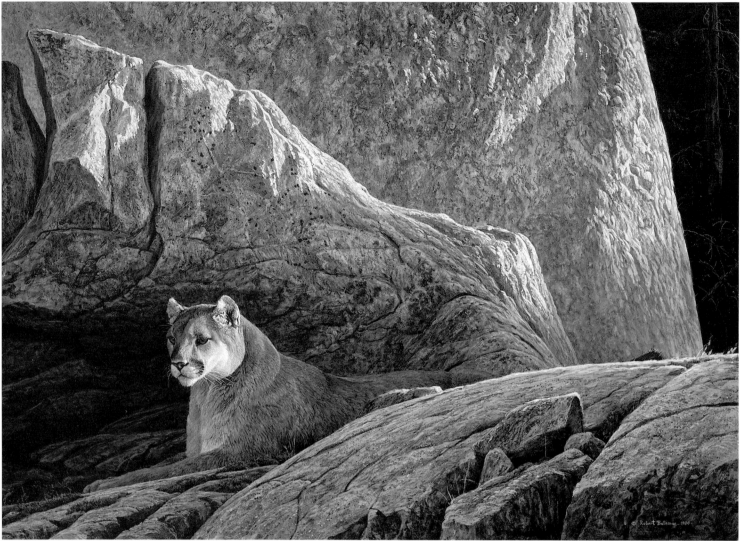

*Rocky Wilderness—Cougar.* Acrylic, 36″ x 48″ (91 x 122 cm). Private collection.

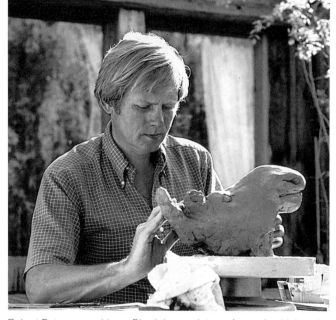

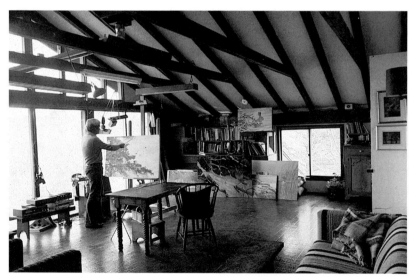

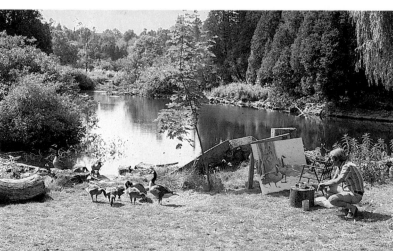

Robert Bateman making a Plasticine sculpture of an animal (above), which he will use while painting to experiment with angles and lighting, and painting in his studio (above right) and in the field (right).

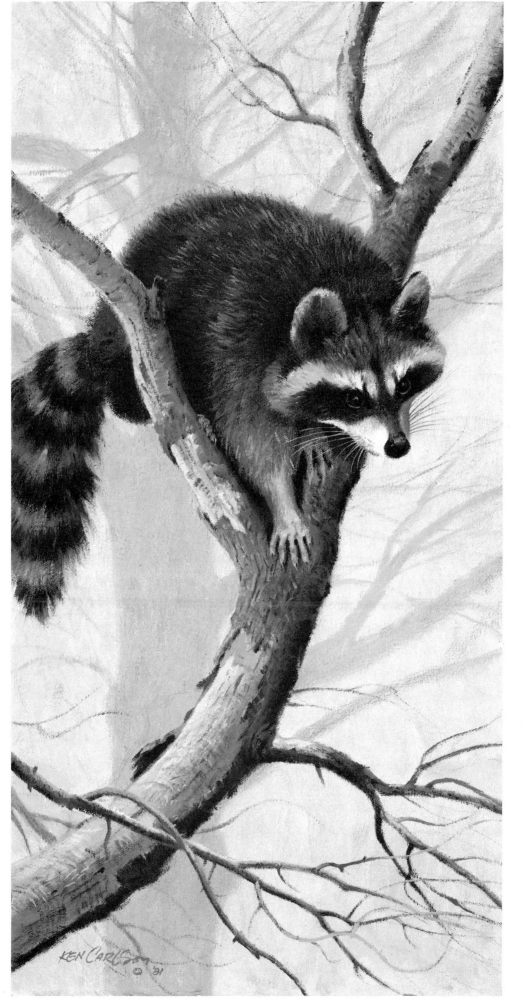

*Masked Bandit—Raccoon.* Oil, 24″ x 12″ (61 x 30 cm). Private collection.

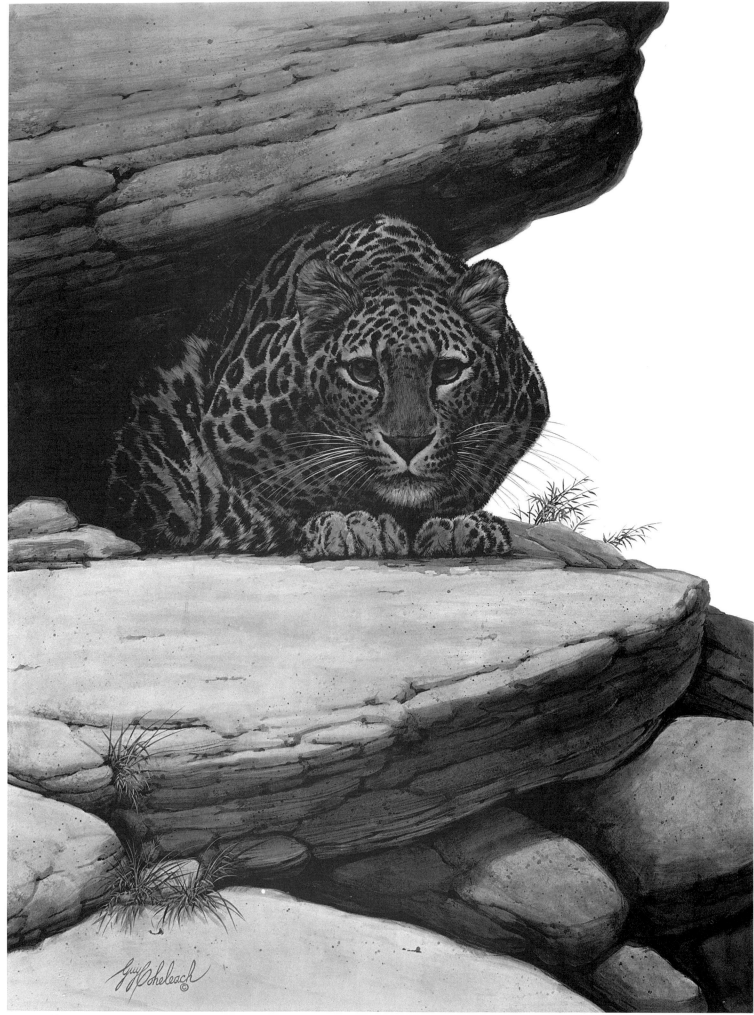

*Ambush.* Tempera, 40″ x 30″ (102 x 76 cm).

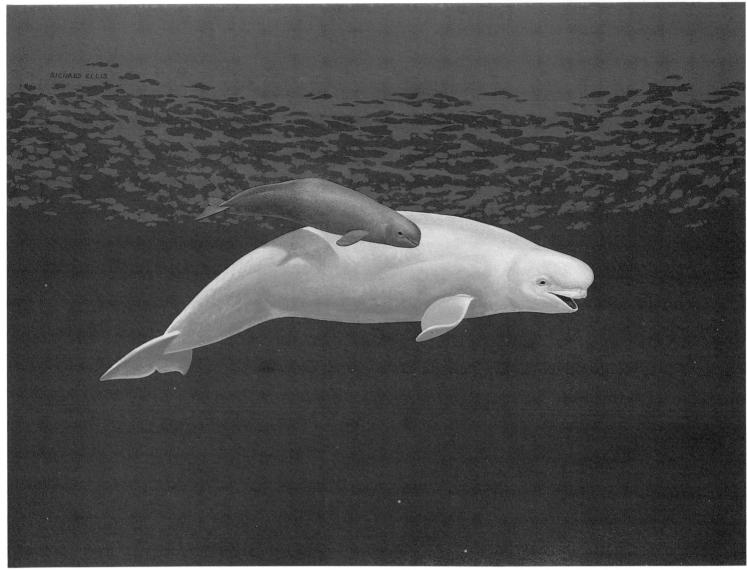

*Beluga and Calf (Delphinapterus leucas).* Acrylic, 18″ x 24″ (46 x 61 cm). Collection of Dr. J. B. MacInnis.

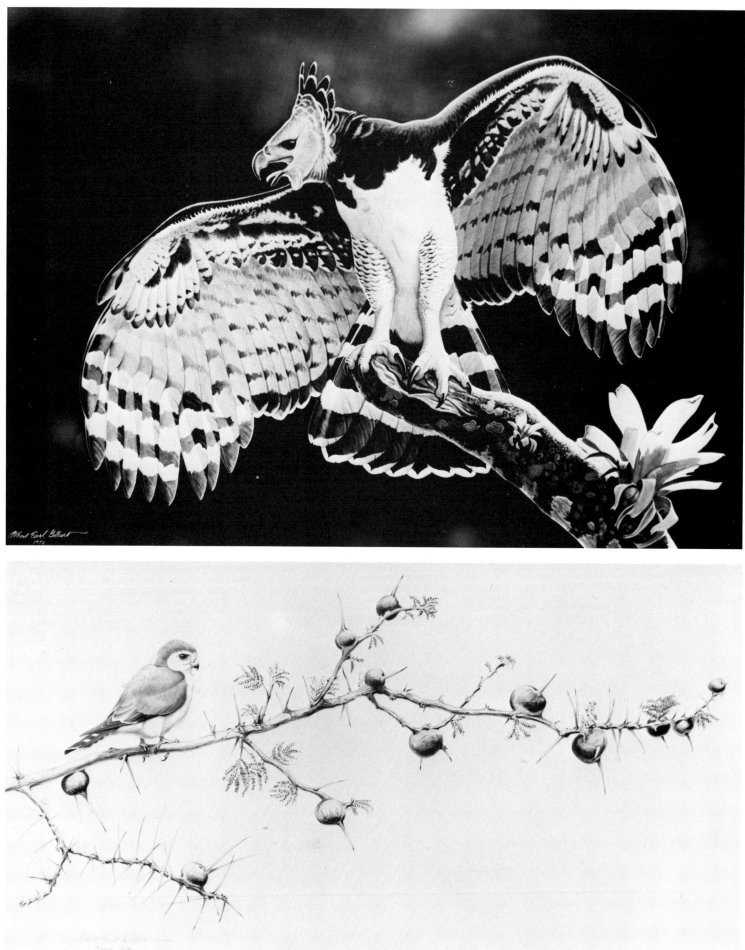

Top
*Harpy Eagle in the Amazon Jungle*
Opaque watercolor, 30" x 40" (76 x 102 cm)
Collection of Mrs. Dielle Fleischmann

Bottom
*Pygmy Falcon on Whistling Thorn Acacia*
Pencil and wash drawing done directly from life in Kenya
14" x 30" (36 x 76 cm)

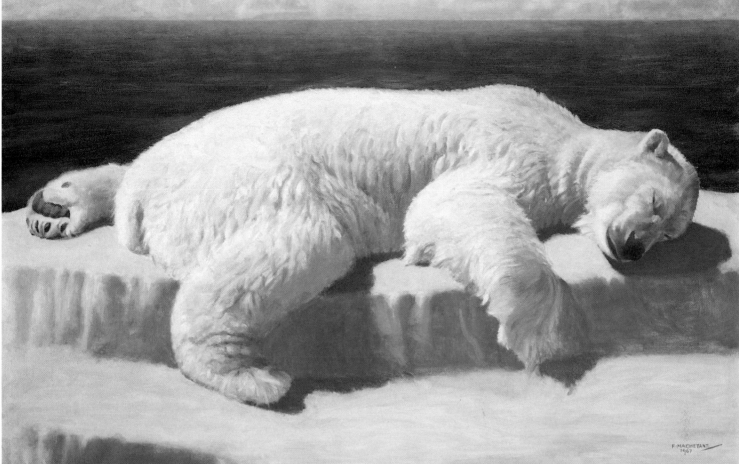

*Mighty Hunter.* Oil, 32″ x 48″ (81 x 122 cm). Collection of Mr. and Mrs. Neill Raymond.

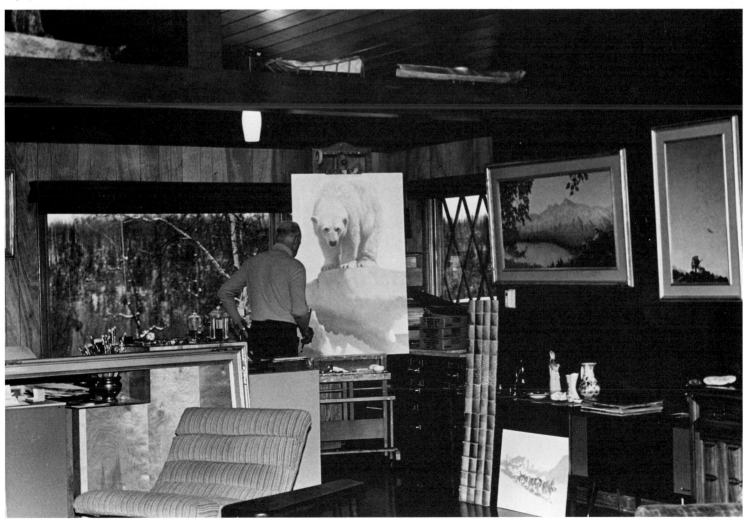

Fred Machetanz in his studio. *Face to Face* (p. 105) is on the easel.

# STANLEY MELTZOFF

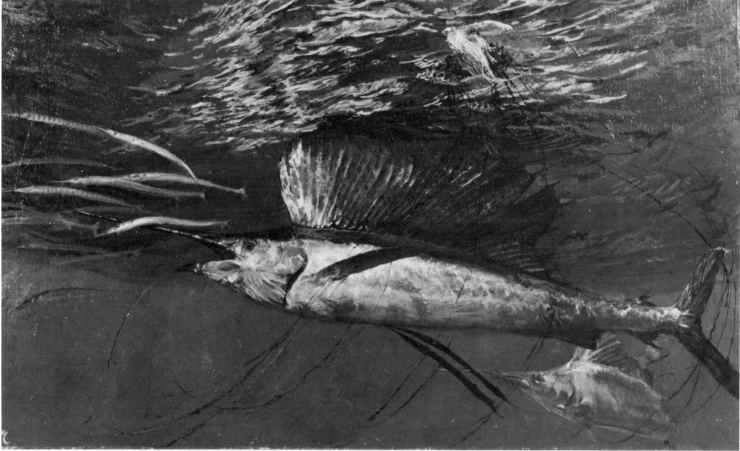

*Shining Sailfish #2.* Oil, 22" x 36" (56 x 91 cm).

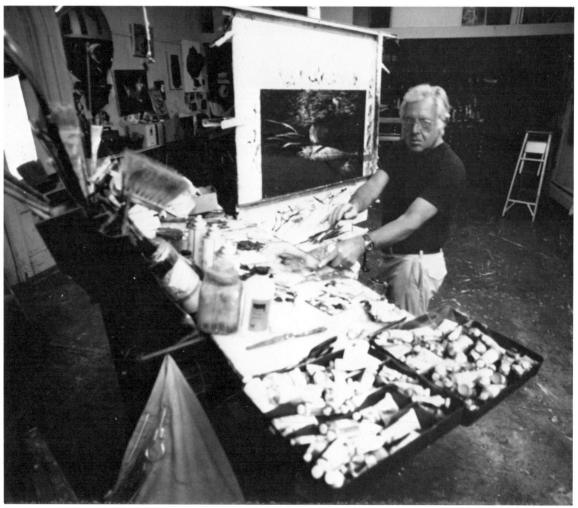

This painting of a shining sailfish by Stanley Meltzoff, who is seen here in his studio with the same painting on the easel, is the third version of one that stood around his studio for several years as an underpainting. He decided that its composition was fundamentally too static and that too little of the surface reflection showed, and so to please himself he set about to redo it. He made a change even in the course of painting— he enlarged the sailfin to make it more visible when he was about halfway through.

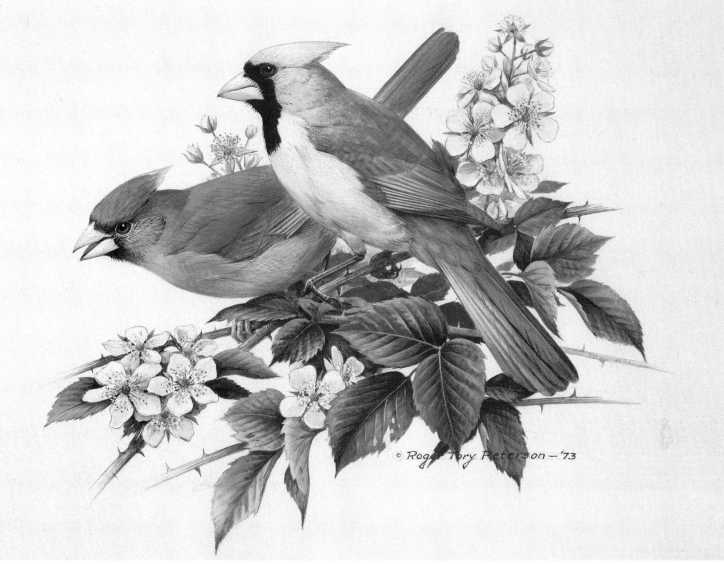

*Cardinal.* Watercolor and acrylic, 18″ x 18″ (46 x 46 cm). Private collection.

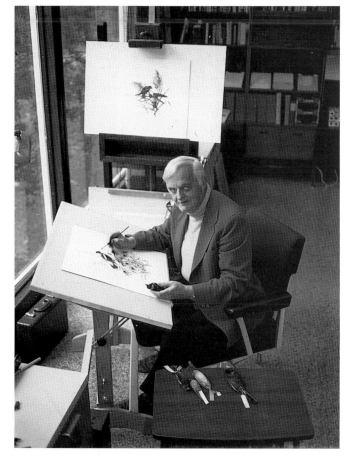

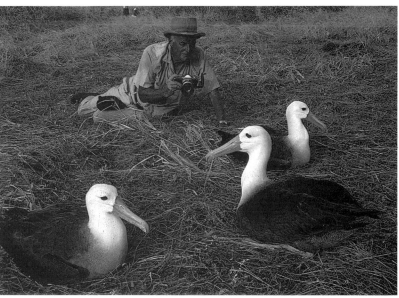

Roger Tory Peterson taking photographs of the waved (Galapagos) albatross (above) and at work in his studio (left).

# MAYNARD REECE

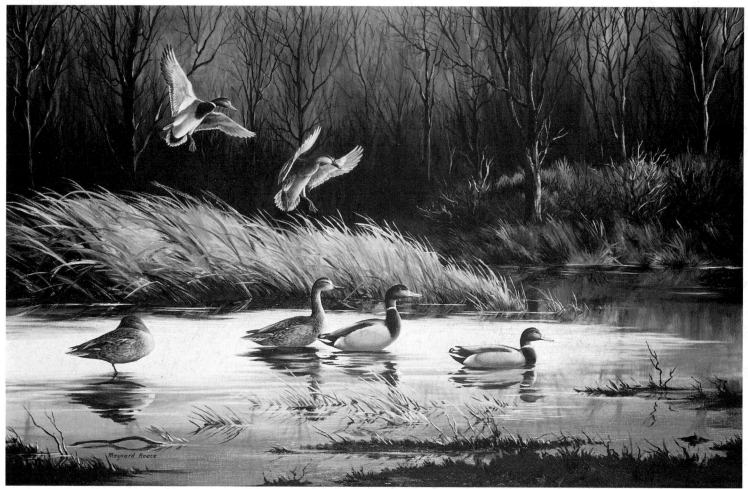

*Shallow Pond—Mallards.* Oil, 24" x 36" (61 x 91 cm). Collection of Mrs. Maynard Reece.

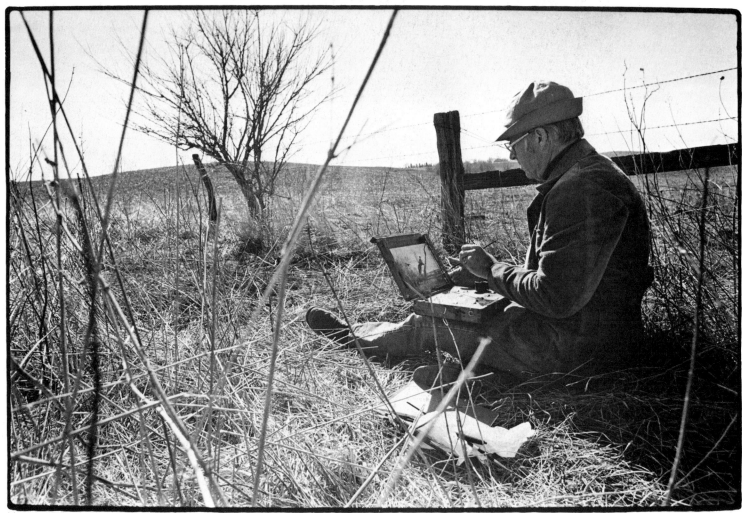

Maynard Reece sketching in the field.

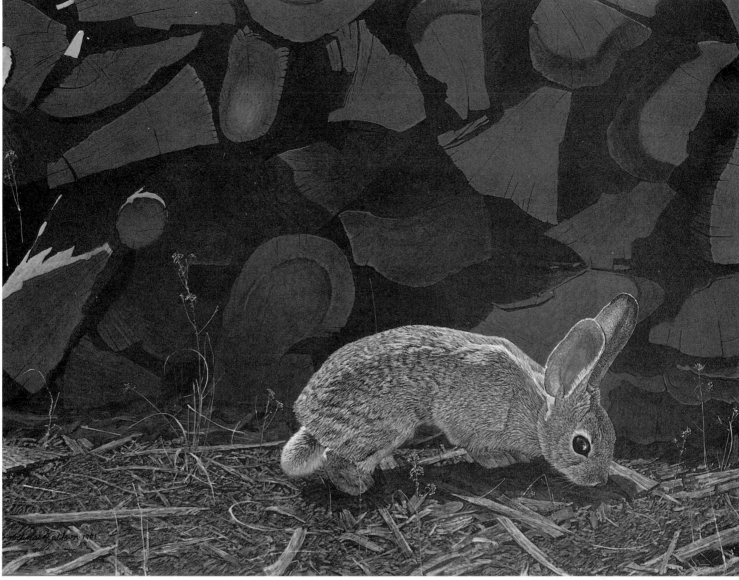

*Change of Season—Cottontail Rabbit.* Gouache, 18″ x 24″ (46 x 61 cm). Private collection.

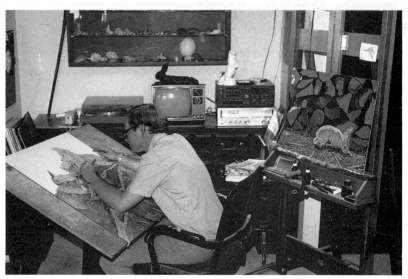

Nicholas Wilson sketching in the field (left) and at work on *Summer A.M.—Coyotes* (p. 168) in his studio (above).

17

# ROBERT BATEMAN

In 1981, when the Canadian government decided to present a painting of its native wildlife as a wedding gift to Prince Charles and Lady Diana, Robert Bateman was commissioned to produce a painting of a family of loons. Symbols of the Canadian north, loons are also found in northern Scotland, where the royal couple frequently visit.

In what has become a hallmark of his style, Bateman portrayed the birds gliding into rockbound waters from far to the right of center—typical of his revelations of wildlife in the fleeting act of arriving or departing before the eye of the beholder. Bateman's mastery of the "fleeting moment"—of getting a painting to "look as though it just happened"—is combined with an almost unerring accuracy of detail, plus a technique that is based upon training in what he calls "art with a capital *A*." "Every one of my paintings," he says, "recapitulates my whole development as a painter."

That development includes work in styles beginning with representational, continuing to the impressionistic and the abstract, and going full circle back to representational paintings, enriched by the influences of all his styles and techniques.

From the beginning, however, Bateman's interest was focused upon wildlife. His aptitude for art began at a very early age, and from the sixth grade on in his Toronto grammar school, Bateman "was always the class artist." At the age of twelve, using the first Roger Tory Peterson *Field Guide to the Birds*, Bateman painted birds, rounding out his childhood repertoire with "battle scenes, Indians, and nature."

Visits to the Royal Ontario Museum and the Junior Field Naturalist Club stimulated his interest in nature. "I took from the library all the books on natural history, and I first saw Louis Agassiz Fuertes's work in some of them. After that, I borrowed and bought all the books I could find with his illustrations." *National Geographic* illustrator Allen Brooks was another influence, as were artists T. M. Shortt and Ernest Thompson Seton. Young Bateman spent time visiting zoos alone and with the Junior Field Naturalist Club. At the age of sixteen he joined the Intermediate Naturalists, which

*Sheer Drop—Mountain Goats*
Acrylic, 48" x 36" (122 x 91 cm)
Private collection

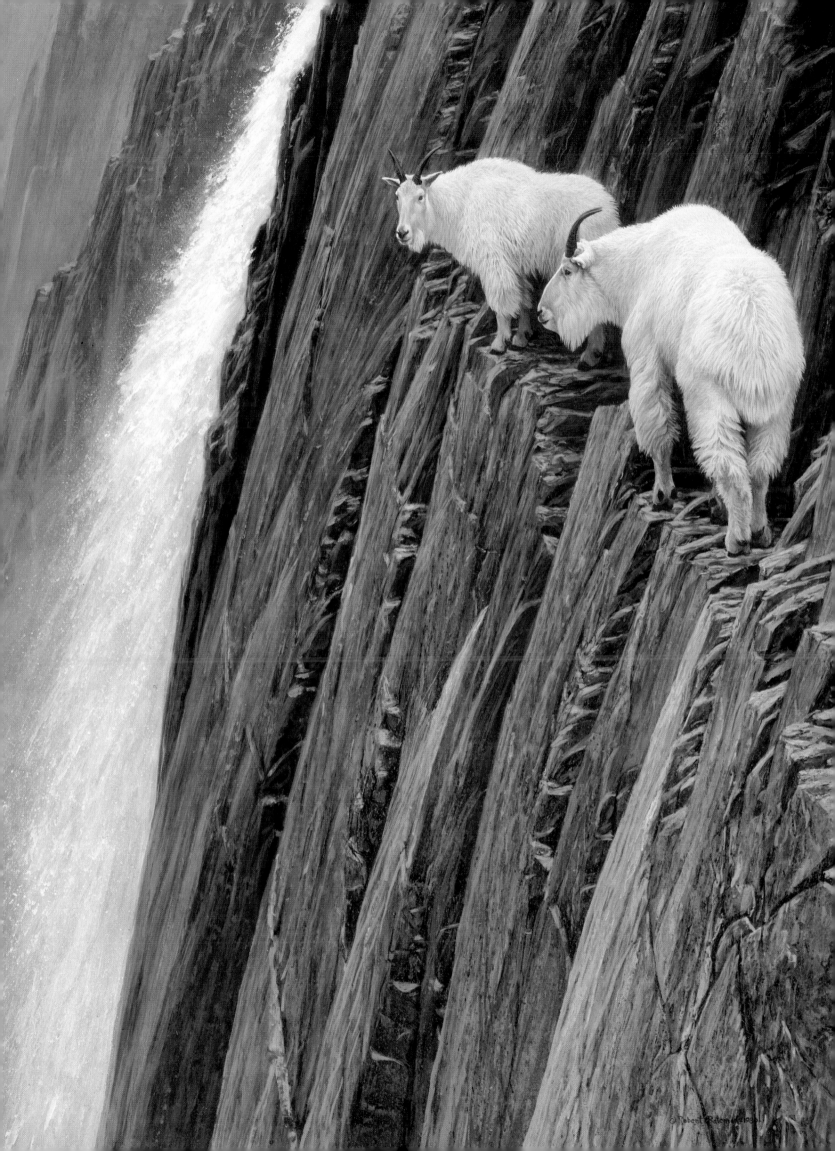

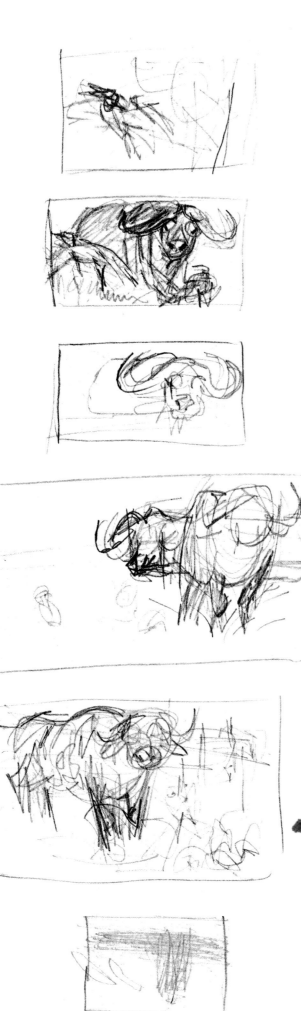

"became the nucleus of the Canadian natural history and wildlife establishment." Bateman recalls, "Returning war veterans joined this group in 1946 and 1947. I was seventeen, and the members of the group became my role models and heroes; all of my friends were naturalists and biologists. Today, the same people are directors of museums, national parks, and other naturalist-oriented institutions—many 'old boys' of the naturalist establishment in Canada."

Through their influence, Bateman became what he calls "an amateur wildlife biologist and wrote some scientific papers. Mammalogy was my specialty. I may go down in history for my mice if not for my art." Bateman went with his naturalist colleagues on collecting expeditions.

High school saw him doing all the posters for the school. At the same time he began winning scholarships for art tuition. At ages seventeen, eighteen, and nineteen, he says, "I took lessons every Saturday morning with Gordon Payne, a very good academic artist. He introduced me to the principles of painting and used the book *Cézanne's Composition* by Erle Loran. That book had a profound effect because it said that the canvas was a little world that the artist assembles like a clock—with tensions and rhythms. I read that book from cover to cover. The author analyzed the tar out of Cézanne, and I have been analytical about paintings ever since."

At the University of Toronto, however, Bateman studied geography and did mapping and geology. He remembers that one of the best summers of his young life was spent mapping iron ore in the eastern Arctic. Along with his undergraduate studies in geography at the University of Toronto, he studied art at night with Carl Schaeffer, learning to draw with the Nicolaides method—"organically, rather than mechanically." He says, "I learned to draw very quickly, to make mistakes and correct them and evolve a composition. I learned to make statements and to change them, without using tissues."

By this time Bateman began to be drawn to contemporary and avant-garde styles of art. He recalls, "I became an art snob and rejected popular, sentimental art altogether. At the age of eighteen I gave up wildlife art and began to look at other artists—impressionists, cubists. I began doing art with a capital *A*. I followed the history of art, first emulating Monet and Degas, always using nature as a subject, mostly doing landscapes. Then I went through a van Gogh and Gauguin phase, followed by Rockwell Kent and Charles Burchfield. I began working in bold shapes and flat patterns. I have always had a strong sense of form—big chunks of stuff. That's my first thing—a sense of form and what's behind form. I want the viewer to see the woods, not only the trees; the form of the bird, not just the feathers."

Bateman considers that his chief aim in wildlife art is "getting the whole painting looking good, getting it all to look as though it just happened, instead of being contrived. The Japanese approach to their gardens is a contriving to look uncontrived, the ultimate in sophistication. It's a problem in a technical sense, to get all the scientific aspects correct without spoiling the artistic sense. If there is a conflict, I have been known to let the artistic win, but I consider it an inadequacy on my part when I haven't achieved both."

*Master of the Herd—African Buffalo*
Oil, 30" x 48" (76 x 122 cm)
Private collection

Through a series of rough sketches and compositional studies, Bateman develops the T shape that he wants for the painting. To begin the actual painting, he roughs in this shape on the canvas. He uses a detailed drawing as a guide for the egrets and makes a Plasticine model so that he can experiment with positions and perspectives. A skull helps him with anatomical details of the buffalo's head.

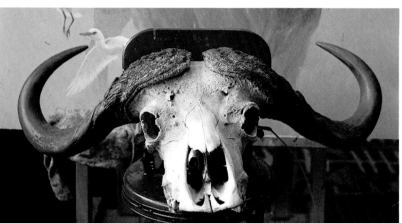

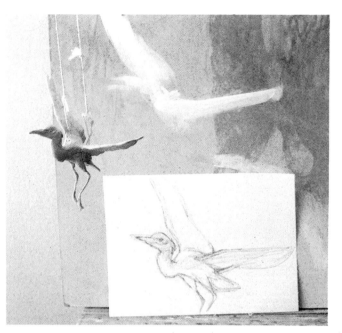

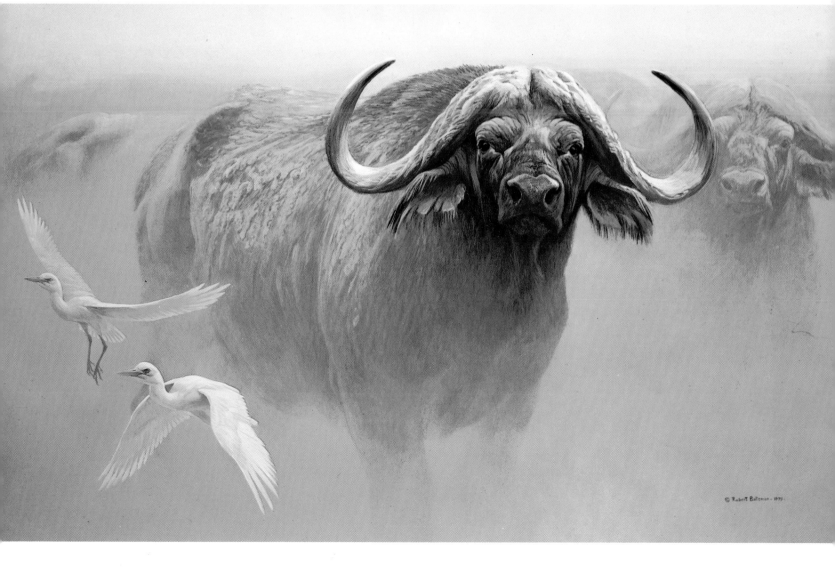

*Master of the Herd—African Buffalo*
Oil, 30" x 48" (76 x 122 cm)
Private collection

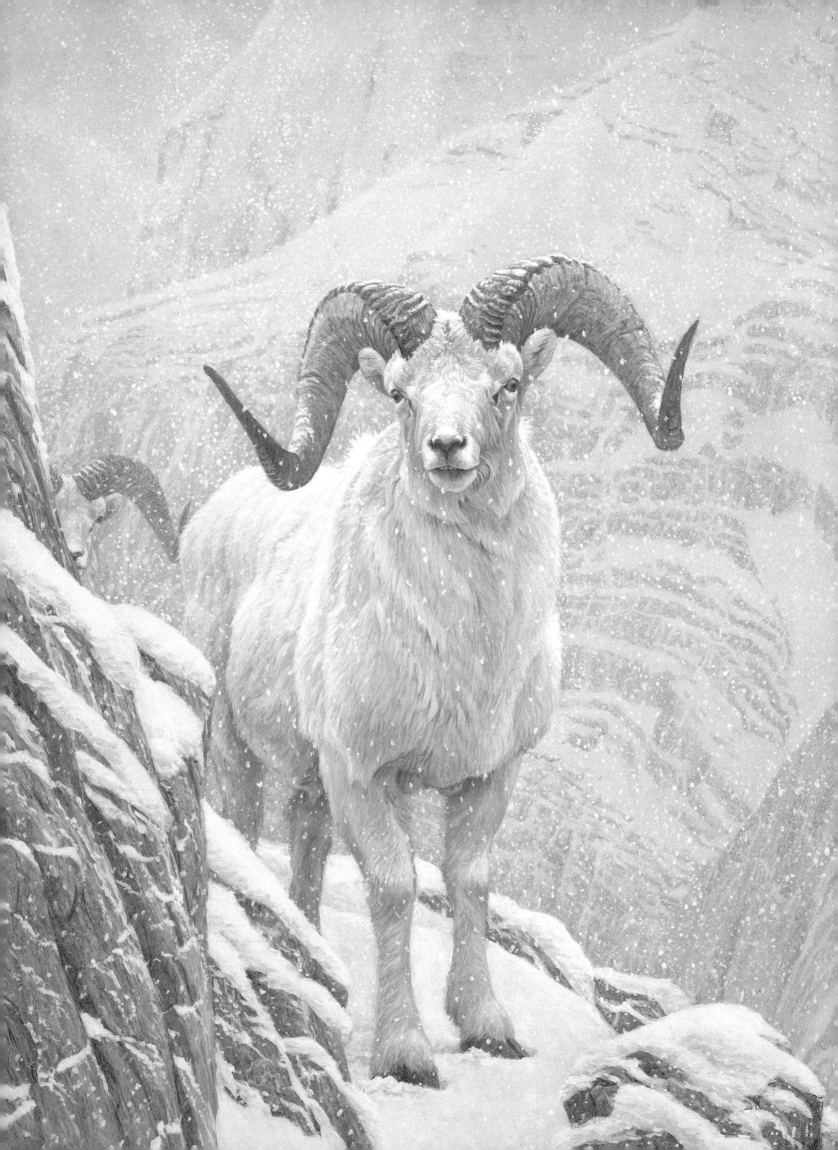

Bateman's experiments with new styles and forms continued into his late twenties. Cubism and Picasso were his next great influences, along with Franz Kline. Of the latter Bateman says, "His powerful, big canvases impressed me a lot. I used to take big canvases and do trees on a large scale. I tried a kind of action painting popular in the nineteen-sixties."

Frequent visits to Buffalo, New York's, Albright-Knox Art Museum gave Bateman opportunities to view the works of all these artists firsthand. On his own, he continued to go out into the wild and sketch birds. But the "art snob" and the naturalist did not come together until 1963, when Bateman visited Albright-Knox to see the first show of Andrew Wyeth. Says Bateman of what to him was a landmark in his own development, "Here was an artist involved with the real world who wasn't concerned with only the surface of paint as I was then. When I saw the Wyeth show it all came together, and I realized I was interested in the distinctions

Left
*White World—Dall Sheep*
Acrylic, 36" x 40" (91 x 102 cm)
Private collection

Above
*White Encounter*
Acrylic, 36" x 50" (91 x 127 cm)
Private collection

between trees as well as the mass of form and color. I went back to naturalism, but kept the impressionism and cubism as underlying concepts for picture ideas."

After Bateman graduated from the University of Toronto, he became a teacher of geography and art in the public schools of Ontario, spending summer vacations traveling widely. Those trips included Europe, from Spain to Lapland, in 1954; field research in Mexico (1956); a trip by Land Rover around the world with Bristol Foster, now director of Ecological Reserves of British Columbia (1957—58); and western Canada and the United States (1958). Between 1963 and 1965 he taught in Africa, where he began painting wildlife subjects of that continent. Later came trips to the Amazon with a research team (1972) and more trips to Africa, the Arctic, and the Antarctic.

All these travels, which have become a regular feature of his life, provide the landscapes and the subjects for his art. Looking at art and admiring artists, including photographers like Ansel Adams and Edward Weston, and even film-makers, provide further stimulation for new ideas. He says,

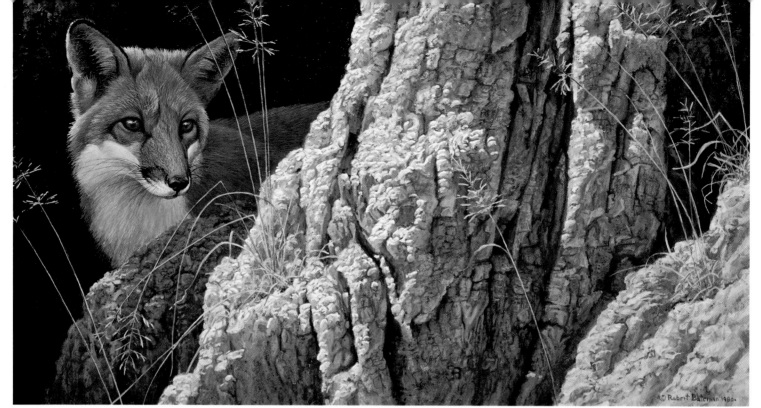

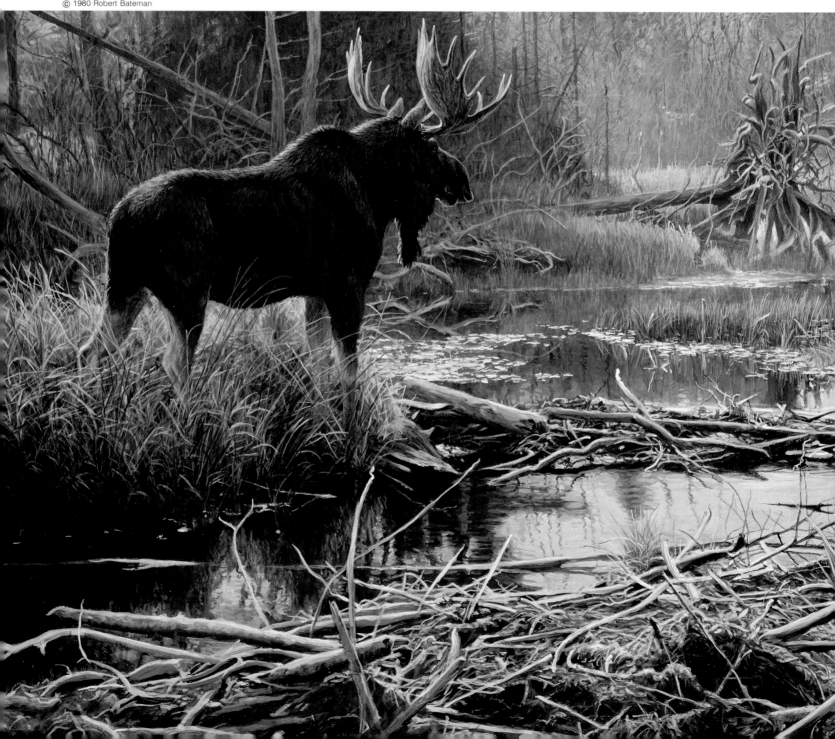

"The 1980 show of Clyfford Still at the Metropolitan Museum was a revelation to me. Everywhere I go I'm open to ideas and thoughts—from Vermeer to Turner. I was so excited by the Clyfford Still work, I did compositional sketches like his. One of my paintings of a pack of wolves was inspired by Clyfford Still's painting of a big black glob with a thick blue vertical line, suggesting to me a menacing group of animals with thin trees as the only thing between you and the animals. One of my ideas for a painting came from the movie *Butch Cassidy and the Sundance Kid.* It showed a huge sky and low horizon with riders against the horizon."

The patterns of dark tree branches against a light background form a design which Bateman feels is related to Franz Kline's powerful abstract black lines against white backgrounds. Bateman's animals, posed against his carefully designed landscapes, are chosen with equal care. "I like all prey animals," he says, "tigers, lions, wolves. I'm not turned on by the cute or cuddly. I look for an exciting sense of form. I'd choose an Arabian horse instead of a cow. I'm now working on a gyrfalcon that looks powerful even standing still."

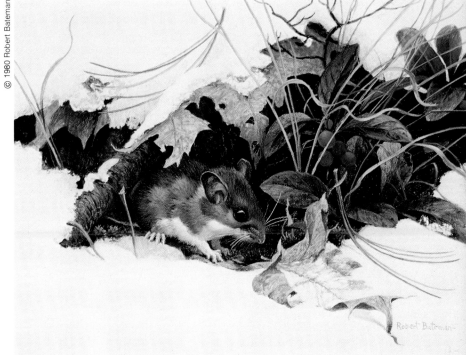

Whenever possible, Bateman tries to work from life. "But," he says, "it's almost always impossible. You can sketch from life, but you can't paint animals from life. A fast sketch is all you can get." His work in the Nicolaides method is most useful for meaningful results from a quick sketch. Although he works in zoos and game parks, Bateman says, "Lions are awful in zoos, and leopards turn into sloths." Usually he gets his environment in one place, his animals in another. His favorite game parks are in British Columbia.

For his studies of birds, he often uses stuffed or frozen specimens, preferring the frozen for posing. Like most other wildlife artists, he is distrustful of stuffed mammals but uses the less manipulated study skins.

For backgrounds and habitats, Bateman feels that travels in the field are important. "I don't have itchy feet," he says, "but I do enjoy traveling in Africa, and I find that the things I

25

see in my travels are often the starting points for a composition. A handsome natural scene will inspire a painting, then I think of which animal would fit into it. Usually I'll sketch the scene on the spot."

As a former teacher, Bateman believes the more information, the better, so he values books of visual reference for his animals, if not for his habitats. His many-volume library includes books of animal photographs of which he says, "They may have some useful anatomical details, such as the nostril of a swan. But I never use these as a prime source for how an animal looks in the wild."

He does special studies from nature for many of his settings. "I'll work for a particular sky," he says. "I may use a sky I saw in the Antarctic somewhere else. Once I wondered whether I could use the pack ice I had seen in the Antarctic for a polar bear scene, since polar bears are found only in the Arctic. I did a little research and found out that I could use that Antarctic ice correctly in an Arctic scene."

Bateman records many scenes and animals with his camera. He uses a Pentax with lenses up to a 400mm Novoflex, with pistol-grip trigger and telephoto lens. He says, "I've been known to use up to fifty slides for one painting, using bits from here and there. I'll use different angles of shots of an animal and do a Plasticine sculpture so I can change the angles for lighting. The Plasticine is put around an armature of tin, the whole being about the size of an apple."

Of photography he says, "Photographs are important as conceptual inspiration, such as early photos of the Old West which I'd like to capture in my art. I use a hand viewer attached to my drafting light, so I can look at the slides and move around them. I don't project the slides and I don't copy an entire painting from any one photo. I always change things around to suit my own ideas and to construct my own picture. After all, 'art begins where nature ends.' "

Most of the making of art from nature takes place in Bateman's studio in the countryside outside Toronto. In the summer, however, he sometimes takes his easel and 3-by-4-foot (91½-by-122-cm) canvases down to a rocky point at the lake near his summer cottage in the Haliburton district north of Toronto. He may also sketch there, using a simple sketchbook and Bic ballpoint pens, medium black. His sketches in the field are done in the same way, with notations for color and poses. "My field sketches are the quick action things I can't photograph, such as a couple of flying birds. The Nicolaides-type sketch gives me the pose; then I'll do sculpture and detail drawing."

His work in his studio can begin as an indoor-outdoor procedure. "I hardly ever start a picture on the spot," he says. "If the scene is near where I'm living, I'll start outdoors and go to the studio, then go back to the spot to check details. For the picture of the great horned owl in the pines, I worked on a stepladder at the tree to see the branches. I'll often go back to the field again halfway through a painting."

The studio in his self-designed house, completed sixteen years ago, is on the second floor. The house itself was constructed to frame a view of the landscape consisting of birch and pine trees, a sloping meadow, and a mountain

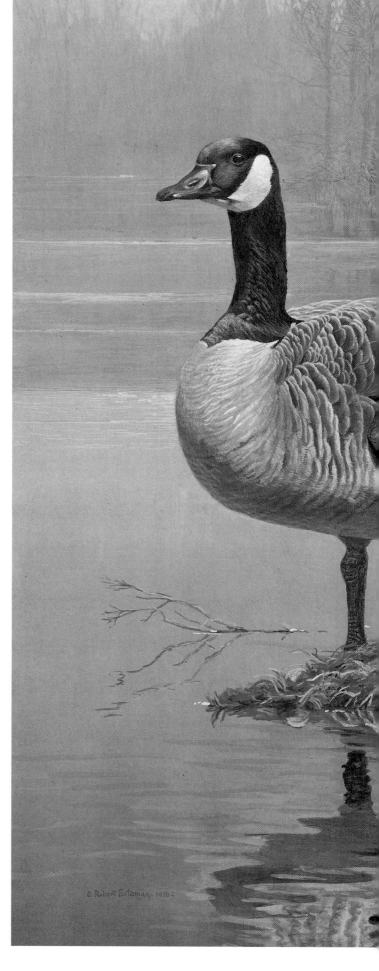

*Nesting—Canada Geese*
Acrylic, 36″ x 48″ (91 x 122 cm)
Collection of Mr. and Mrs. Ulrich Freybe

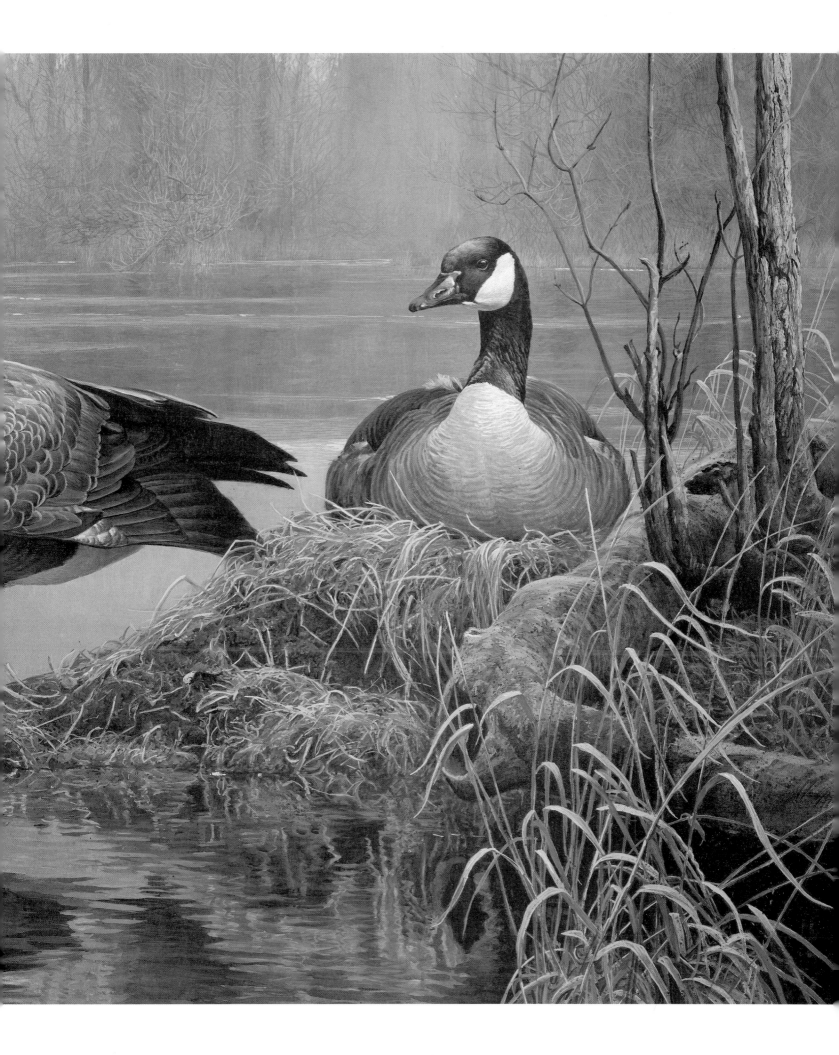

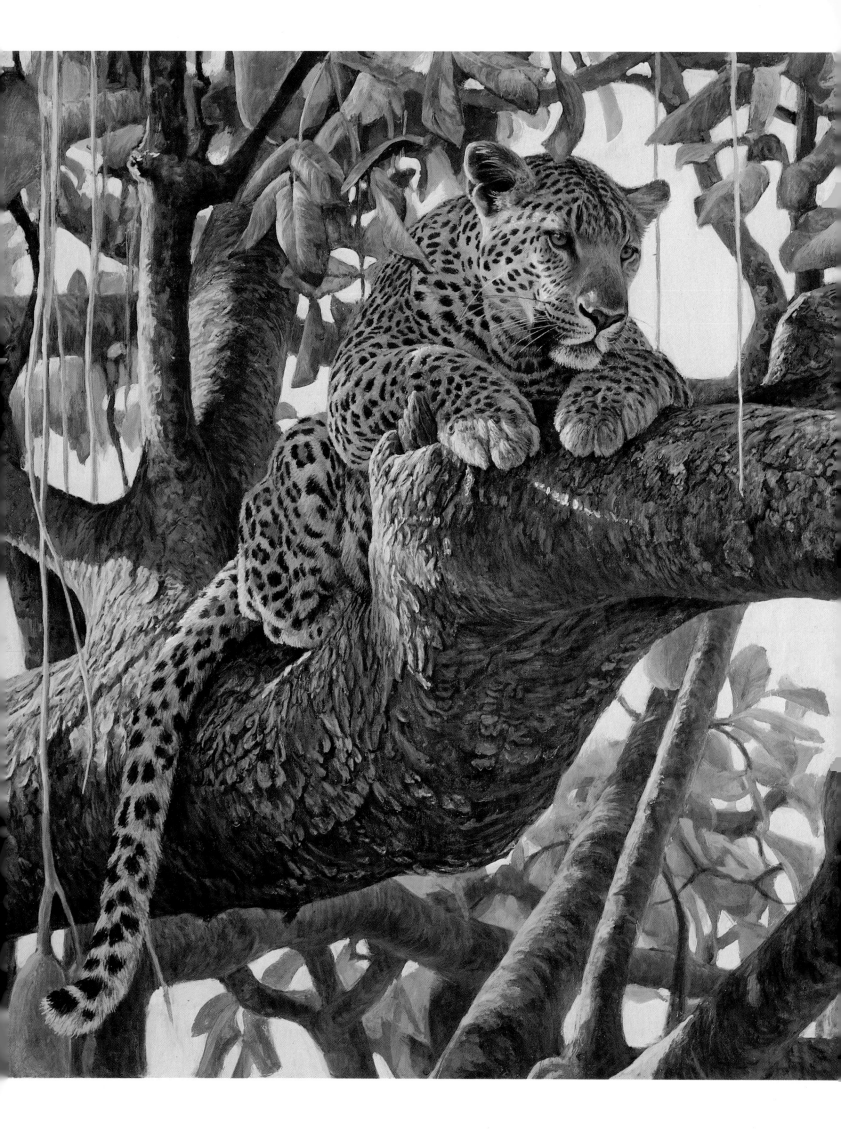

range in the distance. Timbered beams and plastered walls support the large windows designed to bring that view indoors and maintain the atmosphere of living in a wilderness.

In the second-floor studio, north windows from floor to ceiling bring in steady bright light. "I also use fluorescents," says Bateman. "But I'm almost blasé about lighting. I use all kinds of fixtures, daylight itself and daylight fluorescents, as well as hundred-watt incandescent bulbs hanging in the middle of it all."

The 20-by-15-foot (6-by-4½-m) studio contains two easels, one for indoors, the other for outdoor use. About 12 feet (3½ m) behind the indoor easel, a mirror hangs at an angle. "I walk back and forth a lot," says Bateman, "to get my forms, and I consult the mirror reverse image to help bring out the compositional forms of my paintings in progress. The mirror shows hidden rhythms and dynamic tensions." In addition to his standing easel, there is a tilt-top table for both drawing and painting. Paintings are propped up around the

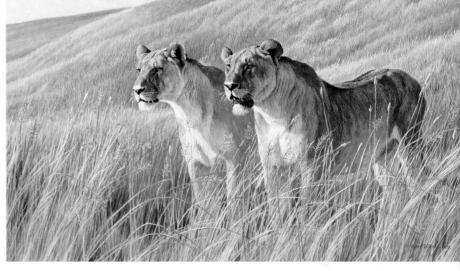

Left
*Leopard in a Sausage Tree*
Oil, 28" x 36" (71 x 91 cm)
Collection of Mr. Robert C. Bartleson

Above
*African Amber—Lioness Pair*
Acrylic, 24" x 42" (61 x 107 cm)
Private collection

room. "I work on five or ten pictures at once," says Bateman. "When I get discouraged with one, I work on something else.

"In the beginning of a painting, I'm always excited. Then, about five percent into a painting, I put it aside because I start to dislike it. Then I become very excited again with the last five percent. I used to worry about a painting's looking overworked. Now I find that it looks that way in the middle, but can be freshened up at the end with pointillist dabs of fresh color flicking around."

When Bateman begins a painting, he prepares for it with approximately twenty thumbnail sketches done with ballpoint pen or pencil. He prefers pen to pencil because "it's fast, smooth, and committed." After resolving his compositional problems this way, he goes straight to painting on a ¼-inch (6-mm) Masonite panel, covered with up to four layers of thinned-down gesso, usually gray. "I like to work up light lines on dark, or dark on light, and I like to work with opaque colors. Occasionally I do a small painting for a thumbnail, but usually I go right to the big board from my black-and-white sketches."

On his full-size panel, he says, "I do the major strokes for the big forms first. At this stage the painting will look like my early abstract paintings. Then it's a process of refinement. Usually I do the background with maybe fifteen minutes of a lot of paint. But I never finish one part of a painting before another. I always work all over the painting at once, using one color all over, then the next, and so on. I treat the painting with great disrespect, lashing out and sloshing away at the beginning. I believe you have to make two thousand mistakes in order to learn to draw. I assume it's going to be wrong, but I will correct it later, and I keep correcting as I go."

Bateman finds it impossible to work out the entire painting in advance. "I never know exactly what it will be until I do it. I work alternately transparent and opaque, and alternate working light and dark, raising and lowering the tones until the painting takes shape. I put dark washes over all areas. Some areas will be too dark. Then I put a wash of light over that. You can do this easily with acrylics or alkyds. I find I can put on a wash in the morning and go back to work on it in the afternoon."

Bateman uses chiefly acrylic paints but lately has been finishing with alkyds. He says, "Alkyd over acrylic blends well and gives a juicier look. After seeing original work of Bruno Liljefors, I rediscovered the looseness of oil."

The acrylics and alkyds on his worktable represent the colors he uses "ninety percent of the time." They are burnt umber and ultramarine or permanent blue. He mixes two of them for his black. He also uses any white as well as yellow ochre, Prussian blue, cadmium yellow, vermilion, or cadmium red light. "I very rarely use purple or alizarin. I like a limited palette. I can get everything I want with these colors. I work with acrylics in liquid form, used as gouache—like poster paints. I like to keep them in baby-food jars at the consistency of melted ice cream. I liquefy them even more on my aluminum palette with little cups. I'll often put three tones of one color in three adjacent cups and then they're really as runny as milk. That way I can get a blending effect, which is otherwise difficult"—for example, he says, "color A plus one dab of white, or color A plus two dabs of white. My colors are used differently in each composition."

On the subject of composition he says, "I like to have the composition expressed in the thumbnail sketch. Some of my favorite kinds of compositions are with a high, empty rectangle at the top, or an allover design like a Jackson Pollock. I like to put the subject near an edge, almost going out of the picture, so that it looks unpredictable and not stereotyped. I'll try a huge moose, too big for the frame, or an elk so small you need a magnifying glass. Sometimes I like to show absolute calm, or again, something flying off into space, sometimes very intense, sometimes very open and soft, because that's how the world is."

Bateman's approach to his art of painting wildlife has been so successful that frequently his exhibitions in both Canada and the United States are sold out before they open. Prints of his paintings are collector's items.

---

Top
*Vantage Point*
Acrylic, 36" x 60" (91 x 152 cm)
Private collection

Bottom
*Edge of the Ice—Ermine*
Acrylic, 11⅞" x 16" (30 x 41 cm)
Private collection

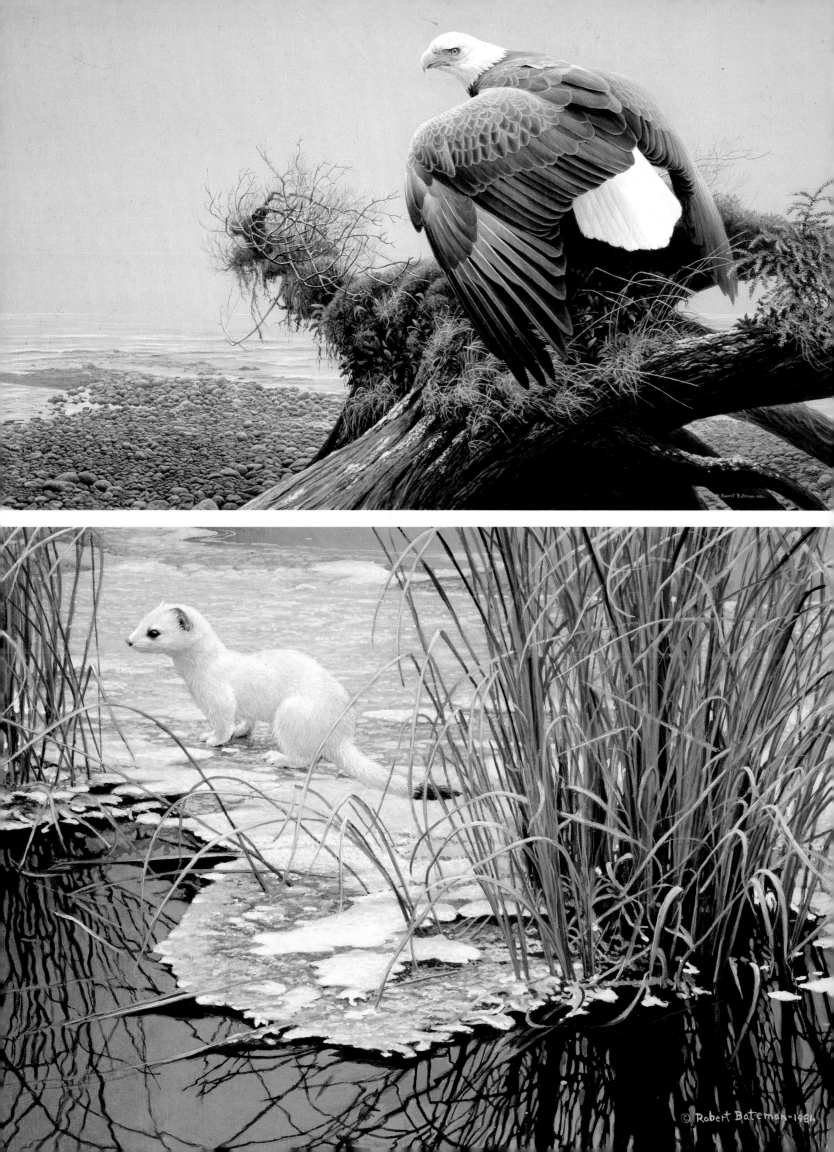

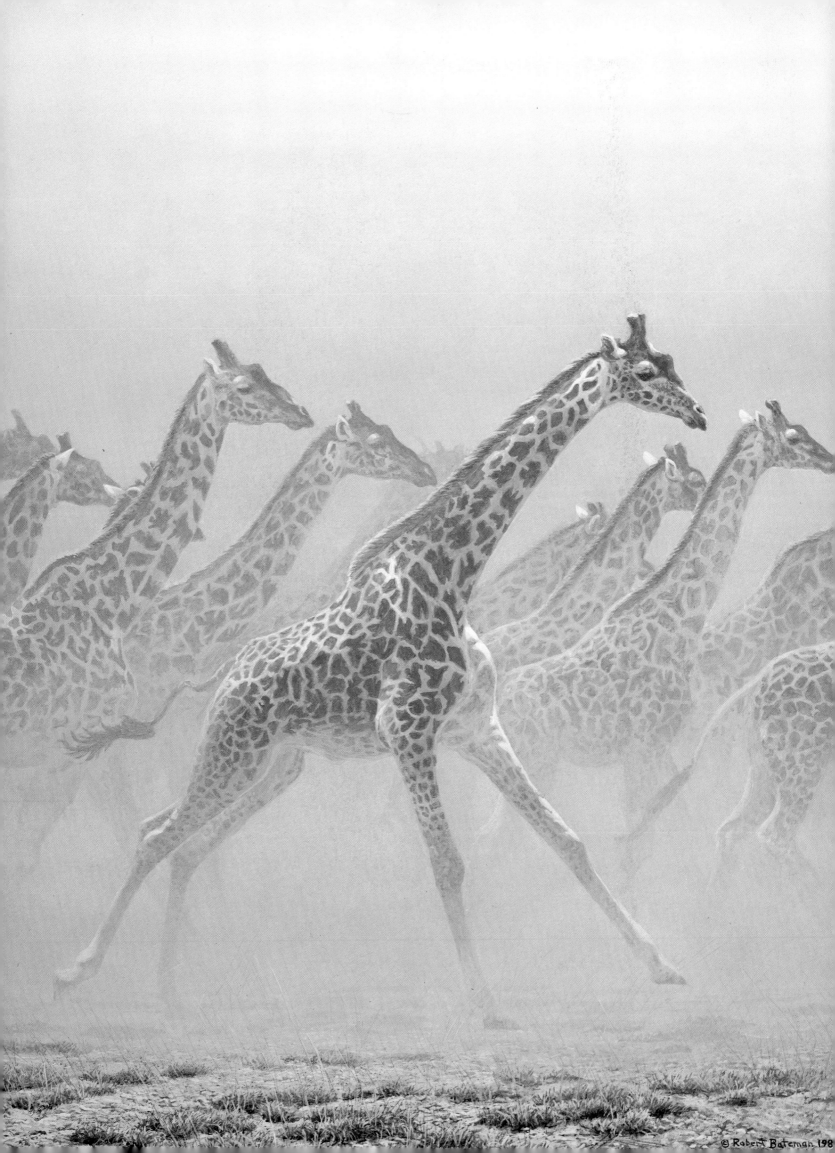

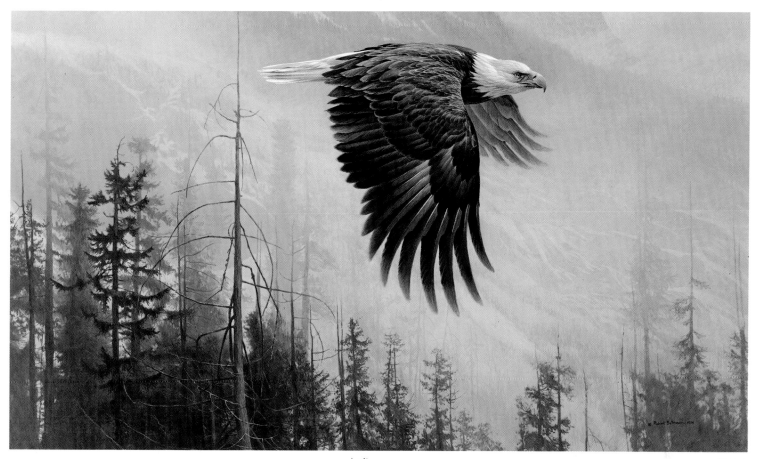

Left
*Galloping Herd—Giraffes*
Acrylic, 30" x 24" (76 x 61 cm)
Private collection

Above
*Majesty on the Wing—Bald Eagle*
Acrylic, 36" x 60" (91 x 152 cm)
Collection of Mr. and Mrs. Marvin Popkin

His advice to aspiring wildlife artists includes following the road he has taken. He says, "The most important thing is to spend time in the field and get to know and understand wildlife. It's very important to have a good background in art, all the way from still life to abstraction. Look at other art, not just wildlife art. There are too many young artists not paying their dues. Instead they are copying photographs. All artists should do more drawing and sketches that will help them understand anatomy."

Drawing on his own experience with undergraduate students, he cautions, "There are many high-school students doing wonderful detail. They expensively frame their efforts, market them too soon, and become prima donnas. They are not going to develop. It's necessary to keep on learning from every source.

"Don't paint for the market. I never sold a painting until I was thirty-five, when I got two hundred and fifty dollars for it. I've always painted to please myself." Bateman's first show was in a small gallery in Ontario in 1967.

"I'm doing now what I want to, and it's a fluke of fate that this is now popular as salable art. But this is a historical phenomenon that I happen to be in the middle of. Luck and fate have made it possible to do what I wanted to do, and sell it, too."

# KEN CARLSON

Ken Carlson lives in northwest Montana's pine and Rocky Mountain country where he is close to the chief subjects of his animal-action paintings. His multilevel house is against a hillside, near a wildlife refuge from which deer and elk visit the feeding station in his yard. Not far away is a national bison refuge where the artist can view a herd of five hundred buffalo during the rutting season when the males are fighting for the cows. "It's a dramatic sight," says Carlson. And it is for the portrayal of the drama in the lives of buffalo, elk, wild horses, and other mammals that Carlson is achieving recognition.

It took several years before Carlson found the ideal place to live and paint the kind of wildlife art that means the most to him. They were years spent learning his craft, beginning with his early childhood in a small town in Minnesota. As a child, he was intrigued with cartoon books, always copying animals. "I've always painted animals and I always will," he says now. A bout of rheumatic fever at the age of twelve put him to bed for a year. Like many others who have been forced into solitary pursuits, he found his life's work during the long hours spent doing schoolwork at home and in becoming more and more engrossed in drawing and copying from magazine illustrations.

Around the age of fifteen, he entered a contest advertised in one of those magazines. The ad was a "Draw me" contest and the challenge was to draw a Jefferson nickel. The prize was a scholarship in a correspondence course given by Art Instruction, Inc., which was located in Minneapolis. With his winning drawing, Carlson was introduced to his first formal training in art and was taken under the wing of the head of the school, who happened to be Walter Wilwerding, one of the foremost American wildlife painters and one of the first to specialize in African wildlife. Carlson recalls, "I sent my paintings to Wilwerding, who was very tough on me. Every time he criticized my work, I would work even harder. That he gave me more criticism than compliments was his method of separating those who were seriously interested in learning. Since then, I have always been interested in learning,

*Evening Shadows—Cougar*
Oil, 20″ x 30″ (51 x 76 cm)
Private collection

34

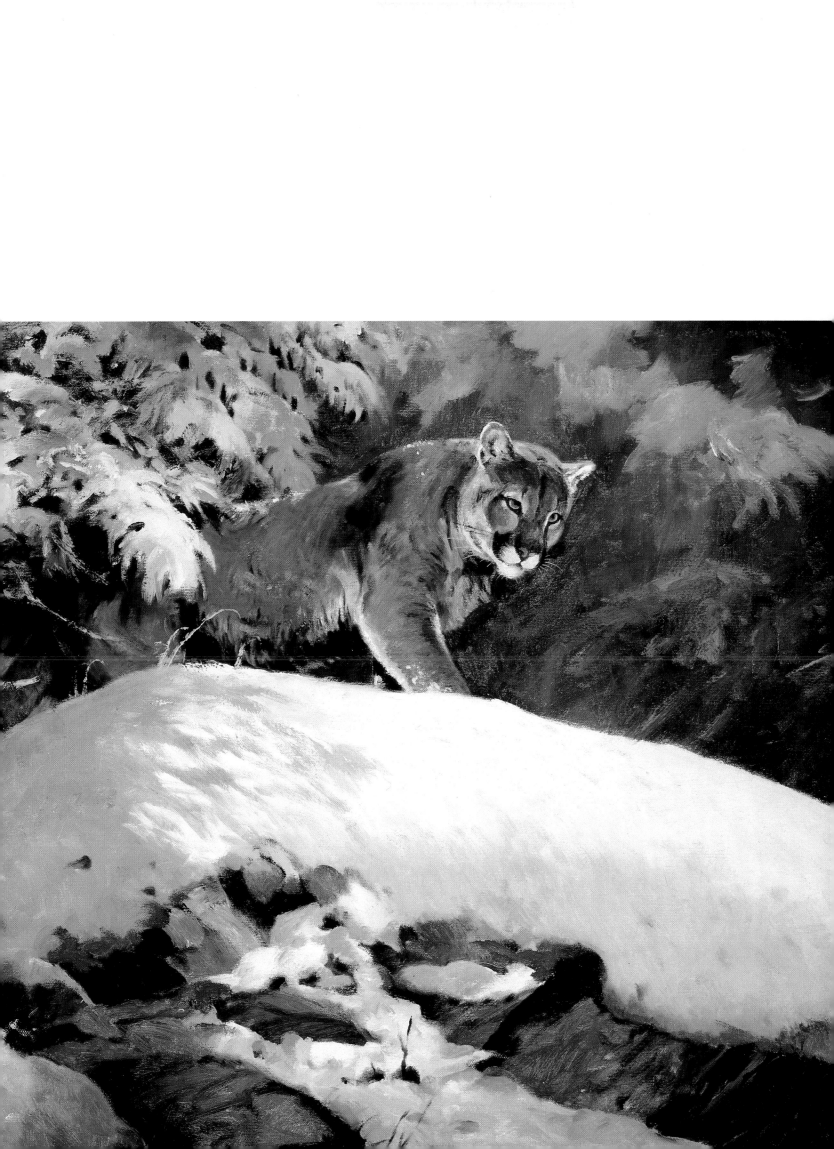

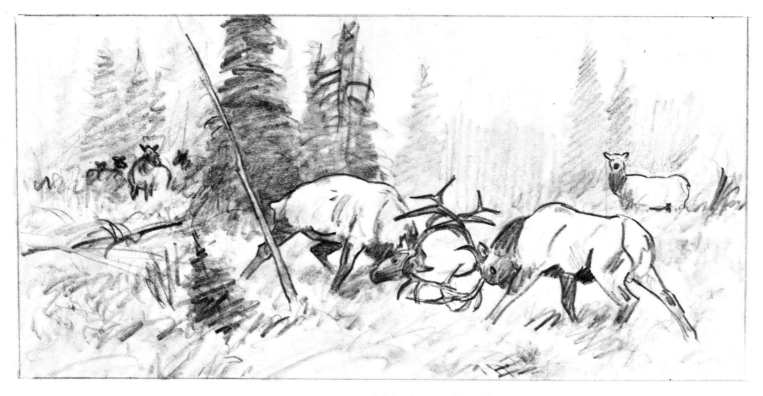

and I feel one should never stop. I listen to it all, sorting out what's of value to me."

After a period of learning through corrections and letters, when Carlson was seventeen, he began spending two days a week studying with Wilwerding in Minneapolis, returning to his hometown for school. Growing up in the tiny town of Morton, Carlson had not even seen an original painting until he was sixteen. But it was the heyday of magazine illustrators, and Carlson says, "I learned from the illustrations of Bob Kuhn and John Clymer." Wilhelm Kuhnert and Carl Rungius were all influences upon his style with wildlife subjects. After graduation from high school, where no art courses were available, Carlson finished his correspondence course. He then enrolled in the Minneapolis School of Art, which he attended while working at a job at a local TV station, where he did commercial art for the promotion and advertising department. Weekends and evenings were spent sketching at the Como Park Zoo in St. Paul. His more formal training at the School of Art proved a disappointment, however. "The teachers concentrated on abstract art, which was not for me. I didn't want to do it. It seemed that if it wasn't a Jackson Pollock, it wasn't worth doing."

Carlson decided to concentrate on his own drawing of animals at the zoo, and eventually the director gave him the keys to the animal cages so that he could go there at night after work. "At night I would turn on the lights in the zoo and sketch. I worked in the pens, wearing a keeper's jacket. One day I went into the elk pen to get photographs of him bugling, and the animal charged and almost killed me. After that," Carlson says wryly, "I lost my zoo privileges and spent a week in the hospital. I had paid my dues as a wildlife artist."

Despite the cost, Carlson learned a great deal from his experiences in the zoo. Sketches in oil on canvas reveal details of a leopard's head, the legs of deer, antelope hooves, and so on. "It's hard sketching an animal in the wild," says Carlson, "because it's impossible to get more than the feeling

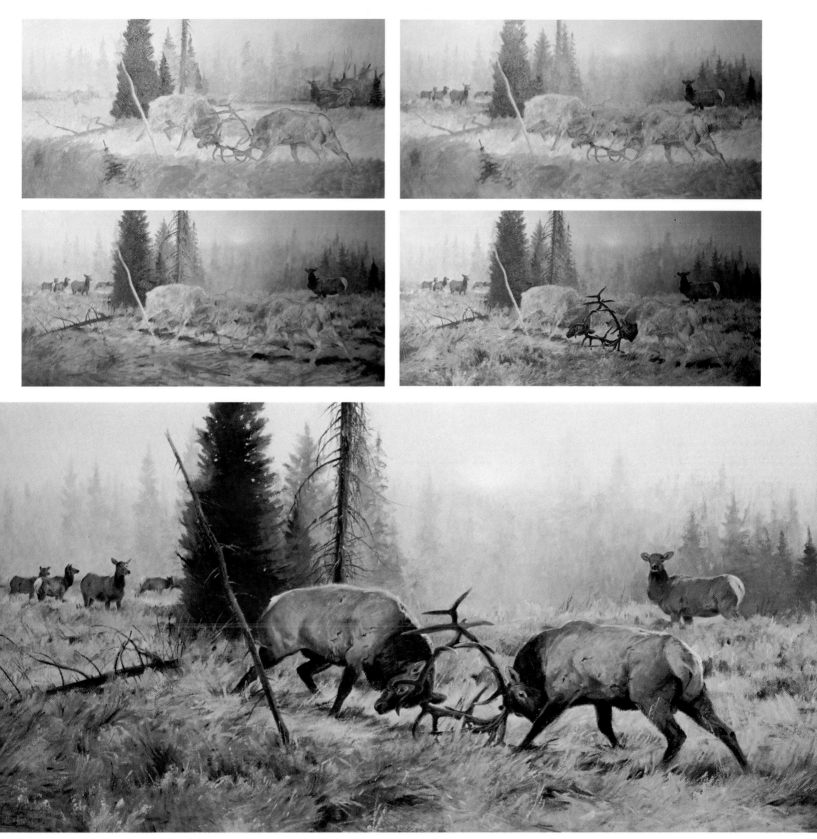

*Dispute at Dawn*
Oil, 24" x 48" (61 x 122 cm)
Collection of Mr. Russ Fink

The first stage of the painting is the pencil drawing. Carlson makes individual sketches, and when he has decided on the final composition, he draws it directly on the canvas. He then establishes the color scheme with a thin turpentine wash of color over the entire canvas. He finishes the background elk and trees first; then the middleground trees, background grasses, and the fallen tree; and finally the foreground grasses and antlers.

of how they look and behave on the run." For the all-important close-up needed for accurate rendering of anatomical characteristics, Carlson used all other possible means, from zoos to slaughterhouses. "Freshly killed animals are better than mounted ones," he says. "But the reason I'm living here in Montana is to have close access to big game. Animals look very different in the wild from the way they do in zoos. I have learned much about what animals should be doing in a painting from observing them on their native turf. One of the major problems of any wildlife artist is to get models. Through observation you get a feeling about how they should look and how they behave that cannot be captured even by a photo."

Carlson, nevertheless, does not underestimate the value of photography. "I believe that by taking photographs yourself, you get the whole atmosphere." That atmosphere can include forty-below-zero-degree weather, which Carlson has felt while photographing elk in Wyoming.

Until Carlson reached his present haven for wildlife painting, he had traveled from Minnesota to California, working as an illustrator, including for children's books. His style of painting had begun as loose and painterly while he was studying with Wilwerding. But soon he was advised, "Tight sells." Collectors in San Francisco began asking for bird paintings, and Carlson obliged with skillfully detailed renderings of feathers and backgrounds. "I used study skins of birds, which I borrowed from the California Academy of Sciences," he says. Carlson illustrated a magnificent book, *Birds of Western North America,* which took him two years to complete. By that time, he says, "I got bored with rendering feathers. My galleries which were selling my bird paintings were leery when I told them I wouldn't do tight bird paintings any longer. But I believe that as wildlife art collectors become more sophisticated, they begin looking for looser, more painterly work."

Carlson also believes every wildlife painter wants to express the features of animals with the utmost accuracy. "But," he says, "you can do that without painting every hair. Now I'm trying to get the feeling of paint, and the brushstrokes become more representationally meaningful. You can't achieve the effect of special brushstrokes by just adding more and more strokes on a detailed background. It took me the longest time to be able to put down just one stroke that says 'rock' without all that detail, or another that says 'fur.' I'm interested in textures that say hard and soft, but still have the continuity of brushwork over the entire painting. There are good uses to be made of principles of abstract design, which can teach you how to create a design and to use color and texture."

All of those techniques and beliefs are put to work on paintings whose themes and ideas come from direct observation in the field. "Backgrounds are most important to me for ideas for a painting," says Carlson. "When looking at a scene, I always try to picture an animal in it. Most of all I like to do action paintings. For that I have to go and see the animals in action." Many of the habitats are available nearby,

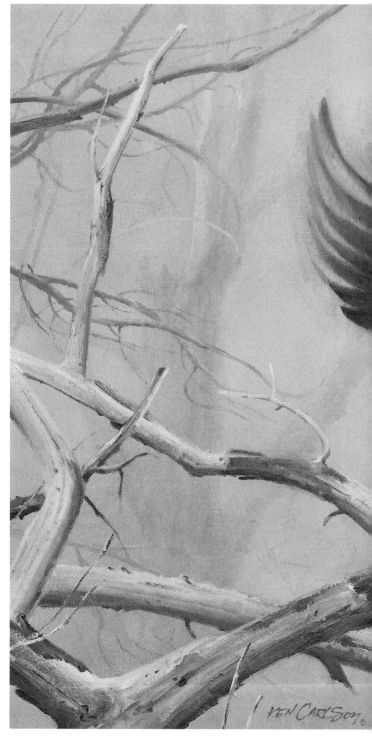

*Wings of Nobility—Bald Eagle*
Oil, 24" x 41½" (61 x 105 cm)
Private collection

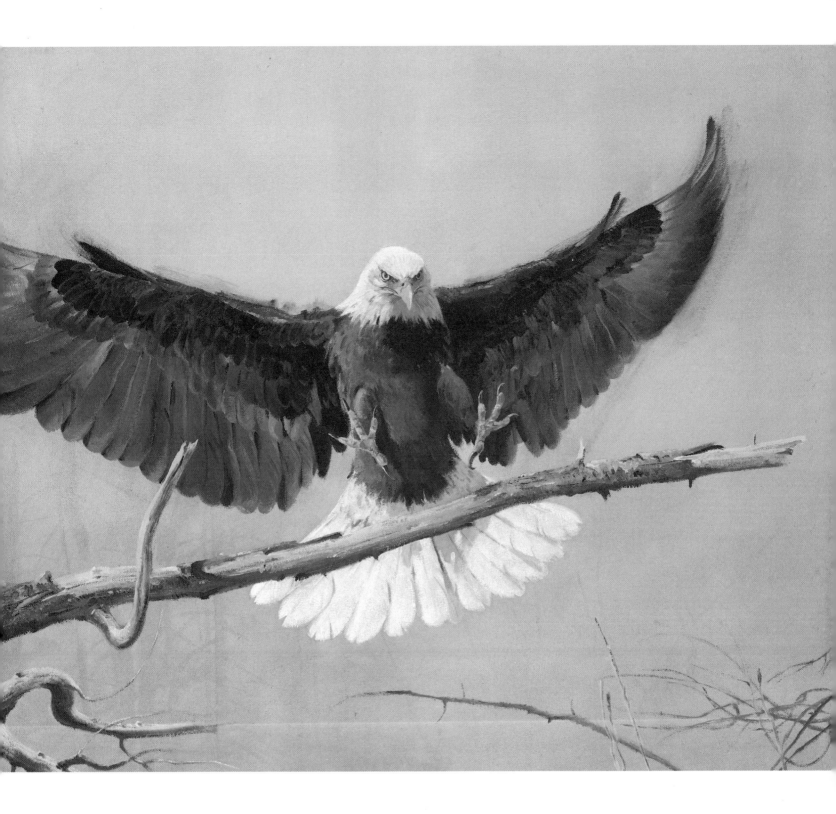

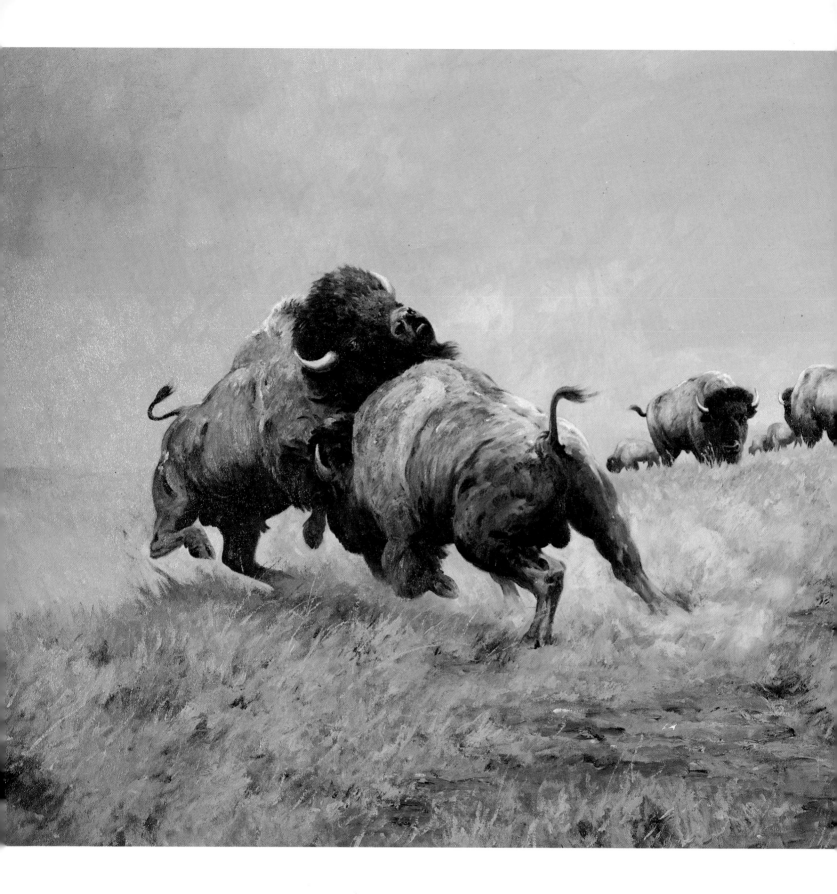

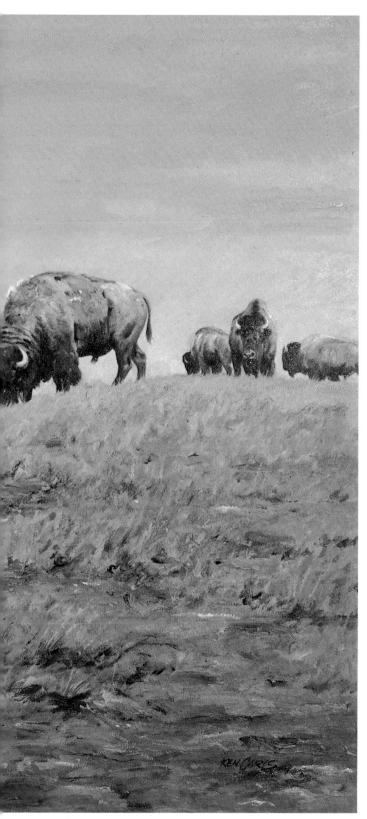

but Carlson has also traveled widely. "I have traveled from Alaska to Texas," he says. "If you're painting certain animals, you must see both the animals and their habitats to do them justice. I've spent weeks in Alaska and will go again. There I saw caribou, grizzly bears, Dall sheep, moose." All of them became subjects of his paintings. In Montana and Wyoming he has observed bison, elk, moose, mule deer, white-tailed deer, pronghorn antelope, and bighorn sheep.

On those trips he does special sketches for settings. "Sometimes it will be just a sketch of a fence or a gnarled tree. Weather is very important." He points to a painting in progress of wild horses. "I wanted them in a hot, dusty setting. The idea just wouldn't come off in fog or rain." On the other hand, the fighting elk he was working on as well were set in an early-morning light with fog rising from the ground, because, he says, "that's when they fight. In fact, most animals are active in the early morning and at dusk. They bed down during midday heat. I'll go to the bison

---

Left
*The Rut*
Oil, 30" x 48" (76 x 122 cm)
Private collection

Below
Oil sketches
of tiger's head
and paws

refuge at dawn, as that is the most active time for the animals. By midday they will bed down for several hours."

Carlson's camera equipment goes with him on these trips. "I only use photographs I take," he says, "and I use these for reference. I take shots of the details of heads and horns, and backgrounds with interesting trees and snags which have wonderful shapes and are great for painting. I don't take photographs in zoos anymore because the animals in the wild are so much more alive. In some photographs the only value may be a leg gesture or an interesting shadow." He may use these details while changing everything about the animal in the final painting.

When sketching in the field, Carlson carries a wooden sketch box that he made himself which holds his oil-paint tubes, mounted canvases that fit into slots so that paint will not smear, and his palette. A second section holds paints, medium, and brushes. Sitting on the ground, Carlson may also use a dime-store sketch pad for charcoal drawing, or he may use no. 2 pencils or Conté crayons.

Sketches, photographs, pencil drawings, and the "feel" of the place and scene are all taken back to the studio and come into play when Carlson decides on the subject of a painting. He says, "I'll do a lot of black-and-white sketches on tracing paper." Several on hand show buffalo in various fighting positions. "You have to know anatomy," he says. "I learned it mostly from my drawing at the zoo. I look for flow of action. I look for a line that will say 'power.' Having seen buffalo fighting, I know what I'm trying to capture. You can't sketch while that action is going on, but you can remember how it looked, felt, and something of what the animals were going through." Among other sketches, some show moose in various positions. "You can't tell a moose to turn its head to the right, so you have to know enough anatomy and have done enough observation to be able to place the animal in any position that is natural to its behavior and physiology."

While working on a painting, Carlson is thinking of ideas, some for future works. "I hike a lot, looking for something that strikes me as having possibilities for a painting." The artist never uses mounted animals but may occasionally use animal skins for reference to get accurate markings and colors.

Above the living room of Carlson's house, occupying the top floor, is the artist's studio, facing north into hills, trees, and sky. The studio is workmanlike and efficient. There are two easels, both usually with a painting in progress. "I sometimes work on two paintings at the same time because I can be working on one while the other is drying." His tabouret holds brushes, paints, medium, and palette.

Before he begins a painting, Carlson renders thumbnail sketches in black-and-white pencil about 2 by 3 inches (5 by 7½ cm) on tracing paper to work out his design. His next step is to draw a more detailed design on larger sheets of tracing paper. At times, he says, "I'll cut the drawings apart and rearrange them." He shows a painting in progress of wild horses that have been sketched in against the background. Dozens of sketches of wild horses in various

Top
*Teton Winter—Trumpeter Swans*
Oil, 24″ x 48″ (61 x 122 cm)
Private collection

Bottom
*Arctic Nomads*
Oil, 24″ x 48″ (61 x 122 cm)
Private collection

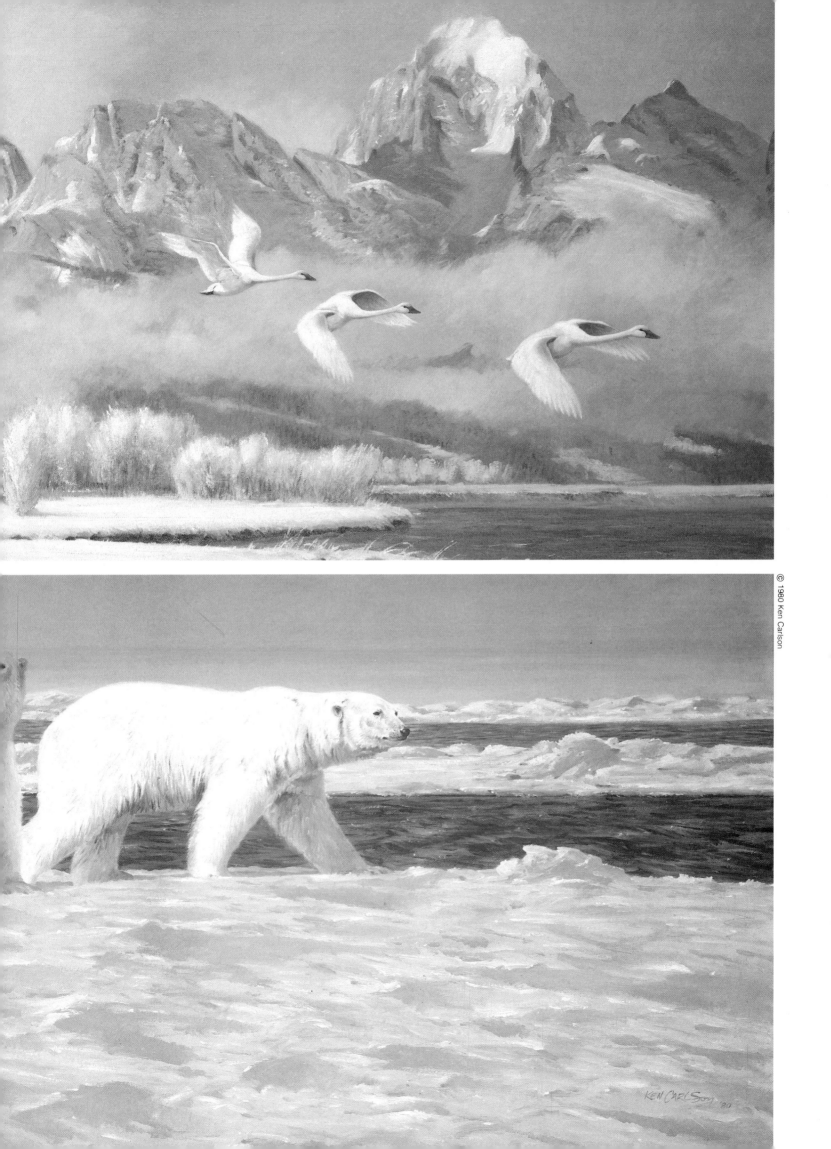

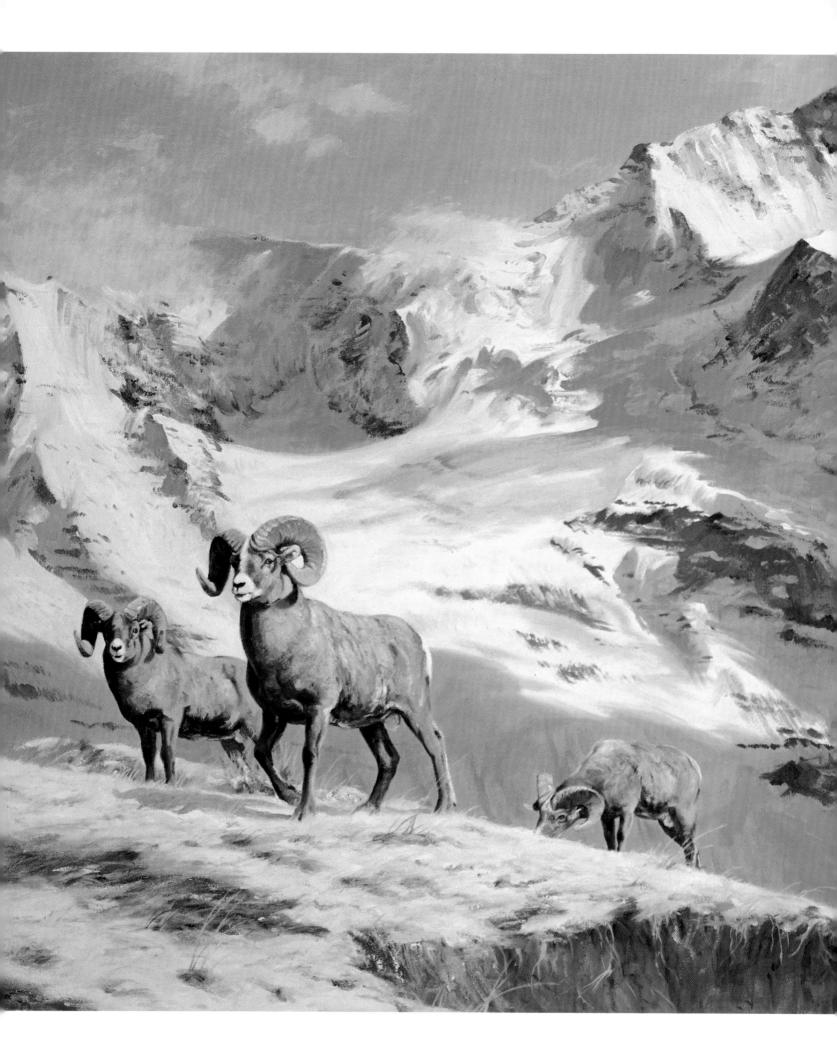

positions have been made as a preliminary to final placement on the canvas.

When he has settled on the final design, Carlson does finished drawings of the poses, working out the details. "I like to solve any problems at this stage, rather than on the canvas. Then I redraw on the canvas." The drawing on canvas is done with pencil. "I vary the approach to my paintings," he says. "Sometimes I tone the whole thing in, using underpainting with the color scheme entirely worked out. At other times I want to allow for spontaneity. With the horses, I did no underpainting. There I tinted the canvas with a turpentine wash of warm tones—raw umber and Naples yellow." Although Carlson never uses a palette knife, he does like to build up paint with his brush to accentuate a highlight on a rock or a few blades of grass. "I

Left
*Winter Rams*
Oil, 26" x 34" (66 x 86 cm)
Private collection

Below
Oil sketches
of mule deer doe
and antelope

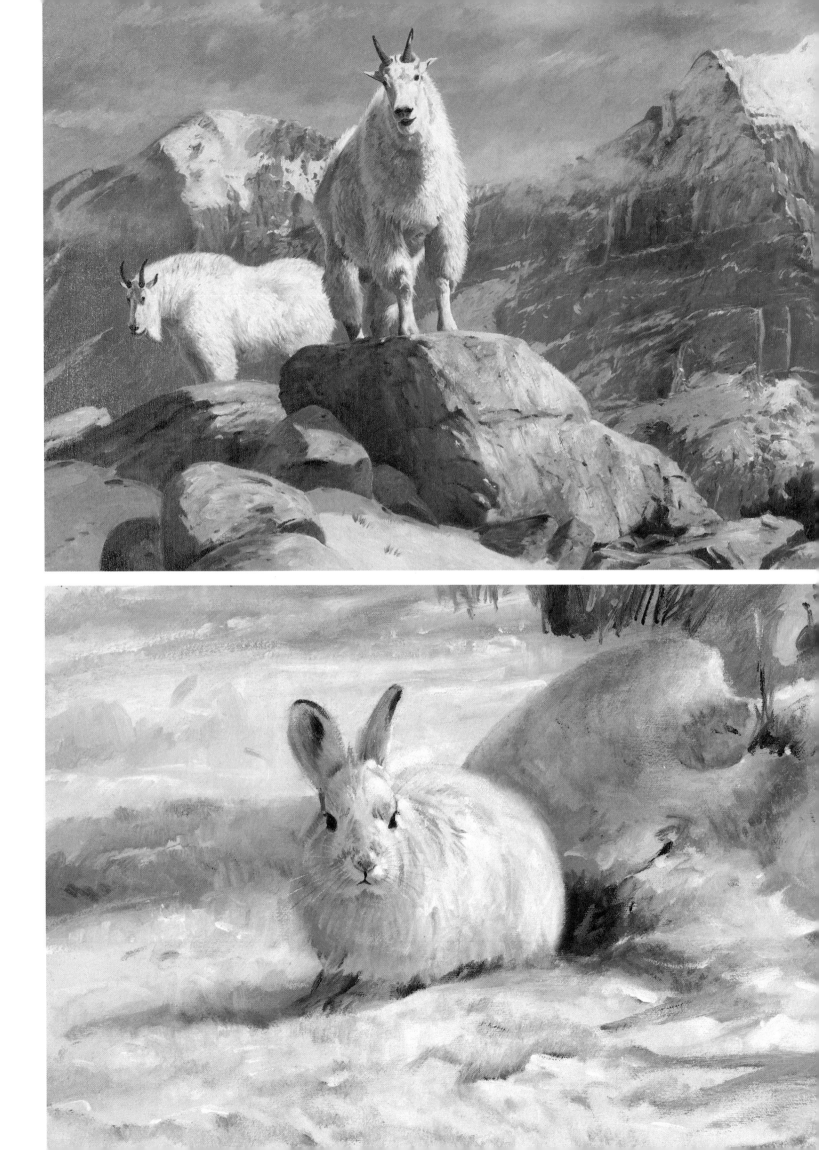

like to show brushstrokes," he says, "to get a feeling of the paint itself."

Carlson works only in oil these days, even in his preliminary sketches which alternately may be rendered in pencil. "I've used pencil all my life," says Carlson. As for the oil sketches, he says, "I like to use oil paint. I've used gouache, but I prefer oil and I can work fast in it. It gives me a wider range of manageability than any other medium, and sometimes I prefer the slower drying time. I guess I just like the way oil handles. I've tried acrylics, but I didn't like the feel of them."

His painting medium is copal. "I can glaze with it," he says. "I can use it as a wash and thinner with my pigments since it goes on like watercolor and speeds up drying." He also uses retouch varnish while painting "to bring up earth colors that may dry too flat to work with. I also use it to spray the finished painting." His canvas is cotton, which he stretches himself. "I like the tooth in cotton." Bristle brushes are used for 99 percent of his painting. Winsor & Newton sables are for the smaller details.

Carlson prefers to keep his palette quite limited. He usually uses the earth tones—raw umber, raw sienna, Naples yellow—along with permanent blue, rose madder, and titanium white. For his blacks he uses a mix of burnt sienna, cobalt blue, with a spot of rose madder. "It appears black," he says, "but it doesn't get muddy when mixed with other colors. I'm trying to limit my palette more and more. Some of my work now is done in just two colors."

Nearly all his work is horizontal in format, ranging in sizes from 9 by 18 inches to 30 by 48 inches (23 by 46 cm to 76 by 122 cm). "Smaller sizes can add to your market," he advises. Most of his compositions are carefully asymmetrical, stressing tensions. The horizontal format gives a range for landscape design. Each painting may take two to three weeks to complete.

Carlson's galleries are Collector's Covey in Dallas, Texas; Trailside Galleries in Jackson, Wyoming, and Scottsdale, Arizona; and Russ Fink in Lorton, Virginia. "I don't take commissions. If I'm doing something that interests a certain collector, I'll show it to him. That way I don't have to worry about what someone else has in mind."

Carlson advises, "Learn how to paint. It's not enough just to like animals. Paint human figures, too, to learn how to capture living movement. I sketched for years at the zoo to learn how an animal moves. You can't do that in the wild. But you can learn both movement and anatomy from zoo animals. If you learn animal anatomy as you learn human anatomy, you can move them to any position you want. For how an animal looks in prime condition, only the wild will show it to you. It's important to develop resources for wild animals. Observe them. Don't buy photographs. Make good use of photographs and learn how to take good ones yourself." He believes that after an artist has mastered his techniques, his feeling for the animals and his feelings for design, color, and drama will have a better chance of being expressed.

Top
*Rocky Vantage Point—Mountain Goat*
Oil, 20" x 40" (51 x 102 cm)
Private collection

Bottom
*Winter Coat—Snowshoe Hare*
Oil, 12" x 24" (30 x 61 cm)
Private collection

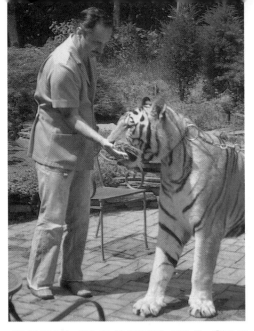

# GUY COHELEACH

One of Guy Coheleach's paintings of a charging elephant once hung in the East Room of the White House. His art was the first to be exhibited by the United States in postwar Peking, and he was the first wildlife artist to be listed in *Who's Who in the World, Who's Who in America, Who's Who in American Art,* and other biographical reference works.

An honorary doctoral degree in 1975 from William and Mary was conferred for his "artistic achievements in the field of animal art, and for the dedication of that art to support the human environment, wilderness areas, and endangered and threatened species."

A trailblazer in wildlife art, Coheleach is also master of all styles in his chosen subject area. Impressionistic, realistic, full landscape backgrounds, and vignettes against white—all these are his interchangeable modes of painting everything from owls to elephants, and sea bass, too. He says, "My loose paintings are the loosest, and my tightest are the tightest possible. I change around to keep myself from becoming bored."

From the first, Coheleach has managed to lead a life that has resisted boredom with activity, travels to wilderness areas, wide interests, and hard work. His beginnings were on New York's Long Island, where Coheleach, one of nine children, grew up in Baldwin. "It was a typical south-shore Long Island town and a lovely place to grow up," he says. "I was always interested in wildlife, beginning with the sea gulls which I used to try to catch with fat held in my hand. My other interest was snakes, which I collected and kept in the cellar. I had one hundred fifty Indian cobras and rattle-snakes. My mother had to cope with an occasional loose cobra when she did the family wash in the cellar. Fortunately, my parents were great people," he says. And the family included those interested in art. Coheleach's grand-mother painted flowers in oil as a hobby; his older sister Bea "was a good artist," says Coheleach. Most of all, the family was tolerant of its members' individual interests; says Coheleach, "My sister Flo was the first woman open-cockpit race car driver."

Coheleach's first grammar-school teachers seemed equally

*Siberian Tiger Head*
Gouache, 30" x 24" (76 x 61 cm)

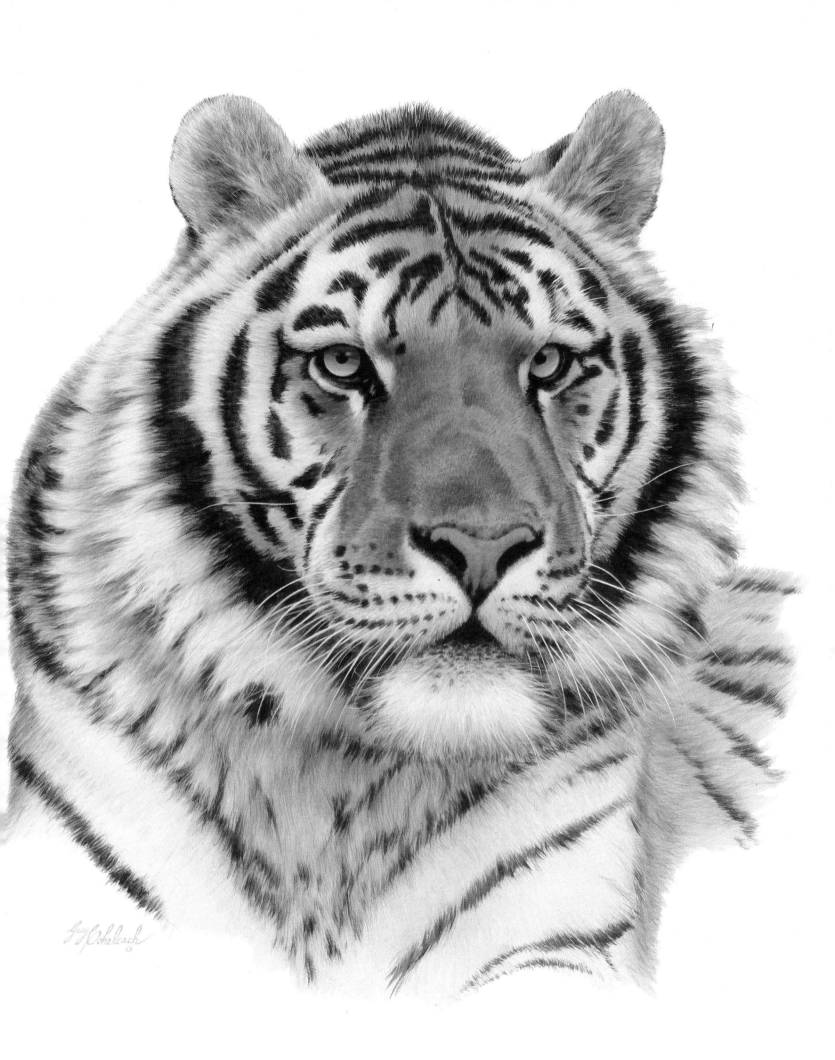

tolerant when they sent his drawings on the covers of books to his parents. Coheleach believes this "punishment" was also a way of pointing out that he had talent.

"We had a drawing teacher who came into grade school fifteen minutes a week; her name was Mrs. Shady. She taught professionally, but she offered to teach me for nothing. I was about ten years old and she taught me to use oil paints. My first was a copy of a picture of a parrot from a postcard, and it showed me how to mix paints. My first original painting was of a wood duck."

A bird trip with the Baldwin Bird Club ended with a visit to a member's home, where Coheleach got his first look at *The Birds of America* and *Birds of New England*, both books illustrated by Louis Agassiz Fuertes. Says Coheleach, "I used Peterson's *Field Guide to the Birds* to identify the hawks near my home. To me, Peterson was the one person who made it possible for all wildlife artists to see more. He made the greatest contribution to nature appreciation of any living American. I used his book to identify not only hawks, but some of the 'lesser' birds as well. To me the predator birds always come first. There was, at the time, no field guide to mammals. I seldom painted my own snakes, because the scales took too long to do."

Coheleach made his first sale of a painting while a student at Bishop Loughlin High School in Brooklyn. "I sold a portrait of a boxer dog to neighbors of my married sister. I did it in oil and was amazed that they gave me sixty-five dollars for it."

Payment for his work was an early concomitant of Coheleach's interest in art. He recalls with some humor that in one of his art classes in high school, the teacher held aloft before the class a painting he had done as a homework assignment and said, "This guy is going to make a lot of money as a commercial artist someday."

"He was holding up my watercolor of an eagle," says Coheleach, who had taught himself how to use watercolor. "That's when I decided that art could be my career, since I had not yet made any other decision about what to do after graduating from high school." Coheleach applied for and won a scholarship to New York's famed Cooper Union for a college-level course in architecture and art. "Cooper Union is great for teaching design," says Coheleach. "I remember a teacher of two-dimensional design who was a great influence on my work. But many of the other teachers only challenged me by making me angry. It was a period when the abstractionists were ascendant and I had no interest in abstract art myself. I had problems with some of the instructors until my sculpture teacher, Mr. Hovhannos, advised me to show them work 'half-done.' "

Coheleach's course at Cooper Union was interrupted by service in the army for twenty-one months spent in Hawaii, Korea, and Indochina. "While in the army," says Coheleach, "I kept up my skills in drawing by doing sketches from my imagination of pretty girls drinking cocktails in nightclubs as a reaction against the cruelty, poverty, and abuses taken for granted in that part of the world."

His return to Cooper Union completed his formal art education, and the new graduate took a job in a commercial art studio in New York, "doing rendering and illustrating for mail-order catalogs, everything from brassieres to can open-

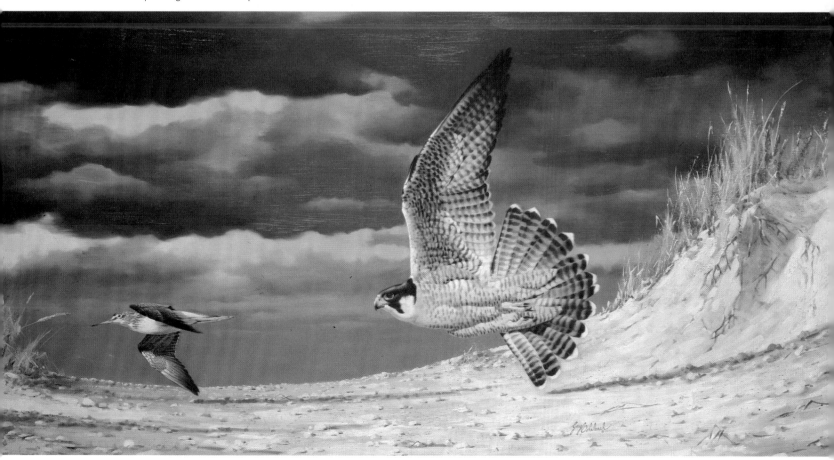

*Barrier Beach Chase.* Oil, 36″ x 72″ (91 x 183 cm).

Coheleach's initial drawing establishes the format of the painting; he
determines the relative positions of the figures and whether he will add background
or other elements. Next, he establishes values and lighting, still working in
pencil. (He typically makes hundreds of pencil drawings for each painting.)
Once he has selected the final pencil sketch, he roughs it in on the canvas
with black paint. Only then does he begin filling in the colors. He
paints the background, first just around the figures to see that value
and color relationships are correct. He continues to fill in the
colors of the rest of the painting until it is complete.

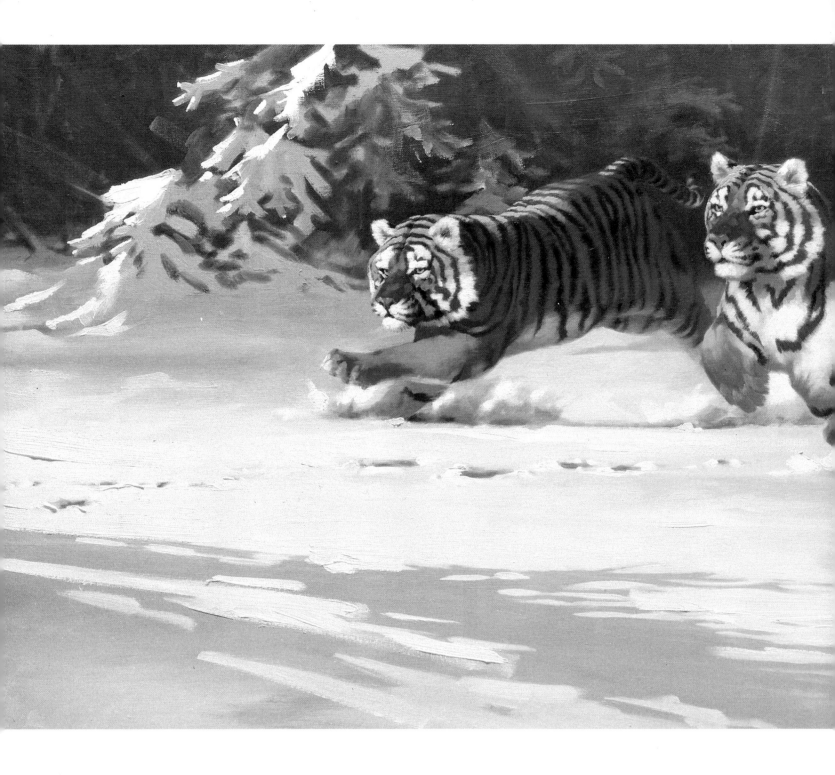

ers." After several years of commercial art studio work, Coheleach, who had become one of the youngest members of the Explorers Club, met the man who was probably the greatest influence on his subsequent career. Don Eckelberry, a well-known painter of birds, met Guy at the Explorers Club. When the two artists met, Coheleach told Eckelberry: " 'I like painting birds and animals, but there's no money in it.' Eckelberry then told me he had turned down twenty thousand dollars' worth of commissions for bird art the previous year. With his encouragement, I quit the commercial studio and my wife, Pam, and four children and I decided to try to live on one-third of my former income. By the next year, with an initial push from Eckelberry—who got me an assignment to do a calendar on the promise that if they didn't like my work, Eckelberry would do it over for them—I began to get jobs from *Audubon*, *National Wildlife*, *International Wildlife*, *Field and Stream*, *Sports Afield*, *National Geographic*, and many book publishers. I began doing illustrations for such books as *Birds of Prey of the World*."

Coheleach's love of wildlife and of painting is based upon his fascination with the outdoors. From the time he was twelve, he had made independent trips in search of snakes for his collection, hitchhiking to Hawk Mountain in Pennsylvania to see the hawks. In 1966 Coheleach won a trapshooting contest which awarded him with his first trip abroad—to London. "From there I took the opportunity to go to Africa—to Kenya, Uganda, and Tanzania—equipped with a thirty-five-millimeter camera and color film plus sketch pad and pencils. I got good photos of big game—elephants, lions, antelopes, leopards, rhinos, buffalo. It was my first opportunity to see African mammals in their own habitat. For me it is important to see animals in their own settings in the wild. It is even important that I see them being hunted and hunting. If I want to show a cheetah hunting antelope, I must see it happening to show how both move."

Traveling to Africa is now a twice-yearly event. "I go to Southeast Asia once a year now," he says. "I go to India and Sri Lanka to see tigers and gaur [buffalo], leopards, snakes, birds, crocodiles." Coheleach learned to shoot a rifle in the army and took up shotgun shooting as a hobby. Although his hunting now is confined to Cape buffalo in Botswana, or occasionally shooting a wounded animal in the wild, he says, "I could never paint wild game as effectively if I hadn't also been a hunter and been hunted or stalked by lions and elephants in the field."

One such experience changed his approach to painting elephants forever. He recalls that someone once accused him of never having actually seen a charging bull elephant. No sooner challenged than Coheleach instigated a charge from a large bull in the field. It was only to see how he would look, but a warning shot fired by game warden Eric Balsam turned the onrushing pachyderm after it had pushed Coheleach into a ditch. Since then, Coheleach's paintings of charging elephants incorporate the personally experienced menace of such an encounter.

Musing on his continuing absorption in painting wildlife, Coheleach says: "All children like animals, then they grow

*Manchurian Chase*
Oil, 24" x 44" (61 x 112 cm)

out of it. I never did. I enjoy doing it and I can make good money at it." Often the paintings help make money for conservationists as well. Coheleach has donated prints and originals to raise sums into the millions of dollars for the cause of preserving wildlife and its habitats.

His own personal success has brought him a large house on three wooded acres on the shore of the Great South Bay of Long Island. His living room is hung with his own paintings and with those of other wildlife artists whom he most admires. Three by Bruno Liljefors are among the collection, which also includes Wilhelm Kuhnert and Francis Lee Jaques. Coheleach admires the work of Louis Agassiz Fuertes, one of the major influences on his own work, and of Carl Rungius. Of old masters, Coheleach appreciates El Greco "for his drama," N. C. Wyeth, Cézanne, Monet, and Michelangelo.

His own works show the range of his styles, from impressionistic to dramatically realistic, and some that are delicately drawn with exquisite details.

Over the fireplace in the library there is a painting of a leopard. Coheleach illustrates how he arrives at an idea for a picture by recalling that he first got the idea for this one by walking around a water hole in Botswana "to see what kind of game was around. Across the water hole I saw a leopard under the bushes in its lair, so I photographed the place, but later I changed it a lot. After working on the painting back in my studio, I also decided to turn the leopard's neck instead of having him looking straight ahead as he had been."

Most of his ideas come to him from his observations in the field, sometimes abetted by his thumbnail sketches done on the spot or back at camp. Written notes describe compositional ideas and colors. Some of his ideas are derived from the landscape, others from the animals. Sometimes they are dictated by a commission, such as a recent one to do a bull and bear for the New York Stock Exchange.

When he begins a painting, Coheleach says, "I'll often go through my file of photographs and scrap of animals such as leopards lying in similar positions to the one I have in mind. I do this for accuracy. I used to use reference books such as those on the anatomy of the gorilla by Harry Chapin. By now I have done a lot of taxidermy in the field and have collected study skins of birds. I also get the study skins I need from the American Museum of Natural History. I know a lot about anatomy from my hunting expeditions. While the other guys are hunting, I'm watching the skinners cutting the carcass." He feels that photographs are necessary for reference, but not to copy.

He uses his own photographs of backgrounds "because I'm not a botanist or geologist and I want backgrounds to be accurate. Then I rearrange them back in the studio to fit into the composition. They must be backgrounds which are appropriate to where the animals live. The bushes in the leopard painting are in Botswana. It would be embarrassing to put an African leopard against an English walnut tree." He is equally concerned with the proper setting, weather, and time of day for the animals in his paintings. "I like painting things in misty, foggy atmosphere rather than

*Rocky Mountain Chase: Cougar and Bighorns*
Oil, 30" x 40" (76 x 102 cm)

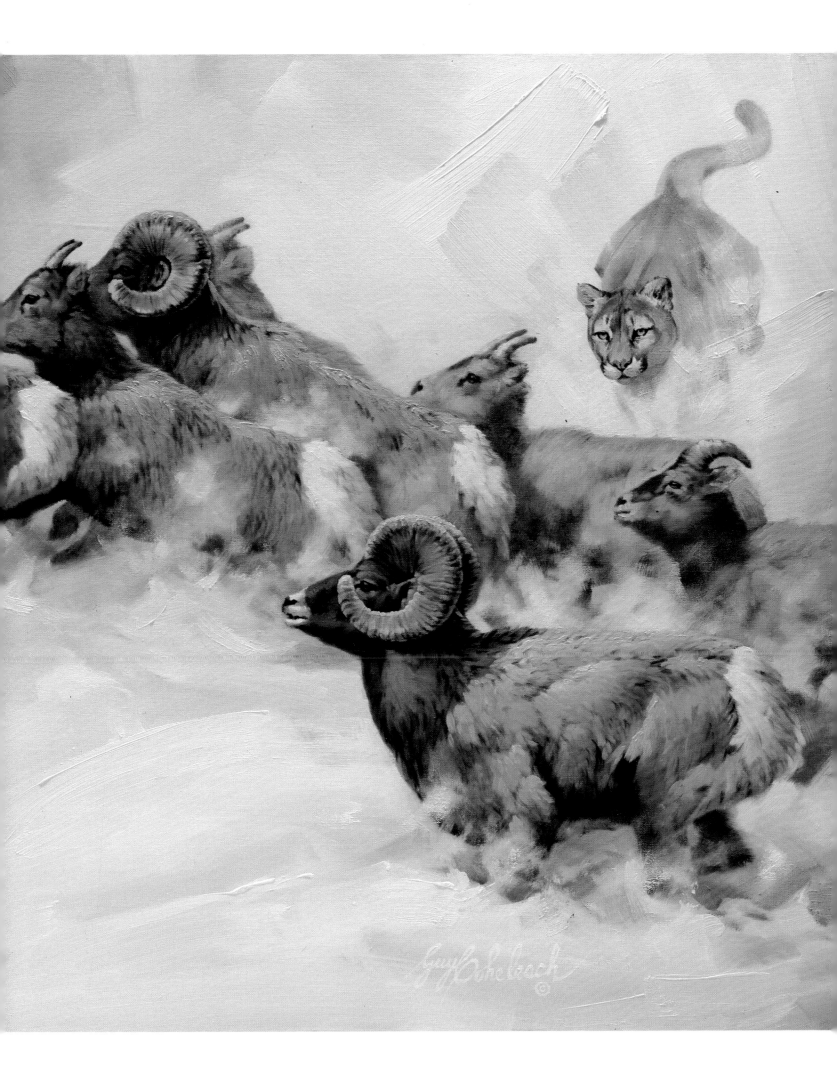

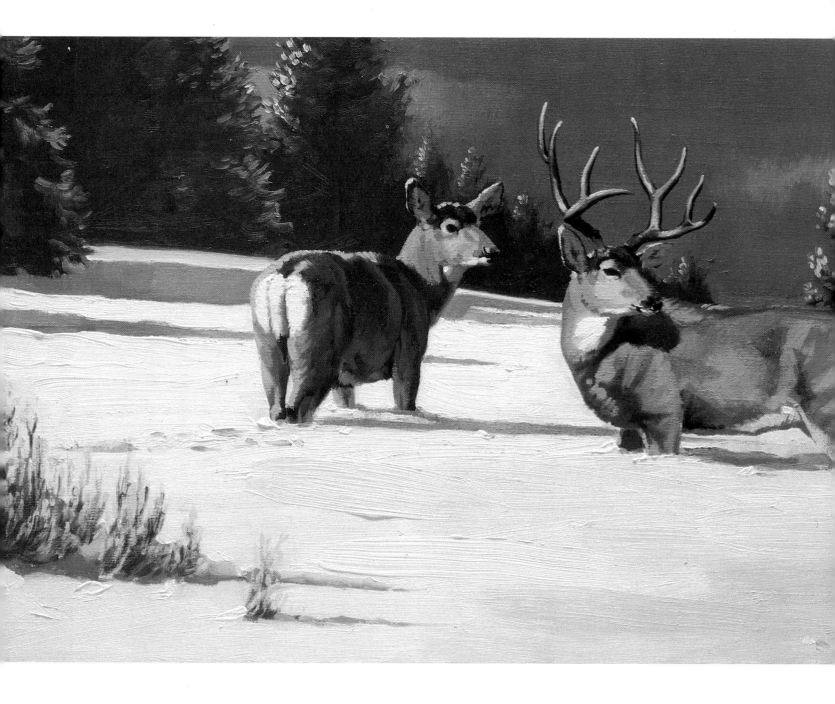

full sunlight. Many animals are seen at water holes and there is fog. It is important that everything be accurate, so when I work, I tack up lots of pictures.

"In the field you experience the tension, the smell, the mood, the electricity in the air, and the stillness. You capture that feeling and something reminds you of it—a photo or a thumbnail sketch. Or it may be just a few lines and a notation such as 'green heron stalking a striped killifish.' Usually I just do motion lines to show a rock or limb. When I see it back home, it all comes back. Sometimes, of course, you can lose a lot. That's why I like to use photos to get colors in the right places. The photos must be corrected for color in the painting, but they are good maps and gauges for color relationships. If the color is off, it's off all over."

In his second-floor studio overlooking the trees and the bay, Coheleach works at the window, its natural light augmented by an overhead array of color-corrected fluorescent lights that are carefully balanced for red, yellow, and blue. On his standing easel is a painting in progress, a 40-by-60-inch (101½-by-152½-cm) oil of a bull attacking a bear which was commissioned by the New York Stock Exchange as its official portrait and from which reproduction prints will be distributed. Of the pose Coheleach says, "It's supposed to show an undecided match between the two, representing the constant, unresolved flux of the stock market."

The size of the painting dwarfs the relatively small rectangular, shipshape studio space. A drawing table is near the easel, and a tabouret holds the artist's store of oils, water caseins, and acrylic paints. File cabinets contain his "swipe" material, thousands of references divided into subjects such as "hawks, eagles, owls, bears," and so on. His reference books crowd the hanging shelves and include titles on flowering trees of the world, life in the far north, mammals, birds, trees, flowers, and insects.

Coheleach remarks that he uses photographs and the scrap material mostly as reference. But he also has had the opportunity of sketching a Siberian tiger in his own swimming pool. "It was owned by a theatrical animal trainer who is a friend of mine. Through others like him, I've also had live leopards and eagles in my studio." When he begins a painting, Coheleach refers to notes taken in his field sketch pads. From them he does a thumbnail sketch, about 1 inch by 2 inches (2½ by 5 cm), just for the design. The next step is a pencil rough on tracing paper. This may be done in color. He sometimes works out as many as three thousand preparatory sketches on tracing paper before addressing the canvas. While sketching, Coheleach refers constantly to slides and other materials, or he may work with a study skin. "I may buy photographs as part of my scrap file," he says, "and use them for reference as well."

His palette is a paper one, which he changes every couple of days. Brushes include bristles, sables, and synthetic sables for soft work. Varnish is used "to bring up contrast." He uses his palette knives for some, but not all, of his paintings.

Coheleach mixes most of his colors from a basic palette. "I use all the cadmiums because they're brilliant and last well,

*Long Shadows*
Oil, 12" x 24" (30 x 61 cm)

including yellow, light and pale; orange, light and deep." Alizarin crimson, he says, "doesn't hold long, but it has depth and mixes well with thalo green and blue to give a deep color going back almost to infinity."

Coheleach says he even mixes his ochres to match lemon-colored grasses or a sandy beach. "Nothing comes out of the tube looking like nature," he says, "except that most manufacturers make a good violet." Ultramarine, thalo blue, cobalt or sky blue, thalo and olive greens, and permanent green light and deep make up the cool side of his palette. For white he prefers titanium for "the opaqueness of flake with the tinting qualities of zinc." He uses Payne's gray as a tint for different grays; "it gives added depth." He seldom uses ivory or jet black except to block in the painting, although he may use umber instead. Burnt umber, burnt sienna, raw sienna, raw umber, raw ochre, Venetian red, and "a lot of unbleached titanium for a creamy tan color and as a light earth color to tint with other colors" make up his earth colors.

When the sketches are completed and the final composition decided, Coheleach blows up the tracing to a larger size. He then uses his opaque projector for small areas at a time. Sometimes he draws on the canvas directly with his brush, but he says, "Ninety percent of my work is in the pencil drawings, especially when I'm doing watercolors." His vignettes of animals against white backgrounds are chiefly done in tempera or gouache. "I used to use casein a good deal," he says, "but I found that it deteriorates in the tube. I liked it because I could rework it, and I used oil paints to work over it. Now I use acrylics both as watercolor and more thickly as in oil, but they have a plastic look. My colors are the same for each medium."

In a small room on the first floor off the living room are more of Coheleach's paintings and drawings in his varied styles. One oil painting of a running tiger, *Siberian Chase*, is done as a blurry, impressionistic rendering of high speed. Next to it is one of the most detailed and tightly done drawings in Coheleach's collection. It shows every scale, accurately and delicately, of a striped bass approaching a sand worm. Coheleach says, "I caught the striped bass at night. I kept it alive and painted it in the morning, then ate it and at night went to catch another one. I finished the painting right in the boat with the live fish so the colors were accurate."

In the same room are photographs taken by Coheleach's wife, Pam, on the many trips into the wilds of Africa and Asia where she has accompanied her husband and children. Tigers, zebras, and elephants are shown in prints that parallel the subjects of Coheleach's paintings. A zebra rug on the floor and four record-book antelope record Pam's hunting trips with him.

Of the many varieties of his painting styles and compositions Coheleach says, "I work in many different ways. Sometimes I do the background first, as I did in the bull-and-bear painting; other times I will do the background after I have done the subject. This was true for a recent painting of peregrine falcons. I usually do my impressionistic paintings

*Charging Elephant*
Oil, 30" x 40" (76 x 102 cm)

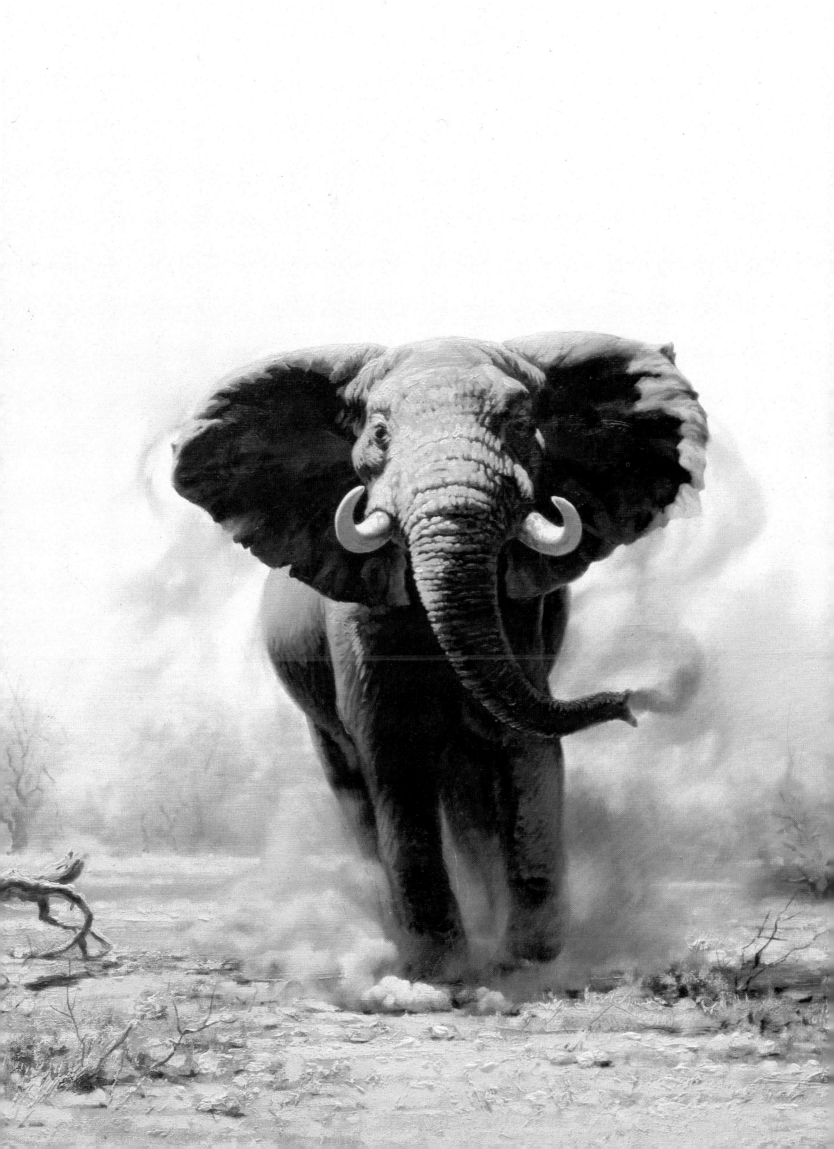

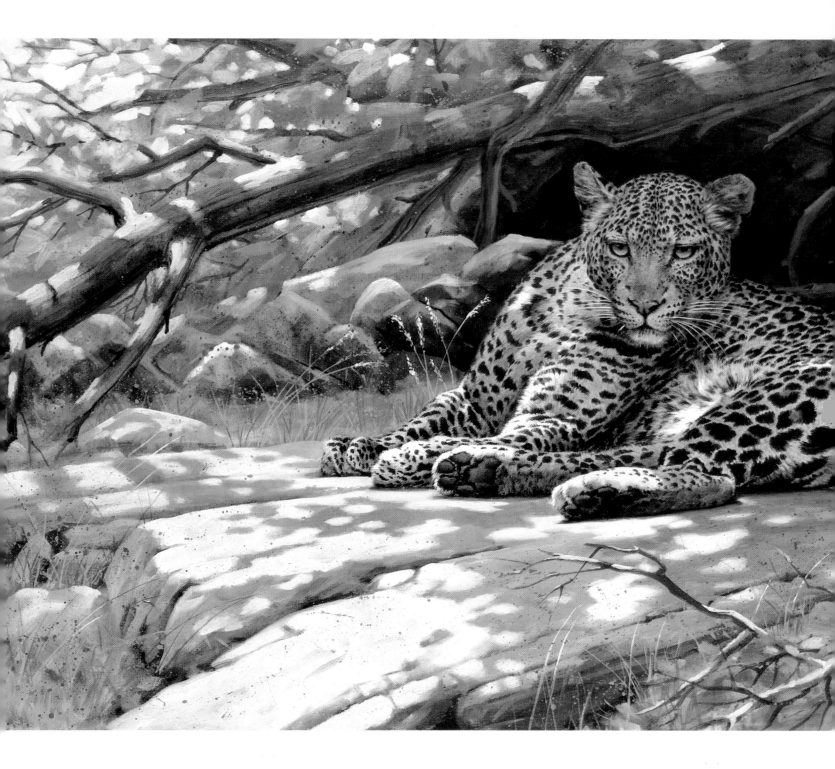

on a smaller scale than the more realistic pictures; each of my compositions is different, depending on the particular subject and picture. Sometimes I begin with the compositional idea, other times with the subject. Most of my animals are fairly predominant. I try to keep most of my compositions classically balanced, always with a counterbalance to the forms. And I try to keep my disasters confined to my pencil sketches. It takes me a month in the field to get excited about a painting, another month to do the pencil drawings, then a few weeks to fill in the colors."

Many of Coheleach's paintings are reproduced in limited editions of offset lithographs. Since 1972 Coheleach has been with Regency House Art, which publishes various editions of his works. One, the Quest edition, is a series of 850, signed and numbered, and includes most of Coheleach's impressionistic paintings where the brushstrokes are evident and bold. Lower-priced editions of up to 5,000 are vignettes of birds and cats' heads with a lot of detail; the Imperial Series, larger in size and limited to 1,500, are of major paintings and some vignettes.

Coheleach points with some pride to the fact that his prints have won a record number of "printing industry awards." Regency House Art is not far from where Coheleach lives: Box 147, Plainfield, New York, is the mailing address.

Based upon his successful experience as a wildlife artist, Guy Coheleach advises students to "learn to draw first so your reference material doesn't trap you. If you let that happen, you'll only be able to copy your swipe material and you'll be a captive to it! Paint what you thoroughly enjoy, not what other people tell you to paint." He believes that the opportunities are unlimited in this "heyday of wildlife art."

*Leopard's Lair*
Acrylic, 44" x 24" (61 x 112 cm)

T. A. Ellis

# RICHARD ELLIS

Among artists and naturalists, Richard Ellis is himself a "natural." An artist who has illustrated his own major books and whose paintings are exhibited in well-known galleries, he was entirely self-taught. A natural scientist whose books on sharks and whales are considered to be among the most authoritative on their subjects, he has a B.A. in American history from the University of Pennsylvania.

By following his own natural bents, he now has a thriving career as a painter, writer, and conservationist with a special dedication to helping preserve the largest mammals on earth—the whales—and other endangered cetaceans.

Born in New York City in 1938, Ellis drew from the time he was a boy. "It's always been easy for me to translate from sight and brain to paper," he says. "But I did very little drawing while in college. In fact, I didn't know what I wanted to do. My skills seemed directed toward advertising and communications."

Both his parents were attorneys, and he long considered his own chief skills to be verbal. There were no artists in his family, so his ability to draw and design found no immediate role model on which he could pattern its development. Nevertheless, he spent his childhood spare time drawing animals at the American Museum of Natural History and at the Bronx Zoo in New York. "The way you manifest your admiration for something is to draw it," he says.

After college graduation, his career decision was post-poned when Ellis went into the army and was sent to serve in Hawaii. There, a love of the sea, which had been another component of his childhood spent on Long Island and later in Rhode Island, led to hours spent walking along the shore, riding the surf, searching for shells, and snorkeling in waters rich with sea life. Later he was to return to Hawaii to swim with the humpback whales off the island of Maui as part of his research for *The Book of Whales*.

In 1962, when Ellis was discharged from the army, he made a firm decision not to go into advertising. Instead he went to Philadelphia and offered his services to the Academy of Natural Sciences. "I said I wanted a job in the exhibition department and I offered to work for nothing. I did that for a month, then I was put on the payroll for a year." During that

*Leaping Dolphin (Delphinus delphis)*
Acrylic, 24″ x 18″ (61 x 46 cm)
Collection of Mr. Arthur Mintz

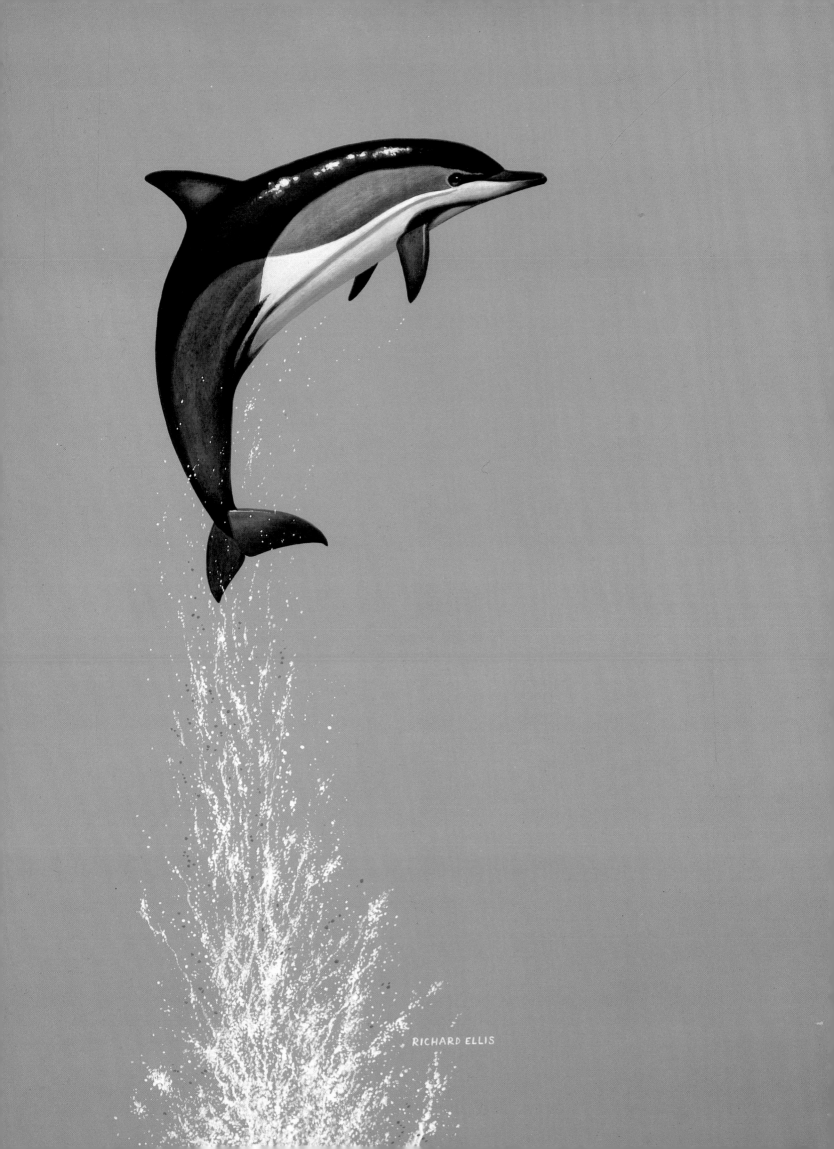

time he designed exhibits, did research for illustrations, hand-lettered labels, built exhibit cases, wrote articles for the magazine, and did cover illustrations. "I had a wonderful time," he says, "and learned all the basics. I gained experience, contacts, and I was building a portfolio. I did a series of exhibits called 'Museum of the Sea' for Aquarama in Philadelphia, which represented my first marine exhibitions."

Ellis then was invited to work for the American Museum of Natural History in New York, where he was the exhibit designer for the Hall of the Biology of Fishes. "It was a cram course in ichthyology for me," he says, and it was his first conscious discovery that here was an area of natural history that truly fascinated him. At the museum he also fulfilled a childhood desire when he painted a background for one of the dioramas, a scene of Jersey Pine Barrens for a small diorama of wasps. He had admired those dioramas as a child visiting the famed museum.

A year and a half later, Ellis felt he had learned enough about museum exhibition designing to start a company of his own. His Museum Planning, Inc., was established in 1966, and soon Ellis and his staff of twelve were designing exhibits for a variety of museums, ranging from the Metropolitan Museum of Art to the Smithsonian Institution. After five or six years of successful exhibition designing, suddenly, Ellis says, "I found myself doing an exhibit for Campbell's Soup. That's when I decided I was too far from the world of natural history, and by now I had also decided I wanted to paint."

The first painting in 1972, after Ellis closed his company, was of a seashell, another childhood love. Eventually he had a show of his seashell paintings in the Schoolhouse Gallery on Sanibel Island, Florida, one of the richest sources of seashells in the country. He developed his painting technique while drawing and painting the shells. As he said in an interview published in *American Artist* magazine in August 1979, "It was a good beginning for an incipient career as a painter, since I began painting still life in a more or less classical sense. I would carefully position a shell, studying it from all angles before I made my preliminary drawings. When I was satisfied with the way the shadows fell, I would set the artificial lighting so that the shadows and highlights would remain constant. I would do a pencil sketch directly on illustration board, then block in the masses and shadows, thus defining the form. After the blocking in was accomplished, I would work on one area of the shell at a time until it was completed, then I would put in the highlights. I studied each shell so carefully that I could easily have redrawn it from memory. I was literally enchanted by the intricacies of these natural forms."

By the time he had fully explored all the possibilities of shell painting, he wrote and illustrated an essay in *Audubon* magazine, "How I Became an Ex—Shell Painter," in which he stated that he preferred to "paint those things that do not have to be killed so that I might enjoy them." Ellis says, "At

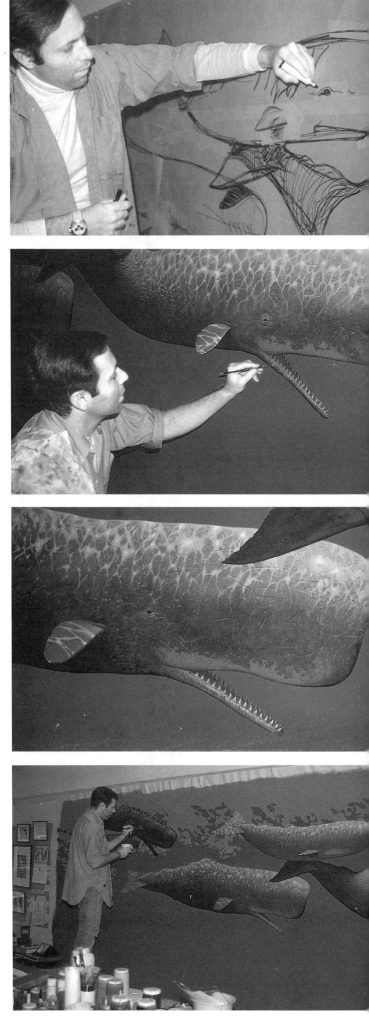

This sequence shows Ellis painting the mural of sperm whales at the Wehle Museum in Buffalo, New York. He begins by sketching the figures on large sheets of brown paper, taped together and tacked to a hanging rail. After rolling the sketch up, he lays the canvas on the floor and paints the background. When it is dry, he staples the canvas to the rail. Then he unrolls the sketch, cuts out the figures, and traces them with white chalk onto the canvas. When he is satisfied with their positions, he paints them, one at a time—first the basic color, then details such as teeth. The final touches are the sunlight patterns and surface air bubbles—and the artist's signature.

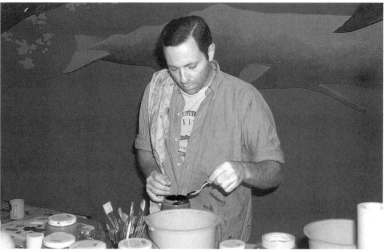

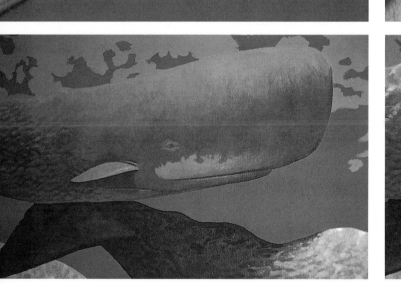
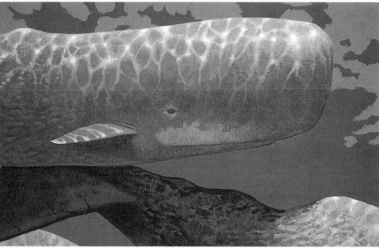
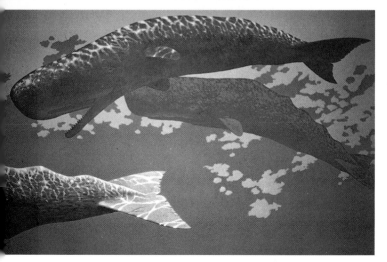

RICHARD ELLIS · 1977

that point I had been a full-time painter for less than a year, with no other source of income. I now thought of myself as a painter when I sold most of the paintings from that show, which were all acrylics.''

Through the Explorers Club, Ellis then got a commission from the *Encyclopaedia Britannica* to do illustrations of whales and sharks. He did them with the help of books such as *Mammals of the World,* by Ernest P. Walker, and *Living Fishes of the World* by Earl Herald. *Mammals* is ''all photographs and is one of perhaps fifty different sources I use for my references.'' He also maintains an elaborate ''swipe file'' of photographs culled from magazines.

''Through that work, I became more and more fascinated with marine 'critters.' I did a couple of paintings, very tentatively trying to paint for the sake of painting. They were paintings of sharks and whales.''

In 1974 one of those paintings of a shark was on his easel in his New York City apartment when one of the first of his lucky coincidences occurred. ''The mother of one of my daughter's friends was visiting and mentioned that she knew a writer who might be interested in my work. The writer was Peter Benchley, who became a friend and who later invited me to his publication party for *Jaws.* My painting of a shark appeared on the cover of the *New York Times Magazine* section in connection with an article on Benchley's book. At the publication party the shark painting was on view, and a man asked what I was doing. Just for fun, I said I was writing a book and the man said, 'I have a publisher for you.' Soon I had a call from the president of Grosset & Dunlap, who said he would like to publish my book on sharks! I had only a few paintings, but then I was called for jury duty, and while waiting there for ten days to be called for a case, I was able to write an outline for the book.''

Ellis's next lucky coincidence also came about because of his daughter, Elizabeth. ''I knew nothing of book publishing,'' says Ellis, ''but one day while I was sitting at a schoolbus stop with my daughter, we met the mother of one of her schoolmates. The mother happened to be a novelist, so I asked her what I should do about my book-publishing offer. She gave me the name of her agent, Carl Brandt (incidentally, he is still my agent). When I took my outline to him, he said, 'Leave it all to me.' ''

Ellis's *Book of Sharks* was published by Grosset & Dunlap in 1976 and has been called the most definitive book on sharks ever written. It contains hundreds of photographs, and all its many drawings and the twenty paintings reproduced in color were done by Ellis. They were based on research that included photographs and study which uncovered what Ellis calls ''a lot of misinformation about sharks. I went shark fishing. I visited scientists and read technical papers. I even fell into a shark tank in Florida.'' The *Book of Sharks* was so successful that it was picked up by no fewer than five book clubs, including the Book-of-the-Month Club.

Next, his attention was directed to the endangered great whales as a subject. With fellow conservationist and writer David Hill, Ellis went to *Audubon* magazine to propose a

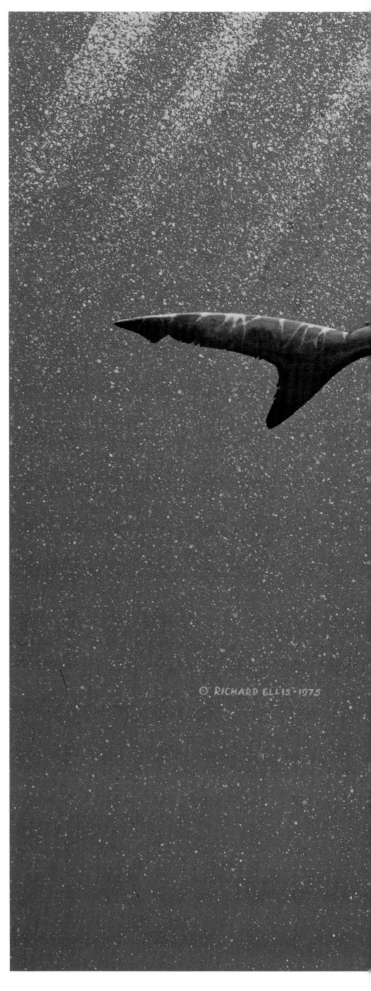

*Blue Shark (Prionace glauca)*
Acrylic, 20" x 30" (51 x 76 cm)
Collection of Mr. Robert Lehman

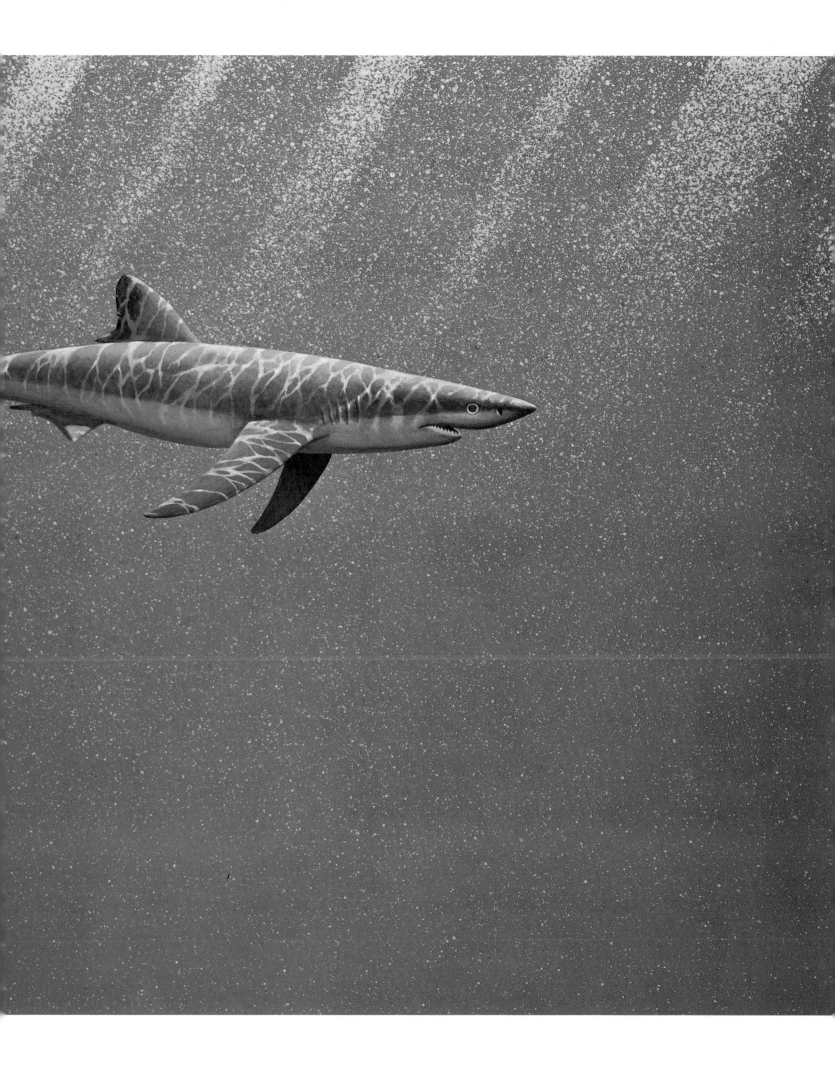

major article on whales. Ellis proceeded to paint a portfolio of whales, working from museum specimens at places such as the Smithsonian Institution, and in serious libraries with whale-related materials, using scientific papers and other materials that gave the exact anatomy, size, proportions, and measurements of each physical feature of the different species.

The paintings for *Audubon* were completed in the fall of 1974 when Ellis received an offer and an advance for his *Book of Sharks*. The paintings for the shark book were all done in acrylics on canvas mounted on composition board. "Originally," says Ellis, "I taught myself to paint with watercolors. But I went naturally on to acrylics, which I use like oils, but not with heavy impasto." By then he had also been scuba diving in Hawaii, Bermuda, and the Caribbean, learning

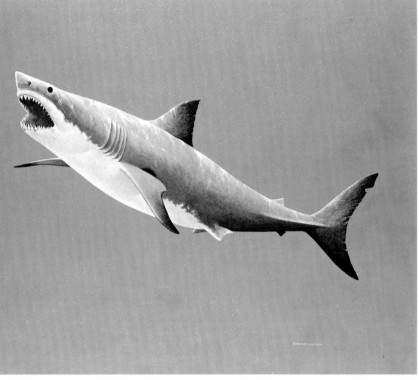

RICHARD ELLIS – 1974 ©

Above
*Great White Shark (Carcharodon carcharias)*
Acrylic, 30″ x 40″ (76 x 102 cm)
Collection of Mr. Norman Seltzer

Right
*Tiger Shark (Galeocerdo cuvieri)*
Acrylic, 28″ x 35″ (71 x 89 cm)
Collection of Mr. Gil Costin

more and more firsthand about life beneath the seas. "But," he says, "even at first hand you cannot see more of a whale or a shark than a passing shape."

But when the whale article appeared in *Audubon* magazine with a cover by Ellis, it quickly sold out, and Ellis became established as a whale painter almost overnight. At that point he decided he had better see some live whales in their natural habitats. He has managed since then to see the gray whales of Baja California, the killer whales off Puget Sound, and whales in the waters off Hawaii, Argentina, and Japan. He says, "They are bigger than you expect them to be. Being in the water with a right whale is like being in the water with a floating bus. It's fifty feet long. There's no way to photograph whales through murky waters, so I try to paint them as accurately as possible. My paintings may look superrealistic, but they are really my impressions. They look as though they ought to be real, and as they ought to look, but you could never take a photograph that looks like one of my paintings."

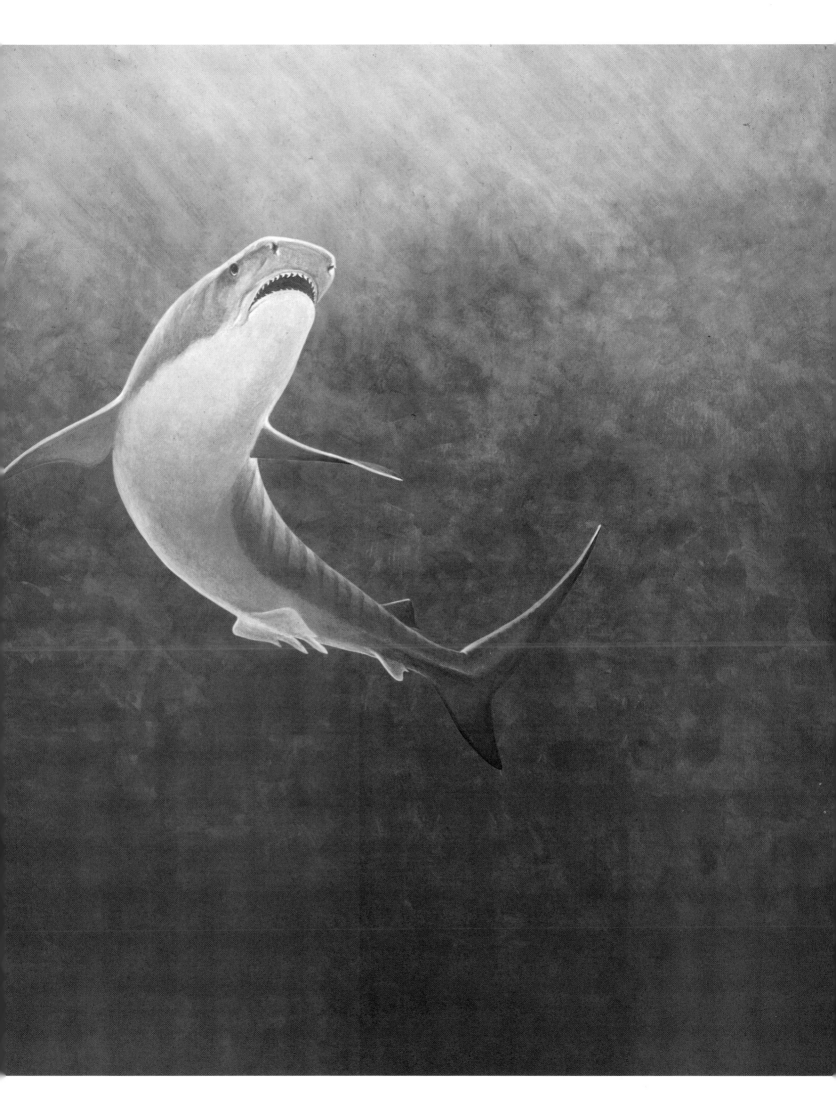

The *Audubon* article brought still another result. A book publisher called Ellis and asked him to do a book about whales. Ellis talked the publisher into letting him do a field guide to the marine mammals of the world. Ellis says, "I told the publisher I could write the text in three months, because I had done so much research for the illustrations. Three years later, in 1979, I turned in the completed manuscript for just the whales, dolphins, and porpoises. It contained two hundred thousand words, and the publisher literally didn't know what to do with it." Ellis took the manuscript and his illustrations to his agent, Carl Brandt, and then went off with his family to dive in the waters off Newfoundland. There, Brandt called to tell Ellis that Alfred A. Knopf would publish the book, which was eventually to grow to 300,000 words.

Because of the length, it was decided to publish two separate books, and the first, *The Book of Whales,* appeared in 1980 to universally admiring reviews. In it are full-color reproductions of thirteen of the best-known whale species as painted by Ellis during the preceding five or six years. Said the *New York Times* book review, "Mr. Ellis is an artist, and the superb reproductions of his paintings and drawings show whales as man can rarely see them. And, when such art is combined with enlightening nonpolemic prose about how whales are born, live and die, the uniqueness of their niche in nature becomes obvious."

Richard Ellis's life has now become dedicated to communicating the story of and the danger to whales as well as to other cetaceans, using his skills as both a writer and an

Below
*Dusky Dolphin*
*(Lagenorhynchus obscurus)*
Acrylic, 24" x 18" (61 x 46 cm)
Collection of Dr. Ricardo Mandojana

Right
*Atlantic White-Sided Dolphin*
*(Lagenorhynchus acutus)*
Acrylic, 18" x 24" (46 x 61 cm)
Courtesy of Sportsman's Edge, Ltd.

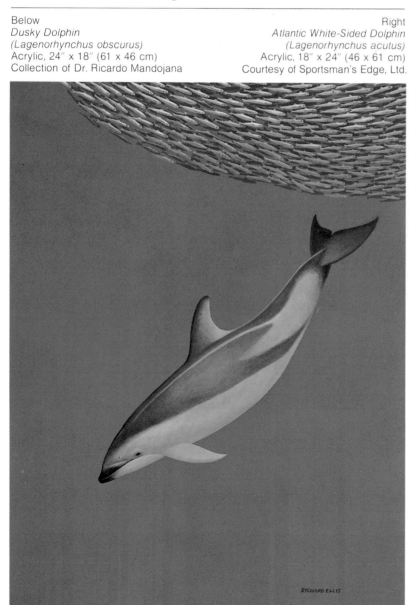

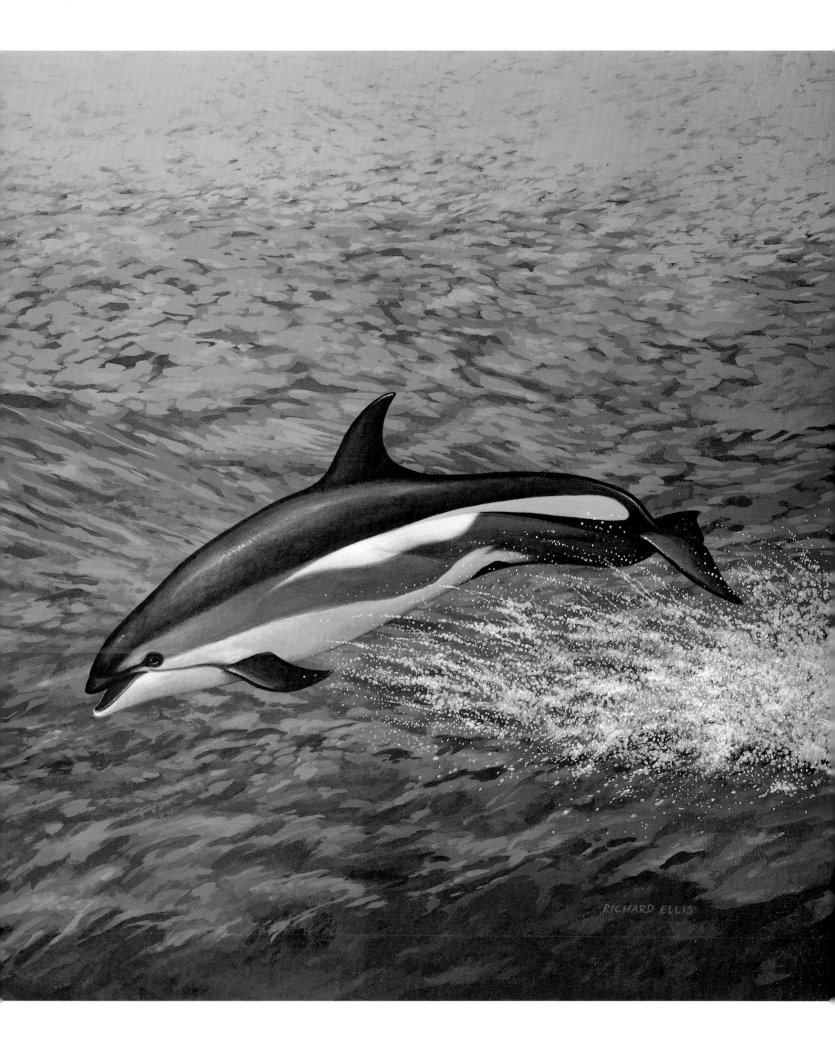

RICHARD ELLIS

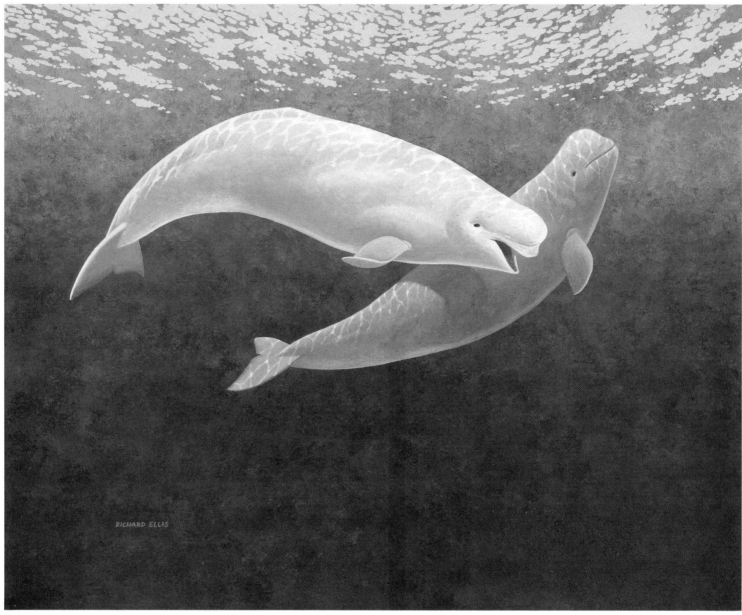

*Beluga Whales in the Saguenay River*
Acrylic, 18″ x 24″ (46 x 61 cm)
Collection of David Lank

artist. Still to come is the second volume of the field guide to marine mammals, which will do for dolphins and porpoises what the first book did for whales. After that, a volume on seals, manatees, sea otters, and walruses, according to a review in *Discover*, "will complete a work comparable only to Audubon's in its ambition and beauty."

As the "Audubon of the cetaceans," Ellis is modest about his artistic approach. "I would say I'm a naturalist who paints. I'm more interested in the subject matter than in the finished paintings." Nevertheless, his paintings are sought by collectors, and his collotype prints are in demand. One collector, the owner of the Wehle Museum in Buffalo, commissioned Ellis to paint a mural of whales for the building. Ellis chose to do a group of sperm whales. First, he sketched the figures on a large sheet of brown paper, then he worked on canvas placed on the floor while he painted the background. The canvas was then stapled to a rail where the brown paper sketch had hung. The figures were cut out from the paper sketch and taped to the canvas, traced with white chalk, and then painted. In 1978 Ellis did another whale mural directly on the newly built, specially primed plaster wall at the Denver Museum of Natural History.

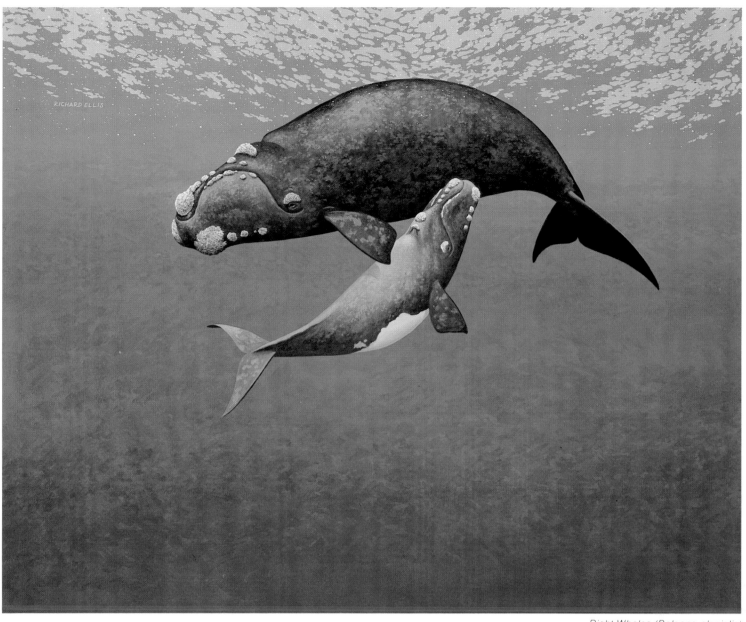

*Right Whales (Balaena glacialis)*
Acrylic, 24" x 30" (61 x 76 cm)
Collection of Dr. Gerard Bertrand

As perhaps the best-known painter of whales, Ellis still looks for different ways to design and portray the various species. He says, "I have painted every species of whale I have seen, but I have also painted animals I have never seen, since there are over seventy different cetaceans, and I have seen only about twenty-five species." He has photographed whales and other cetaceans, usually from a boat or in the water, using an Ocean Eye housing on a Nikon F camera.

"My painting technique is simple," he says, "because I am self-taught. I enjoy figuring out the background—the lighting, its sources, the depth, and the time of day. Designing the picture is of most interest to me, starting with the requirements to do the subject. I don't ever want to repeat myself. But in 1974 I did a painting of right whales, and then in 1980 when I was doing beluga whales, I found that the painting was almost identical to that of the right whales."

Ellis has been strongly influenced in his self-taught style by such early illustrators as N. C. Wyeth, Harold von Schmidt (a cowboy-and-Indian illustrator), Frederic Remington, and Charles Russell. "I used to be very horse-oriented," he says, "and I was impressed by Paul Bransom and Charles Livingston Bull and by Paul Brown. But Winslow Homer is

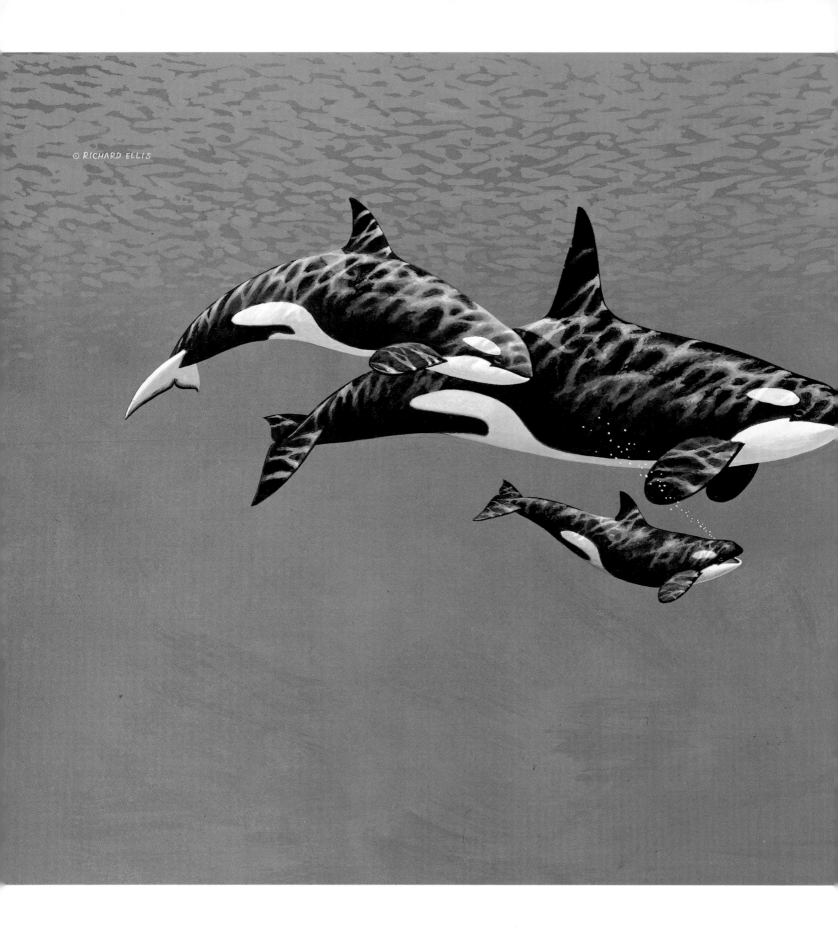

© RICHARD ELLIS

my favorite painter; I try to achieve below the water what he achieved above it."

When it comes to choosing a design for one of his paintings, Ellis says, "I try to show the living animal in its natural habitat. You have three choices: you can show the animal in the water, out of the water, or half out of the water. Out of the water gives you more possibilities for variety. But there is more challenge in trying to paint the water." At times the artist does a combination of fish, such as dolphins feeding on anchovies. "I stay away from the Bambi syndrome," he says. There is nothing cute about his mammoth creatures. On the other hand, Ellis feels that they dwell in a serene world, unchallenged by any predator but man. In one of his paintings of killer whales, Ellis says, "I wanted to show the strength and serenity of a full-grown male killer whale, probably the most powerful animal on earth, and actually one of the most peaceful. I had to show a smaller female and an even smaller baby whale to demonstrate the relative size and strength of the male." One of the problems of painting these gargantuan creatures, indeed, is to convey their actual dimensions on a relatively small canvas. "Design and compositions are important," he says. "I just hope that the paintings convey the feeling of great size. I work in a fairly restricted and restrictive field, but I enjoy it."

When he works outdoors, Ellis may be on a boat, waiting for a whale to appear. When it does, he takes as many photographs as possible. Although he uses color film, he says, "Color is not particularly important since whales are primarily black-and-white animals. And they are not very difficult to paint as forms. The real problem lies in discovering what they actually look like."

At the site of whale watching, Ellis keeps a detailed journal of everything he observes—color notes, the number of whales and other fish. In his spiral notebooks he may do quick sketches and jot down notes on factual material. "What's different about painting these creatures is the amount of prepainting research that's needed. You can't work from photographs, even those I take. I must also do enough research in libraries like that of the Museum of Natural History, and in scientific papers, about their behavior so as not to paint them doing something they would not do. I may get an idea for a painting just from learning about the dorsal fins of killer whales. By learning everything possible about the species for my writing, I also learn enough to get ideas for showing how they live and behave."

In his studio, which is a large room in his Manhattan apartment, Ellis has his own library of reference books. He calculates that he has on hand at least fifteen hundred books on natural history, two hundred on whales alone. His desk and typewriter occupy one corner of the room near a window. His easel is a drafting table, where he paints standing up, using Luxo regular incandescent light bulbs for illumination. He uses his photographs both as documentation for his paintings and as illustrations for his magazine articles.

When he works on a painting, he begins by painting in the background after doing a pencil drawing on tracing paper.

*Killer Whale Family (Orcinus orca)*
Acrylic, 24" x 36" (61 x 91 cm)
Collection of Dr. and Mrs. Craig Smith

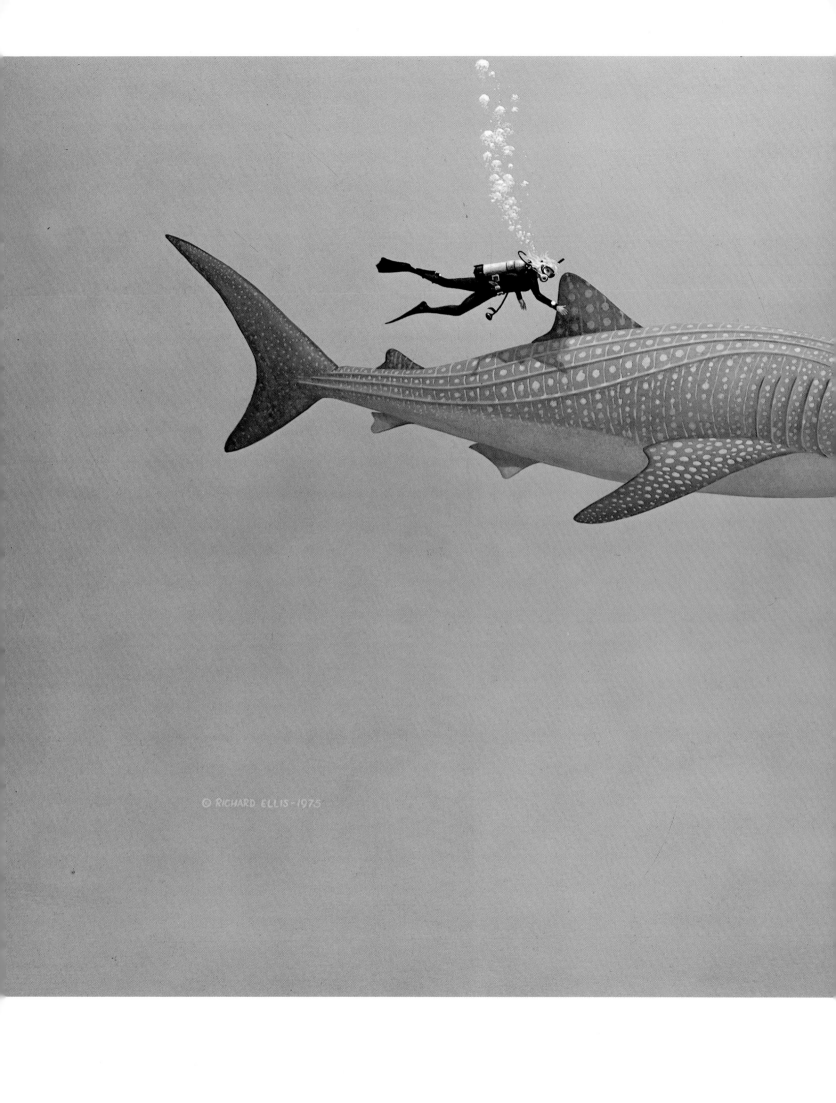

© RICHARD ELLIS – 1975

He says, "I make sometimes as many as a hundred drawings of some animals before I'm satisfied, using references open in front of me and measurements." Then he traces the chosen drawing, using typing carbon paper, on the canvas. After the background is painted, he paints the animals one at a time. Although almost all of his paintings are done for reproduction, they are not only illustrations, but stand on their own as paintings.

His palette, as might be expected, holds a lot of blues—cobalt, manganese, ultramarine, thalo. He also uses Payne's gray, Mars black, burnt umber; browns and yellows to soften his colors; titanium white for mixing them. His greens are Hawkins green and chromium oxide. His brushes are Aquarelles and Winsor & Newton's double zeroes for the details of eyes and teeth.

"Sometimes I get so tired of blue water," he says, "that I have been known to paint a whale in a brown river."

"Most of all," says Ellis, "I have become totally involved with whales and porpoises. I dive with them, paint them, and am involved in their preservation." That involvement includes lecturing all over the world and being active in organizations such as the American Cetacean Society, of which he is a board member. He is a trustee of RARE, an animal relief organization, and was a member of the American delegation to the 1980 and 1981 International Whaling Commissions, representing the National Audubon Society. "I am involved on a full-time basis with whales," he says. "There is no other full-time whale painter. It is something I enjoy doing, and I know it fills a need. The more I learn, the more fascinated I become. To me it's more exciting that I do all the research on a subject and make a painting as well."

From this intense focus, Ellis leads a broad and adventurous life. "I travel to wonderful places, do research, lecture, write, paint." Lately it has become difficult for him to control all the demands on his time, particularly for lecturing. He has lectured on "The Adventures of a Whale Painter" to organizations such as the Academy of Natural Sciences, the American Littoral Society, the American Museum of Natural History, and Yale University. His paintings are sold through the Sportsman's Edge gallery in New York. Triton Press in New York publishes his collotype prints, which are often sold through organizations such as the Massachusetts Audubon Society, the Vancouver Aquarium, and the National Audubon Society. He writes a column for a diving magazine. Along the way, collectors may approach him to commission paintings.

As reported in *American Artist* in August 1979, "The marine paintings of Richard Ellis are unique. They are not painted for the big-game or sport fisherman, because they do not show the scene from a fisherman's point of view."

But still they appeal to many sport fishermen. As for whale watchers and preservationists, Richard Ellis is their archivist, their recorder, and their communicator who uses every one of the tools of the communications trade but is perhaps best known for his paintings of the most awesome creatures of the seas.

*Whale Shark (Rhincodon typus)*
Acrylic, 28" x 38" (71 x 97 cm)
Collection of Mrs. Edwin J. Gould

# ALBERT EARL GILBERT

That special breed—artists who specialize in animal and other wildlife subjects—could have no more dedicated spokesperson than Albert Earl Gilbert, current president of the Society of Animal Artists. Says he, "Today there is no doubt that realism—especially wildlife art—is center stage. A tiger now takes precedence over a tomato-soup can, and the biggest monetary reward in the entire art world is for a five-by-seven-inch wildlife painting—the Federal Duck Stamp Design."

Gilbert won the Duck Stamp Design contest for 1978–79. The contest was instituted by the U.S. government in 1934 for the purpose of selecting a painting of waterfowl to decorate the yearly license it issues for hunting migratory waterfowl in the United States; revenues from the stamp are used to buy additional wetland habitat. But revenues for the winning artist come from collectors, conservationists, and hunters who collect both the stamp itself and the prints made from the original winning entry. Gilbert's winning *Hooded Merganser Duck* was the first design to bring a total of a million dollars' gross return from reproductions, including a special Remarque edition of 1,350 which has seen Gilbert devoting many months to painting in the margins of the prints. Now he works in the splendor of his new studio in Connecticut, purchased with his winnings. The north-light windows look over the verdant Connecticut valley and beyond to the purple rolling hills of the Berkshire Mountains. The spacious ranch building was originally designed by another wildlife artist, John Clymer. When Clymer moved west, he sold the building to theatrical producer Mike Nichols. Gilbert, who bought the house from Nichols, says of it: "I have been in beautiful places all over the world, but this is as beautiful as any of them." Coming from a man whose career has taken him from the Amazon jungles to the hills of Kenya, this is high praise for an adopted New England landscape.

Art and animals have been Albert Earl Gilbert's preoccupation since his early childhood in the Chicago area. "I started drawing animals when I was two or three years of age, old enough to hold a crayon," he says. During his growing-up years, he skipped at least one day of school each week to sketch at the Brookfield Zoo. "That's how I really learned to be a wildlife artist—by drawing from life." Gilbert still considers "drawing from life" to be absolutely essential for the wildlife artist. The young artist had no formal

*Black Hawk-Eagle*
Portrait sketch

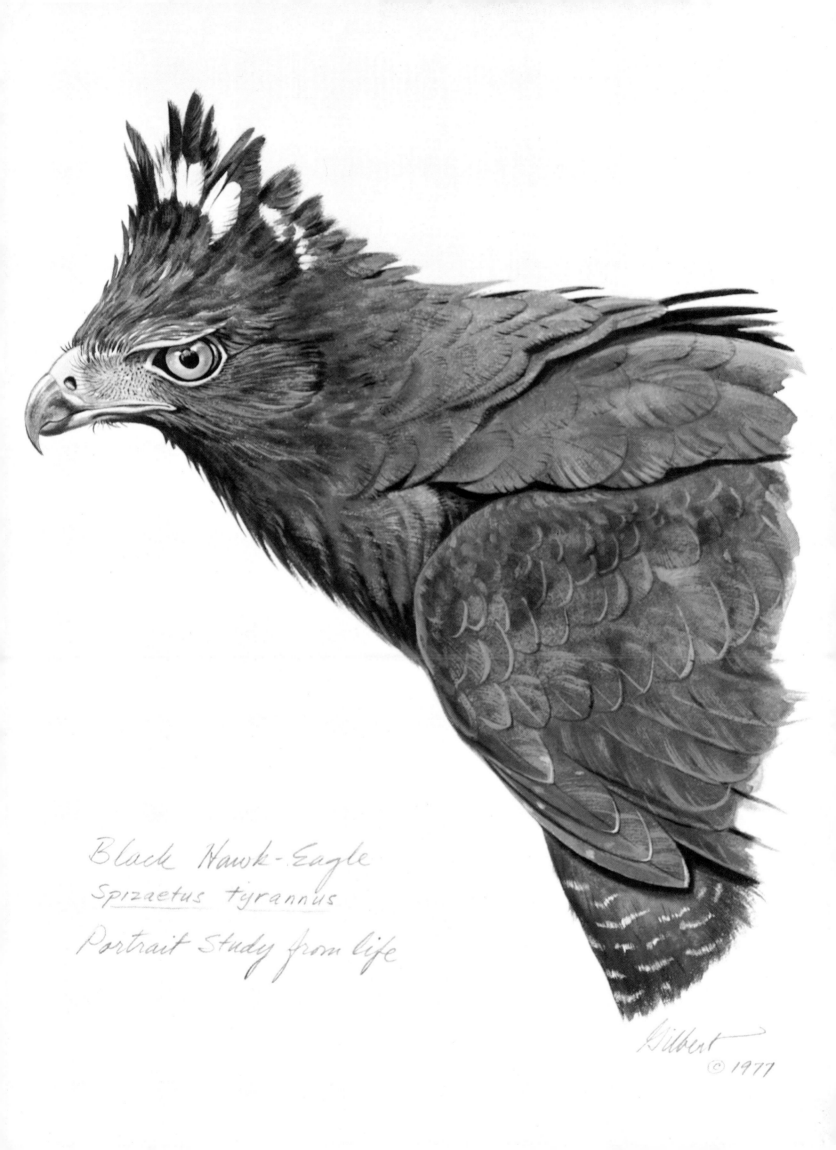

Black Hawk-Eagle
*Spizaetus tyrannus*
Portrait Study from life

Gilbert
© 1977

schooling in art at all. Instead, at an early age, he studied *Animal Drawing and Painting* by Walter J. Wilwerding, published by Watson-Guptill. "That book got me started in the right direction, and I still highly recommend it to any student."

Gilbert's interest in wildlife led him to become a park ranger and naturalist, but he began his professional work in art as an illustrator with the Field Museum in Chicago and later with the American Museum of Natural History in New York. Along the way, he says, "I was lucky enough to have two master wildlife artists as my mentors—George M. Sutton and Don Eckelberry—who gave me invaluable criticism and encouragement and had a profound influence on my style and approach to painting."

When Gilbert began illustrating bird books written by museum ornithologists, he found that the first requirement was absolute scientific accuracy. "This meant that I had to be a naturalist as well as an artist. Fortunately I had access to

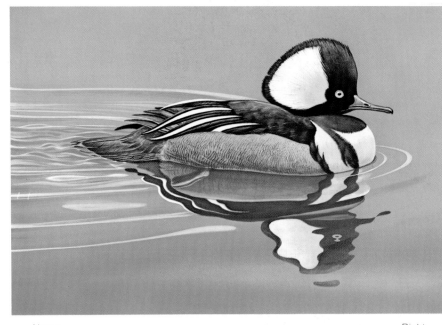

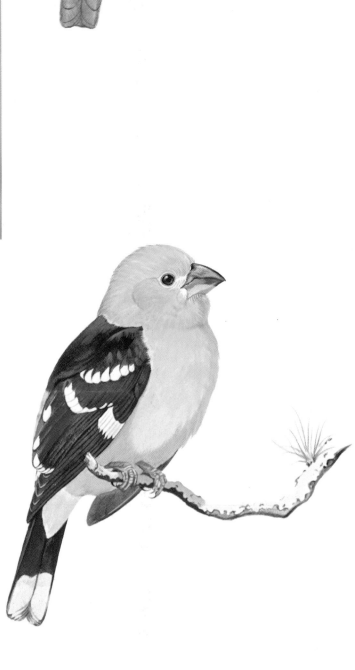

Above
*Hooded Merganser*
1978-79 Federal Duck Stamp design
Opaque watercolor

Right
These five jungle birds were painted in watercolor, directly from life, while Gilbert was on jungle expeditions. He often caught the birds in mist nets, held them for sketching, then released them, unharmed.

vast reference sources of the museums, including their libraries; and the direction of the curators, especially Dr. Dean Amadon of the Museum of Natural History, who helped expand my own knowledge of wildlife."

Gilbert made his name as a bird illustrator at the age of twenty with his illustrations for what is now the classic *Eagles, Hawks and Falcons of the World,* by Leslie Brown and Dean Amadon. His contribution was shared with other artists who together completed a total of 150 plates for this two-volume work, which was first published by Country Life in England, then in the United States in 1968 by McGraw-Hill. Gilbert got his start by going from publisher to publisher with his portfolio and a recommendation from Don Eckelberry. He has now illustrated eight books and has become known not only as a bird painter, with a special affinity for birds of prey, but as a painter of the big cats—an unusual combination, he admits.

Birds of prey and big cats plus elephants and other jungle

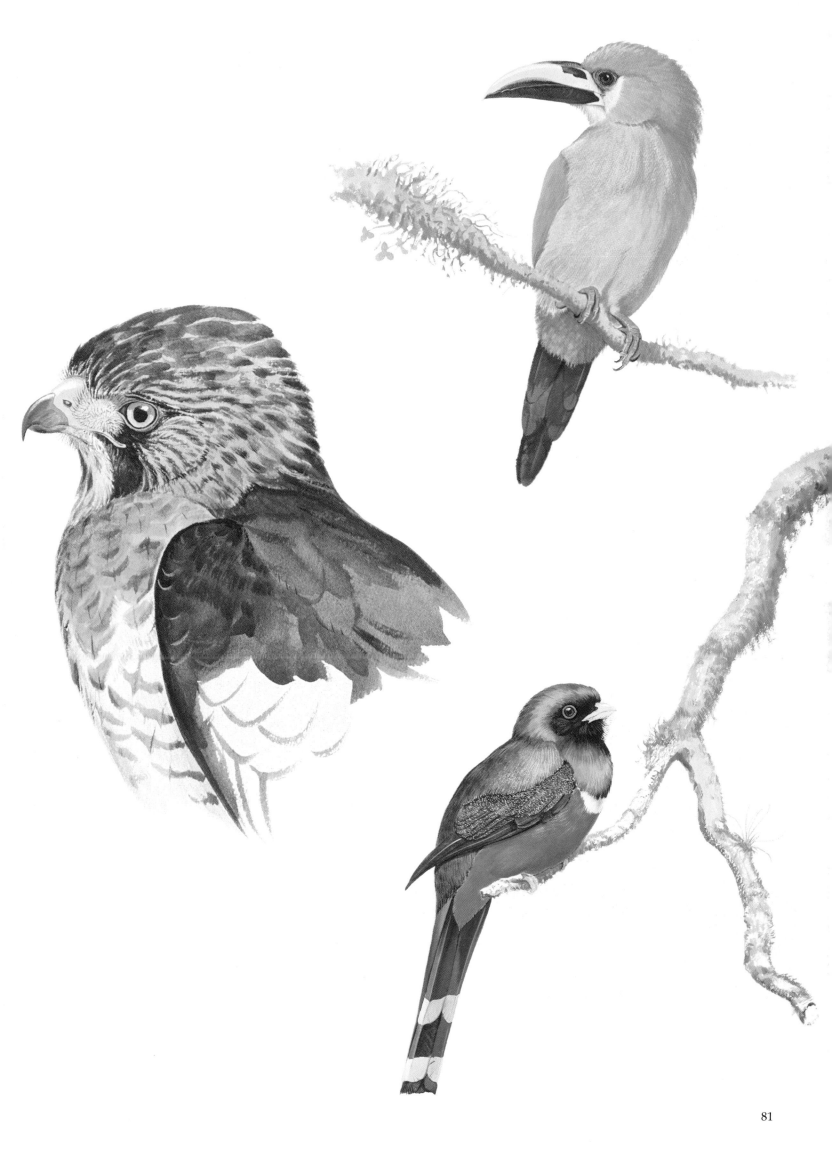

animals have been readily available to Gilbert on his many trips to South America and Africa, where he has traveled with museum expeditions. A life of adventure is a natural accompaniment of life as an animal artist. One long expedition to the Amazon jungle taught Gilbert how to make original observations while fighting off insects. "I can't imagine how anyone can be a wildlife artist," he says, "without extensive fieldwork. Of course, sketching in the field is not always idyllic." He recalls that once in Mexico hornets hovered over his face while he tried to sketch between hornet landings on his nose. A hornet sting on his forearm "made me look like Popeye for three days." Still another jungle trip brought questionable thrills from nearly stepping on the deadly poisonous fer-de-lance snake.

"I should emphasize that all my field sketches are made directly from life. Sometimes I catch birds in transparent mist nets, then sketch and release them. On museum expeditions I sometimes draw birds collected by scientists which are particularly valuable for details such as open wings. I never use stuffed specimens as models, only to check details or to study the effect of light and shadow."

For Al Gilbert, photography can never be the primary vision of a living creature, but he does not underestimate its value. He says, "When Audubon painted the birds of America more than a hundred years ago, he shot every bird in order to draw it. It was the only way he could work—he had no binoculars or camera. Fortunately, the wildlife artist today has a wide range of optical equipment for close study of his subjects without killing them."

As a young artist, Gilbert did not begin to use a camera until he had done about seven years of life sketching. The reason? "The animal artist needs the kind of knowledge that comes only from life study and sketching in order to read a photograph properly; one needs to know how the paws really look even when they are hidden in grass; one must know what's happening in the photo's black shadows." He cautions that "the camera can be both a help and a hindrance. There's no question it can be an important information-gathering tool. It can also be very misleading. Even when I use my own photographs, the final painting is always an amalgam of memory, sketches plus the photo reference. Most of what I photograph in the field with my Nikon thirty-five-millimeter camera is backgrounds—plants, interesting branches—authentic 'props' for finished pictures. I always try to refer to an actual branch, tree, or rock rather than make one up, though of course I will distort or change its shape to suit a composition. It is painfully obvious when one makes up such an important element in painting."

Between trips to jungles and forests, Gilbert's preferred places for sketching are zoos, such as the Brookfield, the San Diego Zoo in California, or the Bronx Zoo in New York.

The delicate balance between scientific accuracy and creative imagination that makes a painting into true art is a matter of special focus and concentration for wildlife artists. It is something about which Gilbert has strong feelings. He

Study sketches done from life
Top, *Hooded Vulture*
Center, *Javan Rhinoceros Hornbill*
Bottom, *Falconets*
Right, *Toco Toucan*

CO  TOUCAN

ORANGE

R.O.

TIP : BLACKISH·GREEN
FAINT RED-BROWN
CAL STRIPES

THROAT PATCH
WHITISH TINGED
PALE SULPHUR

BEAK YELLOW-ORANGE
UPPER M. BRIGHTER

SKIN ADJACENT TO
EYE : DEEP ULTRA
BLUE
IRIS : BROWN
PATCH AROUND EYE
DEEP CADMIUM
YELL - ORANGE
CRISSUM : RED
UPPER TAIL COVERTS
WHITE

FEET GRAY

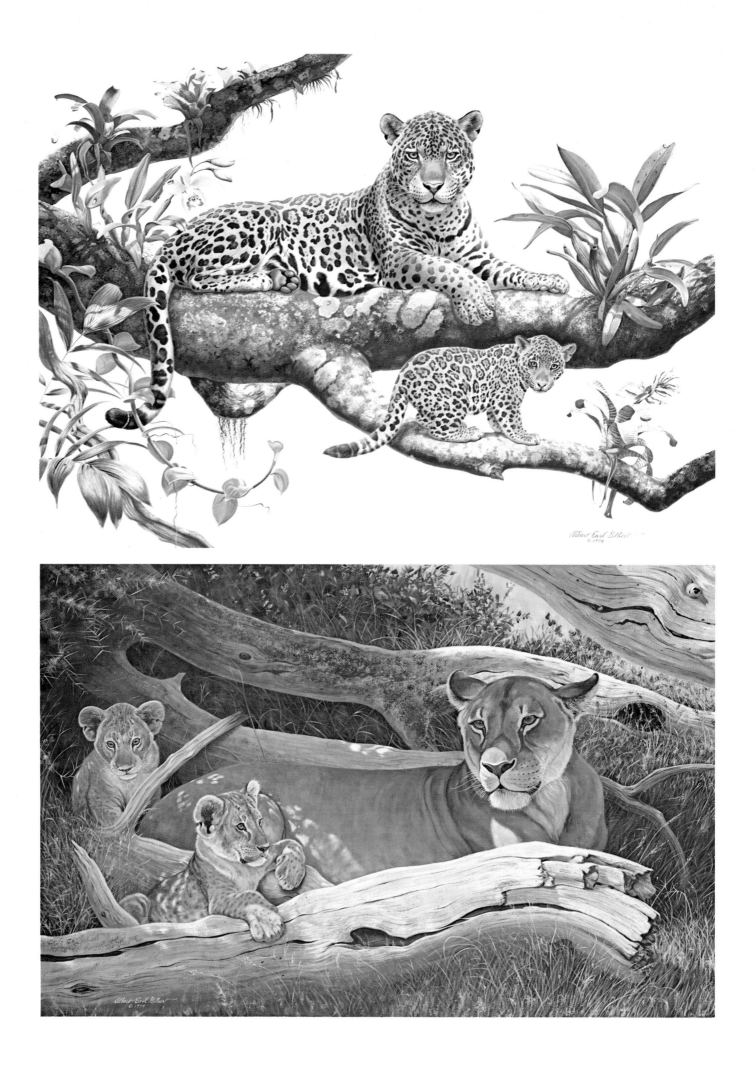

says: "If modern art history has proved anything, it is that subject matter is irrelevant—or should be. Unfortunately, animals have usually not been regarded as proper subjects for art in Western cultures. Eastern civilizations, however, have never been bothered by this hang-up. In their art, animals and nature have always been major elements; when people were portrayed, they were often insignificant in relation to mountainous landscapes, indicating philosophic and religious concepts of man as part of nature. In contrast, Western civilization has always viewed mankind as having dominion over nature. Because of the Judeo-Christian concept of man as apart from nature (especially the animal world), the focus of art was for centuries heavily anthropocentric. Great works of art were created, but animals for the most part were relegated to the manger in Nativity scenes—although there were notable exceptions, such as Dürer and Rembrandt. It has taken centuries for animals to become acceptable subject matter for art."

Even so, in more recent history, animal art was relegated to still another minor role—as illustration for the biological sciences. "For too long," says Gilbert, "scientists wanted accurate illustrations of dead specimens from museum cabinets with no hint of perspective, shading, or movement. Paradoxically, portrayals of live animals were regarded by art academicians as 'objects of natural history' unfit for exhibition in art museums! This absurd attitude still persists among some curators." But more and more the art academies are open to painters of wildlife, and Gilbert envisions a bright new future for wildlife as a major element in the tapestry of contemporary art.

He believes that many other artists, like himself, will continue to be fascinated "by the endless variety of pattern and color in nature. In my paintings, I try to heighten, refine, and crystallize the raw experience which inspired me. Whether it be an encounter with a pride of lions at arm's length, or the scintillating colors of a tropical bird and jungle blossom, I try to convey the essence—and the intensity—of my original experience with nature. In so doing, I edit, exaggerate, or understate to achieve my purpose."

Since his early days, when Gilbert concentrated on rather tight and detailed watercolors of birds, he has evolved a broader, more painterly style with more emphasis on the animals in their natural habitat, working now in oil and acrylics as well as watercolor. But he still begins with the sketches taken from life, his observations, and photography in the field. "I save the more complicated paintings for the studio. I may start with an idea in my mind's eye, or I may refer to field sketches and photos I have taken. I begin to sketch on tracing paper without much detail, often at thumbnail size, then refine and develop as needed. I do my drawing on fine-quality vellum tracing paper with fresh sheets laid over the initial drawing—saving its best features, refining and changing others—until a satisfactory 'working drawing' has been achieved.

"At this stage, all problems of composition and design should be solved. This working drawing is then transferred

Top
Amazon Jungle Jaguar and Cub
Opaque watercolor
30″ x 40″ (76 x 102 cm)

Bottom
African Lioness and Cubs
Acrylic, 40″ x 60″ (102 x 152 cm)

Above
*Sable Antelope*
Pastel on toned paper
24" x 18" (61 x 46 cm)

Right
*Cheetah*
Acrylic
16" x 40" (41 x 102 cm)

directly to the illustration board or painting surface. If it is to be a large painting—larger than two by three feet [61 by 91½ cm]—I will enlarge the working drawing by mechanical means to the desired dimensions.

"Before painting, I sometimes do a small color comprehensive, particularly if the subject is complex. There is a real danger of burning out one's creative energy on these color sketches, and often I prefer to dive right into the final painting.

"Regardless of the medium, I usually paint the sky and distant background first, moving forward to the middle distance and then to the foreground, leaving the bird or animal subject until last. Values are easier to establish with this sequence. It's rather like building a jigsaw puzzle.

"With oil or acrylic, I tend to work over the whole picture at once, after having covered the canvas from sky to foreground. Compared to watercolor, one can 'tinker' more with oils or acrylics; also, there are subtle hues and values of opaque colors which are not apparent in transparent watercolors.

"I do a lot of underpainting with acrylics or oils, building up certain areas gradually by overpainting to add detail. For certain textures I like to use a plastic sponge; its stipple effect is especially good for rendering lichens on rocks."

When painting tropical birds and flowers, Gilbert finds it necessary at times to use exotic colors like Bengal rose and Carthamus pink, but says, "My everyday palette is as follows: Payne's gray, Winsor violet, ultramarine blue, cobalt blue, Winsor blue, white, cadmium lemon, cadmium yellow pale, cadmium yellow, cadmium yellow deep, cadmium

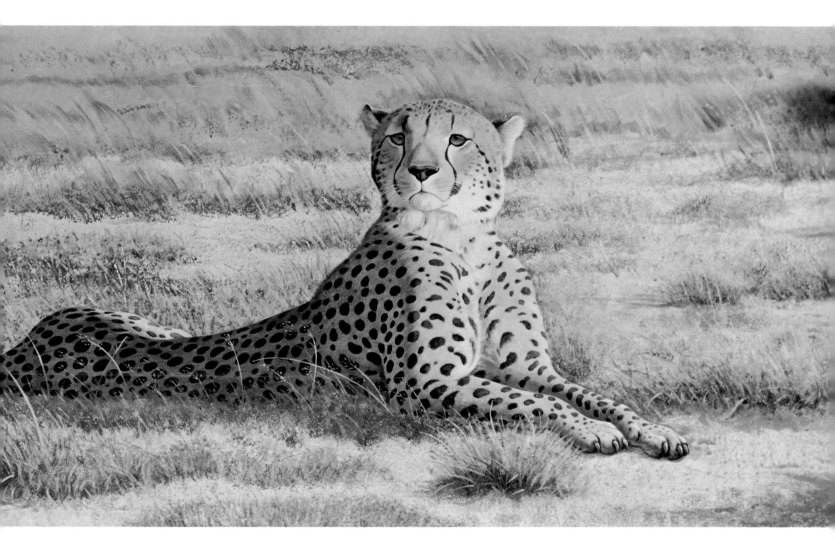

orange, yellow ochre, olive green, light red, Indian red, cadmium scarlet, alizarin crimson, and burnt umber or sepia." He seldom uses black.

Gilbert finds it interesting to speculate on the future direction of wildlife painting. He muses: "Will it adopt some of the innovations made by the abstractionists? Some artists are now using abstract shape and design within the context of realism to emphasize character and mood. Motion and flight are yet to be fully explored by contemporary artists. Many new directions are open. There is a great need for invention—to bend and stretch the bounds of realism. Certainly, more vigorous and varied approaches will be demanded of wildlife art in the years ahead.

"Today, too often technical ability, without feeling, masquerades as art. Artists must communicate the intensity and immediacy of their experience in order to produce an emotional response in the viewer. Far too many artists are imitating instead of innovating. Sometimes I wonder if we need to call a moratorium on paintings of ducks flying over a marsh—surely the most trite statement in all of contemporary wildlife art. The recognized masters of this subject matter are being copied ad nauseam by a legion of would-be artists. On balance, even though there is an ocean of uninspired work, there are many islands of original work and certainly more good wildlife painters than ever before."

As for Gilbert's own future, now that his income is secure, he says: "Come back in ten years and I think I'll be able to show you some great paintings. So far I've been very lucky, but it's too early for me to assess my own work. Of one thing I *am* very proud: my association with the Society of Animal Artists. It has been a real accomplishment to help the society bring wildlife art into a position of major significance in the world of twentieth-century art."

For those who would like to become wildlife artists, Gilbert says: "There are probably more opportunities now than ever before; it is nevertheless a highly competitive field. One does not become a wildlife artist overnight. It is a specialized calling requiring the knowledge of a naturalist and the skill of an artist.

"One very positive note for the beginner is the opportunity to exhibit in the many wildlife art shows now held in almost every region of our country. Nearly every state in the Union publishes an excellent conservation magazine; they all solicit contributions from new artists. Every student should read *The Animal Art of Bob Kuhn*, published by Watson-Guptill.

"I would also ask the student to memorize this quote from Michelangelo: 'Let this be plain to all: design, or as it is called by another name, drawing, constitutes the fountain-head and substance of painting and sculpture and architecture and every other kind of painting, and is the root of all sciences. Let him who has attained the possession of this be assured that he possesses a great treasure. . . .' "

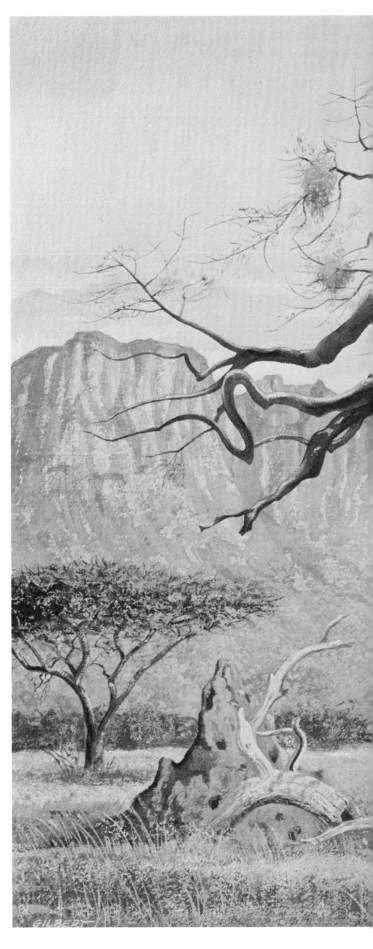

*Elephants and Baobab Tree—Tsavo*
Watercolor and pastel, 22" x 30" (56 x 76 cm)
Collection of Carter Middendorf

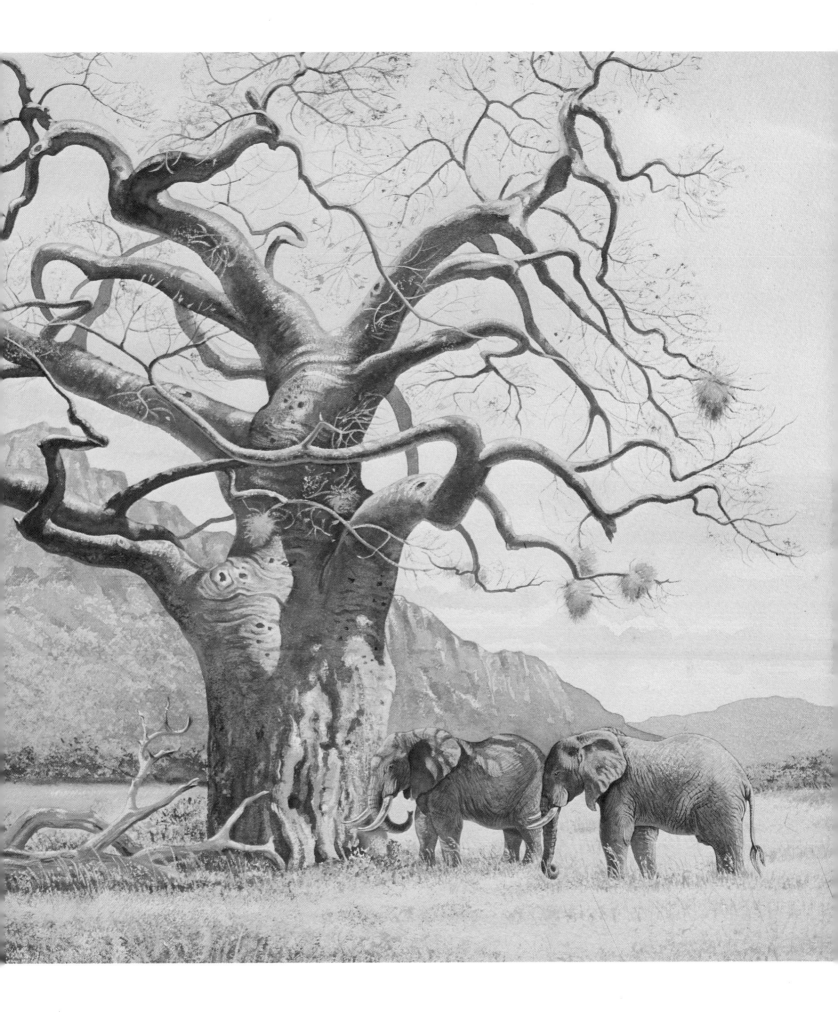

# FRED MACHETANZ

"Alaska's wilderness is a long way from lost, but most of it can't even be seen unless you rent a plane and visit it," says Fred Machetanz, who has been living in that wilderness since 1935. Today, Machetanz's oil paintings of polar bears, grizzlies, huskies, and the "transparent, translucent, and opaque blues of pressure ice in the spring" are bringing a vision of that last great wilderness to a growing audience of collectors and appreciators both near and a long way from his home.

Machetanz himself brought a classical training in art to his adopted land back in the Depression years of the 1930s. As a young graduate of Chicago's Art Institute and American Academy, he also had a master's degree in art from Ohio State University, where he received his formal training as an undergraduate. His master's thesis, which prophesied his ongoing preoccupation with technique, was called "Permanent Pigment and Mediums in Oil Painting."

But his interest in art went back to his childhood in his native Kenton, Ohio, when, at the age of twelve, "I copied a pen-and-ink illustration of a pretty girl in a newspaper in pencil. I thought to myself, 'I want to be an artist.' Nobody else in my family had an interest in art, but while they were surprised at my ambition, they didn't discourage me. Still, my two brothers became lawyers, and I suspect I was considered the black sheep."

At Ohio State University, young Machetanz learned drawing from Will Rannells, illustrator of animals. "He mostly did dogs and was a feature of the old *Life,* the humor magazine," says Machetanz. "And he's still doing the animals now at the age of eighty-nine. Back then, he really taught me how to draw—including charcoals of plaster casts. I still think that's important for everyone to learn." Still another influential teacher was James R. Hopkins, who achieved fame for his paintings of mountaineers and who was head of the Ohio State University art department. "It was Hopkins who really taught me how to paint," says Machetanz.

*Making the Evening Rounds*
Oil, 32″ x 26″ (81 x 66 cm)
Collection of the Anchorage Historical Fine Arts Museum

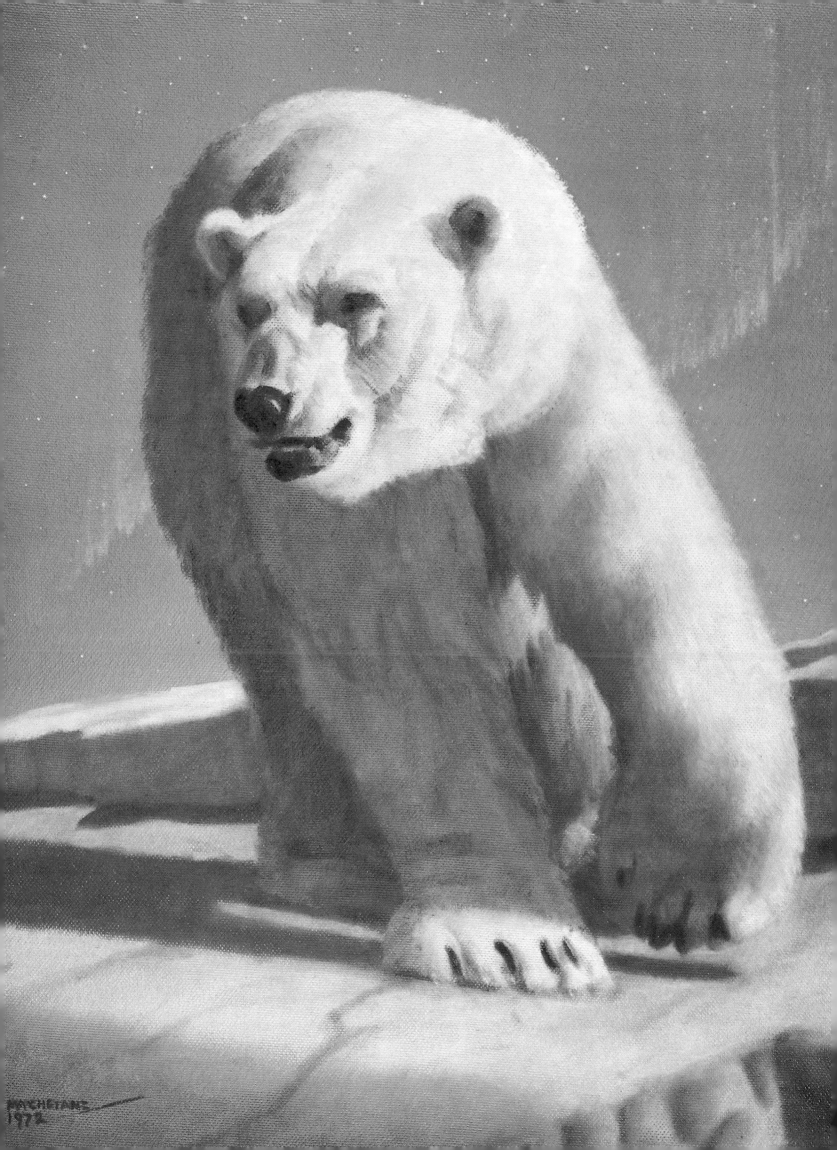

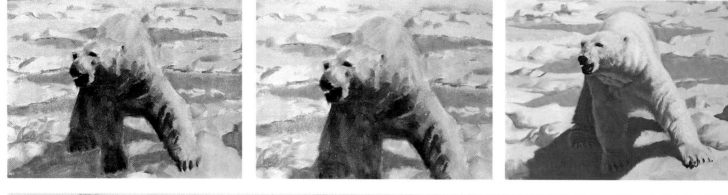

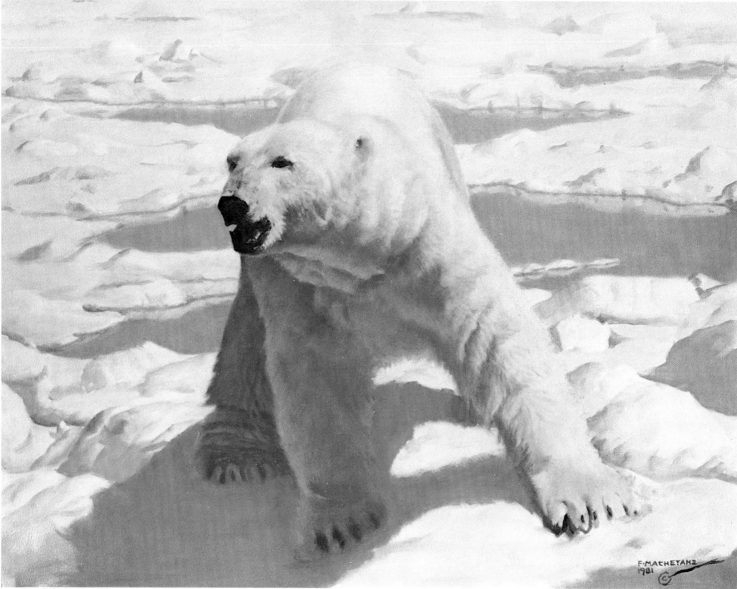

Above
*Back Off*
Oil, 26" x 32" (66 x 76 cm)

Right
*The Potentate*
Oil, 28" x 22" (71 x 56 cm)
Private collection

For this painting Machetanz begins with a preliminary painting, 9" x 12" (23 x 31 cm), which includes a blue and white underpainting. To this he adds the following glazes: gold and red on the bear, blue green on the pools of water, and a light pink on the snow. When he is satisfied with the preliminary, he begins work on the final panel, first with the underpainting. The finished work is built with glazes of gold, red, and a final one of blue green on some of the ice.

This painting sequence shows Machetanz's method of constructing a painting. Using a bristle brush and turpentine or mineral spirits as a medium, he establishes the construction lines and the rhythm. At this stage he finds the correct placement of the figure on the panel. He begins to refine the rough sketch and starts shading slightly with washes of ultramarine and white. He blocks in the main shadow areas with a flat allover value. For better placement of dark and light areas, he washes off the lower portion and adds a diagonal form to counter the slant of the bear's head and body. He now paints lines of fur to define the animal's form and adds form to the mass of ice at the bottom. He paints the ocean in the background to provide a dark pattern. These steps are done with glazes of color and a medium of linseed oil and mineral spirits on the sky, bear, and ocean. Finally, he adds details and refines the painting.

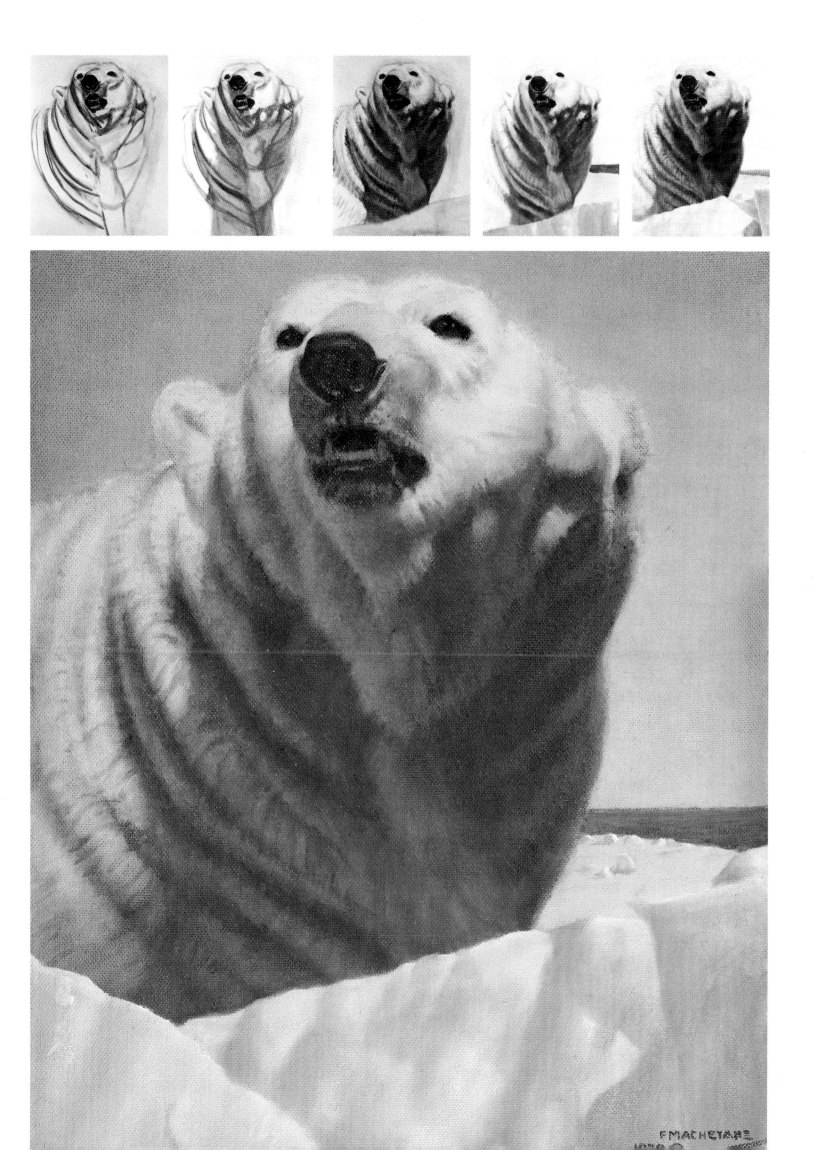

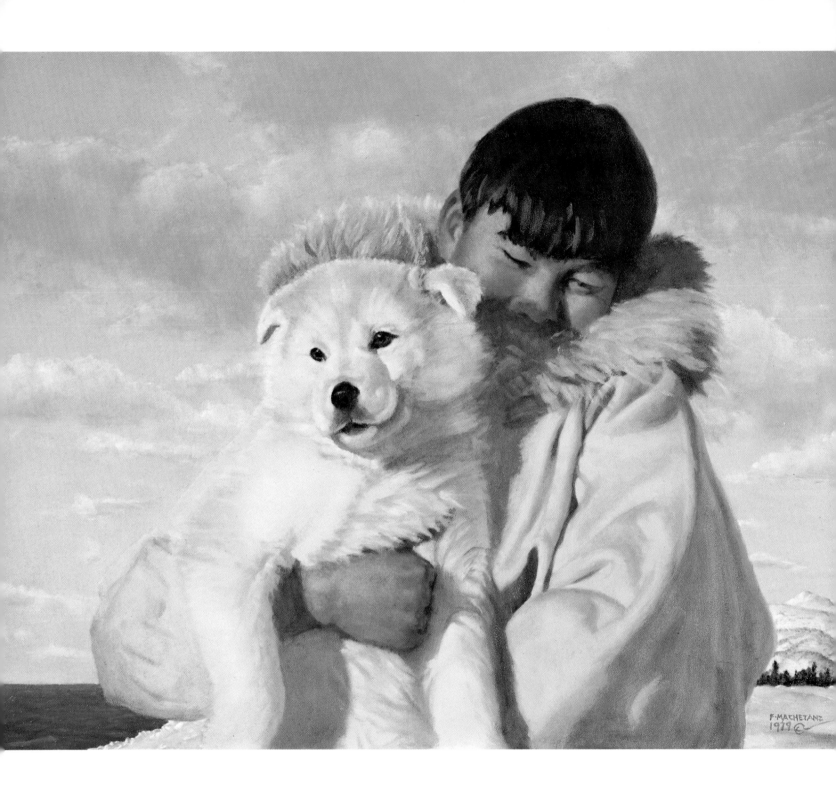

He became fascinated by the work of Maxfield Parrish, one of the outstanding illustrators of the period. "We became personal firends," says Machetanz. "I used to visit him in New Hampshire every spring and fall. He talked in broad principles of art and gave me ideas for color. He was an inspiration to me, although he wasn't a traditional painter. He used stencils and had a 'hard-edge' style. He gave me an appreciation of transparent colors."

After doing his postgraduate work in Chicago, Machetanz worked as a free-lance illustrator and also taught art at night. His own painting at this time consisted chiefly of portraits. Although Will Rannells had already instilled in him an interest in painting animals, it was not until Machetanz went to Alaska that he began to focus on wildlife art.

He reminisces about that time in 1935, when, he says, "Alaska was the last place I wanted to go, but those were Depression years and there was little opportunity for making a living at art." Machetanz was understandably intrigued when his uncle who had established a trading post in the tiny Eskimo village of Unalakleet in 1898 invited him for a summer's visit.

"I came to Alaska at the romantic period and became friendly with prospectors who had been to the Klondike and the Eskimos who lived in unspoiled villages. I fell in love with Alaska. Life was awfully pleasant with Uncle Charlie at the trading post. The sled dogs fascinated me with their unique markings. I began to be interested in portraying the animals of the area, and with painting the landscapes and Eskimos." The summer's visit stretched to two years and it was during this period he resolved to become a permanent resident of the North Country.

"To do animals, you have to be a good draftsman and be able to do everything else, too. I like to do fur as a mass, not a lot of detail of hair. You need to be a good painter as well as a draftsman, and I think it's very important to study your edges closely. It's especially important to know habitats so that you can put an animal in a proper setting. Here in Alaska, one can see the animals in their natural habitat and talk to the hunters as well. But I've always found that the best way to study them close up is to go to the zoo."

For many years Machetanz and his wife, Sara, a writer, supplemented his slim income from art with a more lucrative travel-lecture program. From 1947 until 1961, both of them spent two winters out of three traveling throughout the United States showing films and lecturing about Alaska. "At that time," says Machetanz, "I was able to do only about three paintings a year." But during those trips he visited zoos, took photographs, and "got the feel of how animals behaved toward each other. I saw my first wet polar bear in a zoo—quite different from the usual fluffy polar bear."

During the periods spent in Alaska, Machetanz learned to know the "setting" for his Alaskan animal paintings. "I like to experience whatever I paint," he says. "I once spent a month on the ice with Eskimos hunting for whales. During my regular watch around midnight, as the sun dipped below the horizon to the north, I would see sunset colors on one

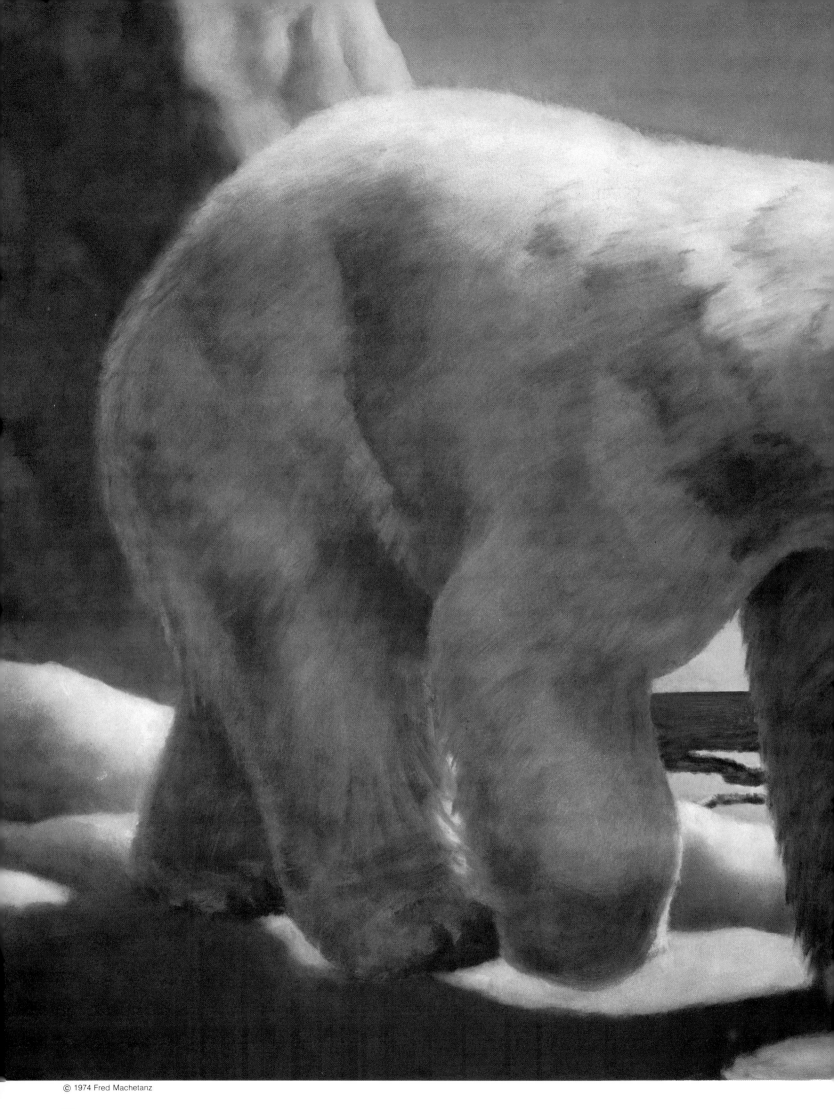

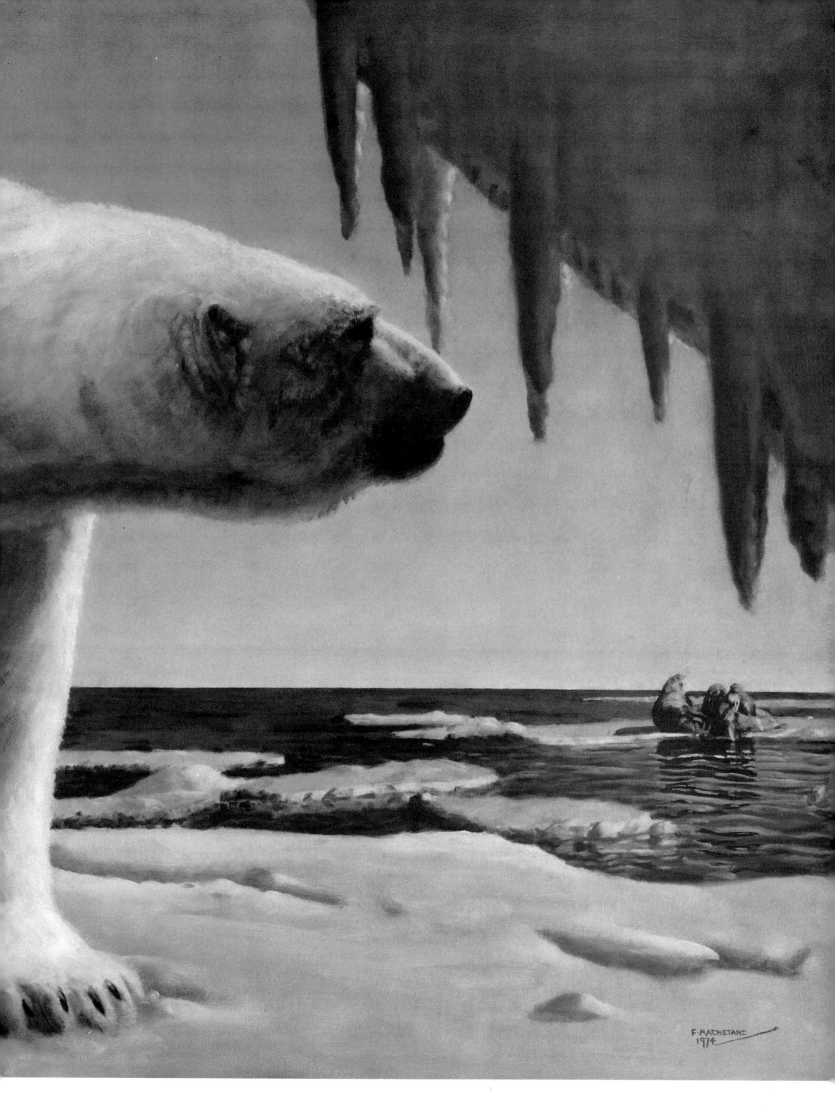

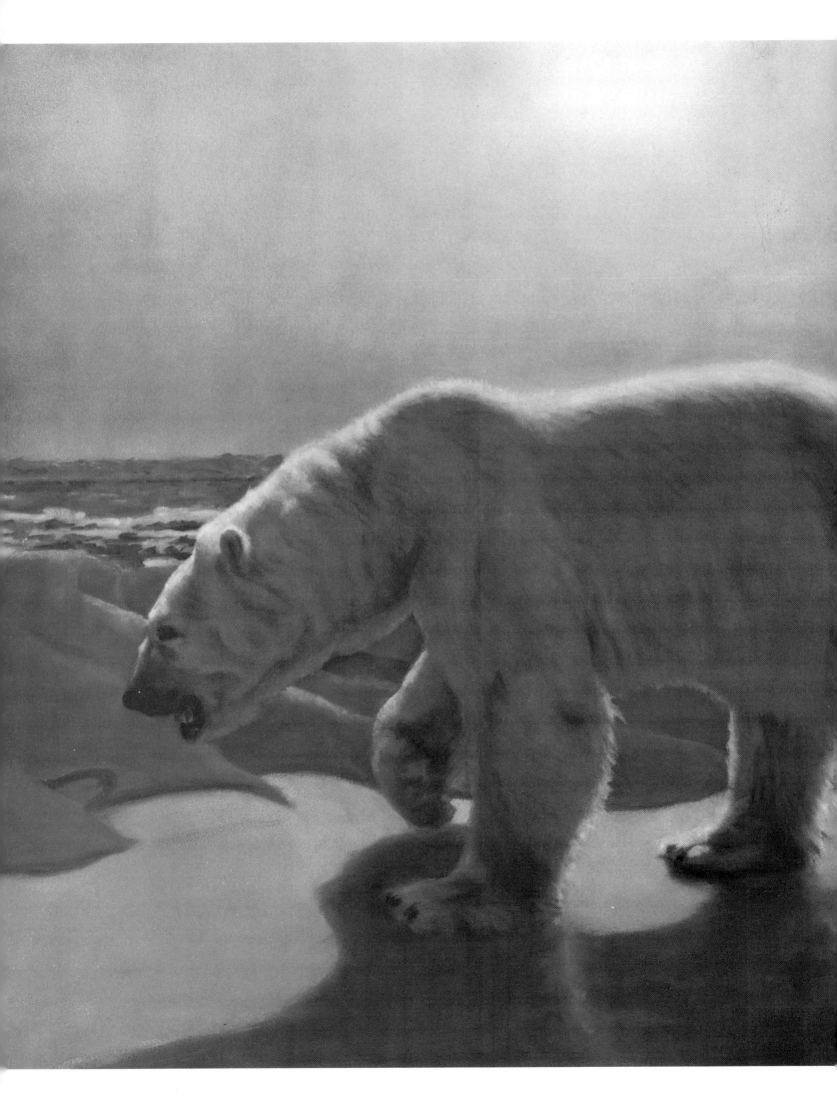

side, and on the other the gold and pinks of sunrise. This was the time of lowest temperatures when frost crystals would literally form in the ocean water and as you watched, finally make a thin film of ice. That was a wonderful setting for animal art. I made notes of the colors and did many black-and-white sketches."

His love of sled dogs inspiring the subject, Machetanz began to write and illustrate books. His first book on Alaska was called *Panuck, Eskimo Sled Dog* and was published by Charles Scribner's Sons as a children's book. His second book, *On Arctic Ice,* elicited an offer from Admiral Fred Zeusler, the Coast Guard commandant in Alaska, to sail aboard the famous Bering Sea and Arctic Patrol which stopped at villages from Ketchikan to Point Barrow. During World War II Machetanz volunteered for the navy. He asked for Alaskan duty and was assigned to the Aleutians, where he served as officer in charge of the Intelligence Center for the North Pacific Command. He emerged with the rank of lieutenant commander.

At the war's end, Machetanz returned to Alaska. To his careers of painting, writing, illustrating, and lithography he had added moviemaking. It was at this time he met and married a writer, Sara Dunn. From then on she shared his movie-lectures in winter and spent the rest of the year writing cinema scripts and press releases for their winter tours and books for Fred to illustrate. Amidst all these activities Fred somehow managed to paint their beloved Alaska and its wildlife.

Machetanz believes that the major problem in painting is to be consistent—"trying to hit a home run every time. I'll leave a painting on the wall unfinished sometimes for years and change and finish it slowly. I like using light and shade for the feeling of form. Alaska has an unbelievable range of light. In winter, with the sun close to the horizon, the colors are almost entirely golds and pinks. On the longer days of the year there are still the golds and pinks in early morning and toward evening, but at high noon sunlight is of a colder variety."

These days Machetanz can observe his Alaskan settings without interruption and can devote himself to painting on a full-time basis. But it was not until 1960, a year after their son, Traeger, was born, that Fred and Sara Machetanz agreed to take a gamble that they might live year round at their home in Palmer, Alaska, on the proceeds from Fred's art. At the urging of their close friends Herb and Miriam Hilscher, and of other friends who promised him a one-man show, the Machetanzes borrowed enough money to allow Fred to paint uninterruptedly for a year in a newly built studio attached to the one-room log cabin in which they had lived until then.

At the end of that year, forty-four of Machetanz's paintings were shown at the Westward Hotel in Anchorage with "a real fancy opening." During the show, which lasted fifteen hours, twenty-four paintings were sold for a total of $10,000. From that time on, Fred has been able to live by his art alone.

In 1971 Tennys Owens and Jean Shadrach opened an art

*Mid-day Moonlight*
Oil, 26" x 32" (66 x 81 cm)
Private collection

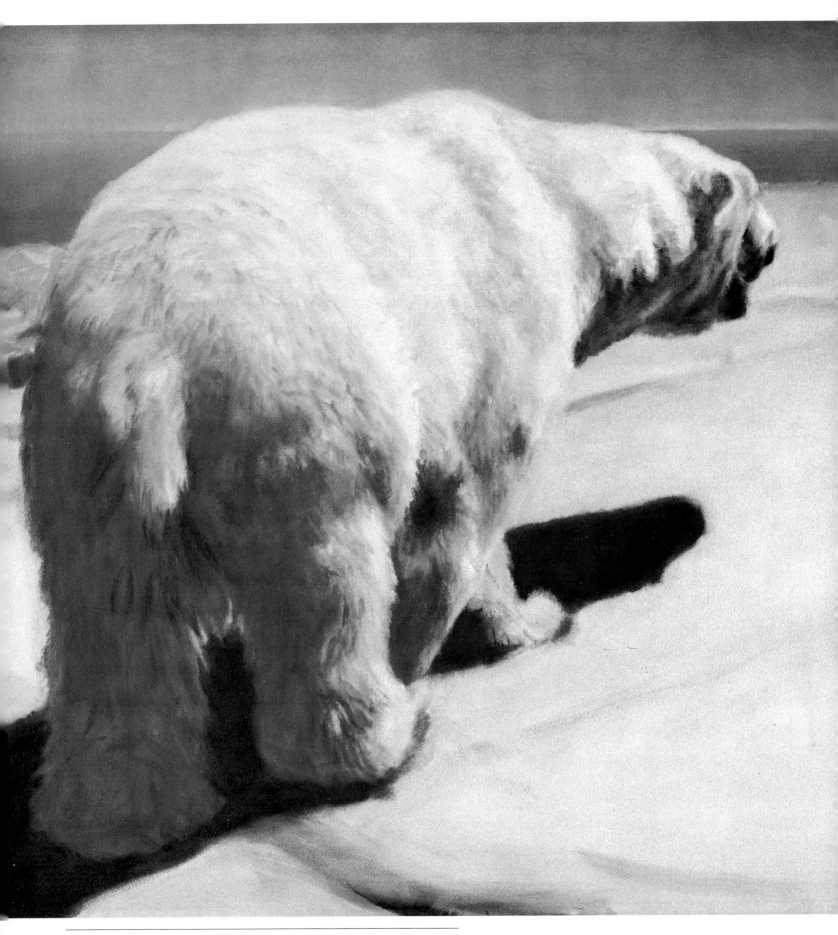

*High Noon*
Oil, 22" x 44" (56 x 112 cm)
Collection of Dick Silberer

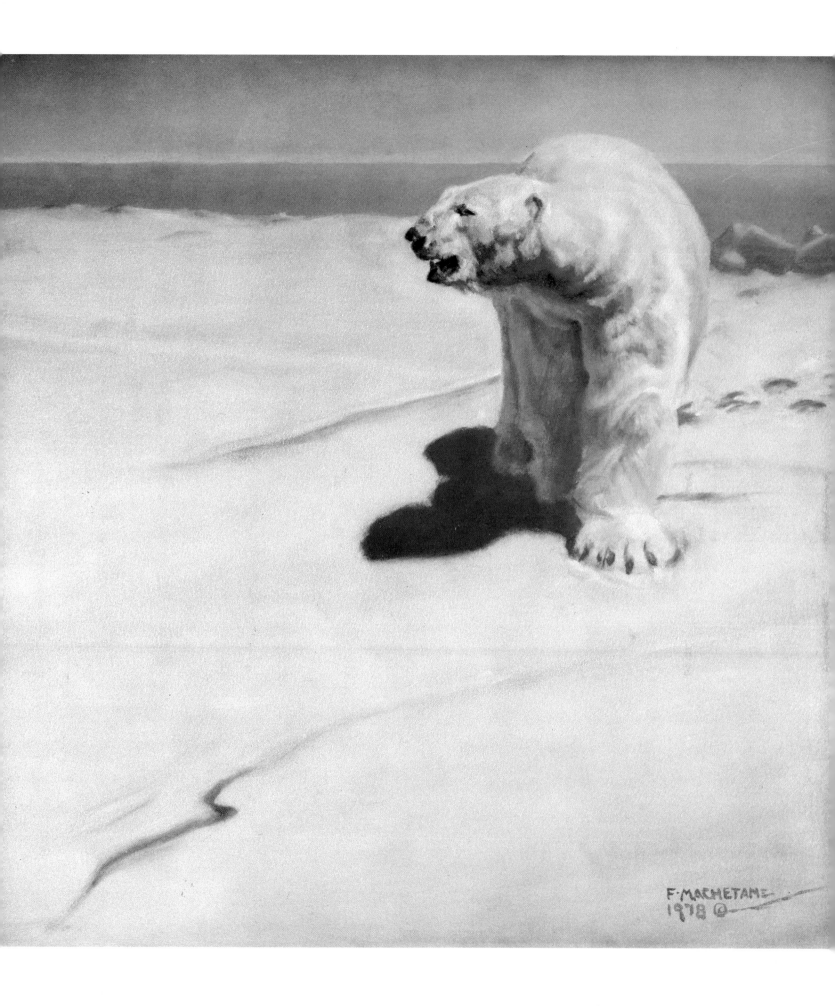

F. MACHETAME
1978 ©

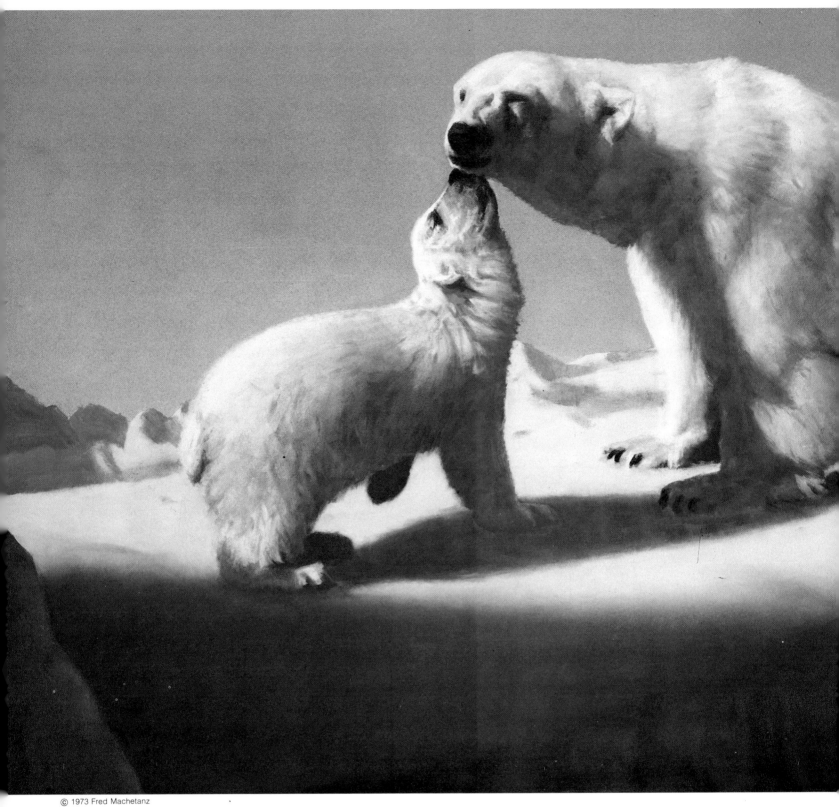

102

gallery in Anchorage. They soon became Machetanz's agents and doubled his prices in a short time. Their gallery, called Artique, Ltd., is considered one of the best in Alaska and is visited by travelers from everywhere. Machetanz is also exhibited in prestigious galleries in the contiguous states, and his works are collected nationwide.

In the interim, the single-room cabin they had built by hand in 1950 grew to occupy additional space in the surrounding forest. Situated on a lake amid spruce, cottonwoods, birch, and poplars, the house looks out over Pioneer Peak and the Chugach Range, which rises twelve thousand feet from sea level. "On the other side is the Pacific Ocean," says Machetanz. "I like this area. Although giving a feeling of wilderness, it is only about fifty miles to Anchorage and its airport. Not only is it one of the most beautiful in Alaska, but when we first saw it in 1950, the price was right. It was open government land too steeply ridged for agricultural development and so considered fit only for goats, writers, and artists. It was selling at five dollars an acre."

Since 1960, additions to the cabin have made the house a rambling, roomy one. The studio on the entrance floor measures 24 by 36 feet (7½ by 11 m). On a lower floor are storage rooms and Machetanz's drying room, used for his special technique of painting in layers with glazes and varnishes.

At work at his easel near the windows facing mountain peaks, Machetanz discusses his techniques and his artistic development over the years. "In art school I used opaque colors mixed on my palette and transferred to canvas. Since then, I have developed a blue-and-white underpainting-and-glazing technique adapted from the techniques of the early Van Eyck, who did underpainting in either gray and white or blue and white. Vermeer, another of my favorites, probably used a blue-and-white underpainting technique." Machetanz also draws inspiration from the work of Frederick Church and Albert Bierstadt, nineteenth-century American landscape painters. "And I like Sanford Gifford, another nineteenth-century American, for his gorgeous paintings of sun, sky, and landscape. I'm interested in painters' use of light. The Luminists are my kind of artists," he says. "For color in Alaska, to me the most dramatic are the ice fields in spring. There you'll see pressure ice which has transparent, translucent, and opaque blues."

For this artist, both light and landscape are all-important. "I look for animals to suit habitats," he says, "and I prefer males among bears and dogs for their 'blocky' appearance—even though female sled dogs are more intelligent and are usually the lead dogs for that reason."

Machetanz frequently uses his own sled dog, Rocky, for details. "Usually, my paintings are a combination of photographs, sketches, memory, and imagination. I get most of my ideas from my forty years of living in Alaska. I'm constantly looking for things and thinking of ideas. Sometimes I have an idea for many years." He points to a painting of a large polar bear looking down from a high ice cake. "I saw that ice cake years ago and wondered, 'What if I saw a polar bear coming at me on that ice?' Twenty years later I

*The Tender Arctic*
Oil, 32" x 52" (81 x 132 cm)
Collection of the Charles and Emma Frye Museum

103

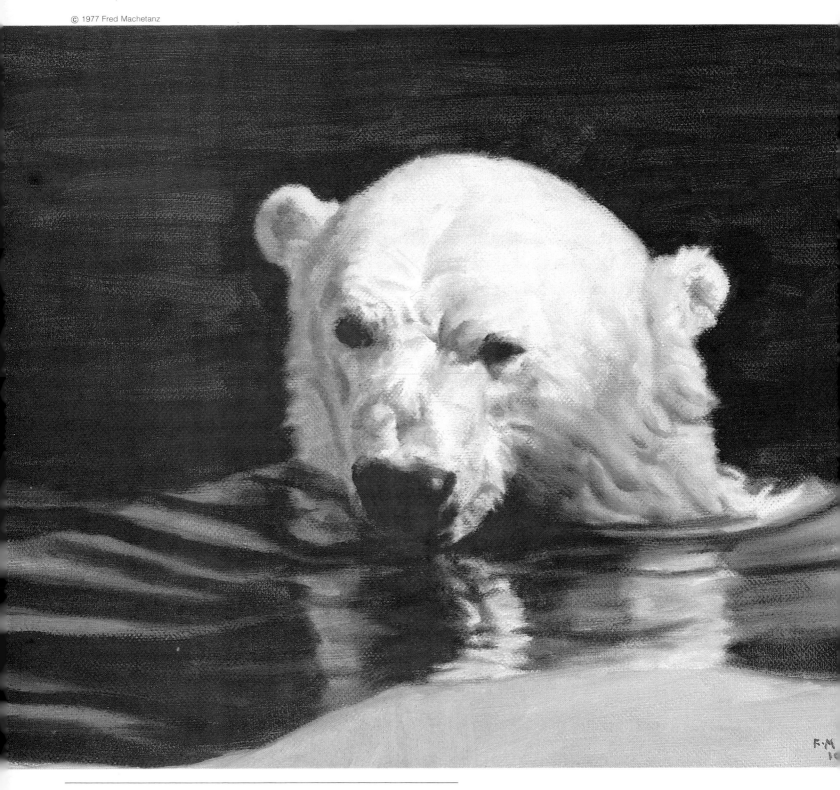

Above
*Deep Thoughts*
Oil, 18″ x 24″ (46 x 61 cm)
Collection of Mr. and Mrs. M. Kadish

*Right*
*Face to Face*
Oil, 52″ x 32″ (132 x 81 cm)
Collection of Mr. M. Lamont Bean

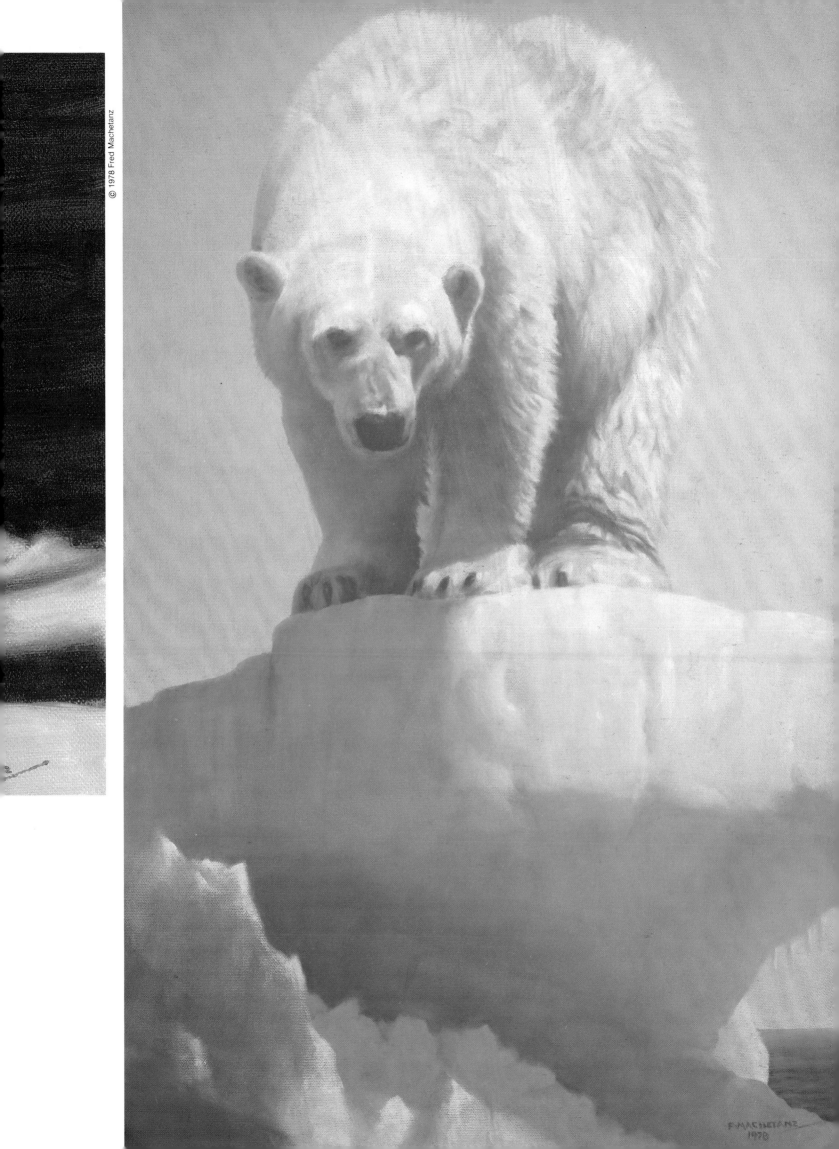

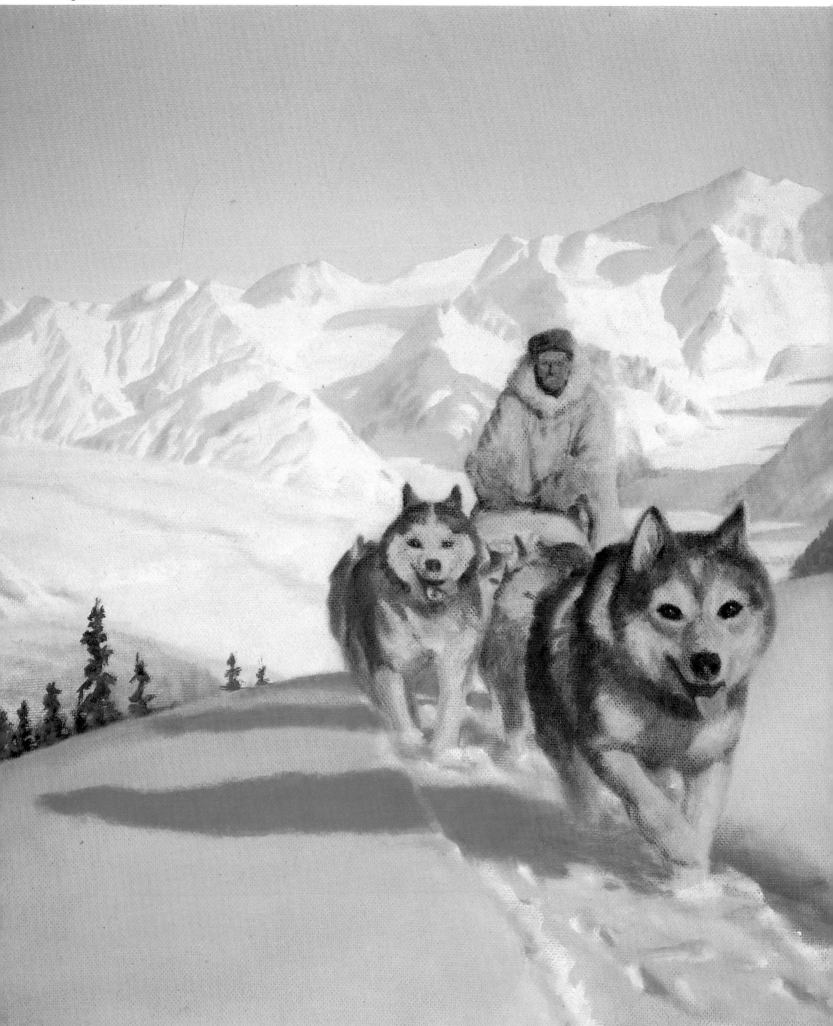

painted that idea in a picture called *Face to Face* [p. 105]."

Machetanz still visits zoos, including one south of Anchorage. "Recently," he says, "I spent time watching wolves in the Portland, Oregon, zoo. Sometimes I also look at stuffed animals, but only for details, such as nostrils, eyes, and hooves.

"I used to sketch on most of my trips," he says, "and take photographs as well." In his early days in Alaska, he did many watercolor sketches of settings. These days he mostly uses his own photographs, taken with a 35mm Pentax with telephoto lens in black and white. With it he has taken pictures of moose and bear in the wild as well as at the zoo. "It doesn't really matter how good it is, but the photo should be your own. It's the result that counts. I use photographs only as reference material. I sketch less and less, as I rely more and more on brushwork.

"All my work is done in my studio. I don't paint outdoors. I like the Barbizon painters. They went out of doors, but completed their paintings in their studios. When I go outdoors, I walk my dog, look at trees and clouds, and take photos, or just plan new things. At one time I used to take oils and shellacked illustration boards and do sketches on my trips. But I never did a complete picture on the spot, and now I do no more sketches, either."

Working at his easel in sight of the magnificent mountains, Machetanz uses artificial incandescent lights for illumination. "It's what you're going to see the pictures under, mostly," he says. Opposite the easel is a long, narrow mirror. "It shows how the painting looks reversed and gives a fresh eye on it." The easel itself is a specially designed one that includes a palette, which extends directly under the easel stoop, made of glass over a white board. The extension also holds tubes of Winsor & Newton oil paints.

"I like to put a painting in progress in a frame from time to time to see how it looks. Also, I turn it upside down to see how it looks from that angle." His tabouret to the right of the easel holds his painting medium of mineral spirits and linseed oil. Instead of turpentine, he uses copal varnish mix. "I am also interested in alkyd medium as a varnish," he says.

Before beginning a painting, Machetanz completes a small sketch in oil, roughly massing darks, lights, and colors, usually in sizes of 8 by 10 or 9 by 16 inches (20½ by 25½ or 23 by 40½ cm), always in the same proportions as the planned painting. "I like oil as a medium. Watercolor is the toughest medium there is. Once you've learned to draw with a brush," he remarks, "pencil drawing is a waste of time. It would tighten me if I had to follow outlines."

For his first underpainting, on the final canvas, Machetanz uses mainly Permalba white and ultramarine. "There's every blue in the world reflected on ice and mountains," he says. So his palette holds, in addition to ultramarine, cobalt and Winsor blues, as well as rose madder and rose dorée, Indian yellow, viridian, thalo green, sienna, umbers, and Hansa yellows. "It covers the range in nature as I see it," he says. "I like to go over colors such as green trees with rose madder to gray them. I never use black. Instead I use Winsor blue or cobalt for the darks."

*Along the Nelchina Trail*
Oil, 26" x 32" (66 x 81 cm)
Private collection

When Machetanz composes an animal painting, he says, "I like the animal mostly to fill the canvas. I like to do man small—to show the immensity of Alaska. But I like to put animals low in the foreground." He points to a painting of a looming grizzly bear taking up most of the canvas. "I feel all my compositions should dramatize the animal because it is of paramount importance."

His paintings are done on Masonite panels covered with layers of white oil paint (titanium, lead, and zinc). He ages the panel for at least a year in his storage area in the basement. When the panel is aged, he says, "I do a rough oil sketch on a small panel first, with a rough painting including the underpainting in ultramarine and Permalba white. I let the underpainting dry under infrared lights for two or three days in the drying room.

"For the overpainting, I use a glaze of linseed oil with transparent pigments. I brush it on and smooth it out with bristle brushes. The underpainting divides the work," he says. "The underpainting is for form and composition; the overpainting is for color. Sometimes I use sables for details, and I use copal varnish over the underpainting. Each glaze has to dry. I may use five or six glazes in a painting. Each one is varnished and dried between layers. I'd say it takes at least six weeks to complete a painting, but some take months and some take years before I consider they're ready."

On the wall of his studio is a magnificent landscape of snowcapped mountains and green valley. High up against the white-clouded blue sky is a soaring eagle. "I put that eagle in years after I completed the landscape," he says. Near the painting is another of a cow moose with calf. Moose are a frequent sight outside their studio named High Ridge. In winter deep snows drive the moose down from the mountains in large numbers. Another painting shows a polar bear emerging from the water onto the ice, and in still another a polar bear reflects the pink and gold colors of sunset on the ice.

Based upon his years of painting, Machetanz believes that the aspiring wildlife artist should first learn to draw and paint. "Study still life and anatomy," he says. "If you can learn textures, you can do animals. Do sketches at zoos for learning the motion of animals. Any reasonably good artist can paint animals. But wildlife artists must know habitat, so you must be a good landscape artist, too."

Fred Machetanz is also known for his paintings of Eskimos and landscapes. He estimates that his animal paintings amount to 50 percent of his output. He has also produced stone lithographs of the early days in Alaska . . . the days of romance. He is now famous in his adopted country with many friends and supporters. All of them are staunch Alaska boosters and count Machetanz as one of the chief protagonists of that great natural wilderness whose portrait he has painted in countless scenes of its natural beauty, its native animals, and its vanishing way of life.

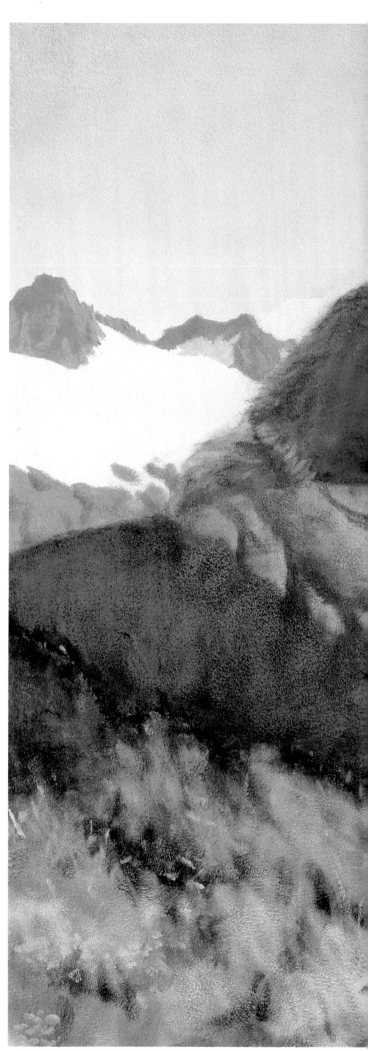

*King of the Mountain*
Oil, 26" x 32" (66 x 81 cm)
Private collection

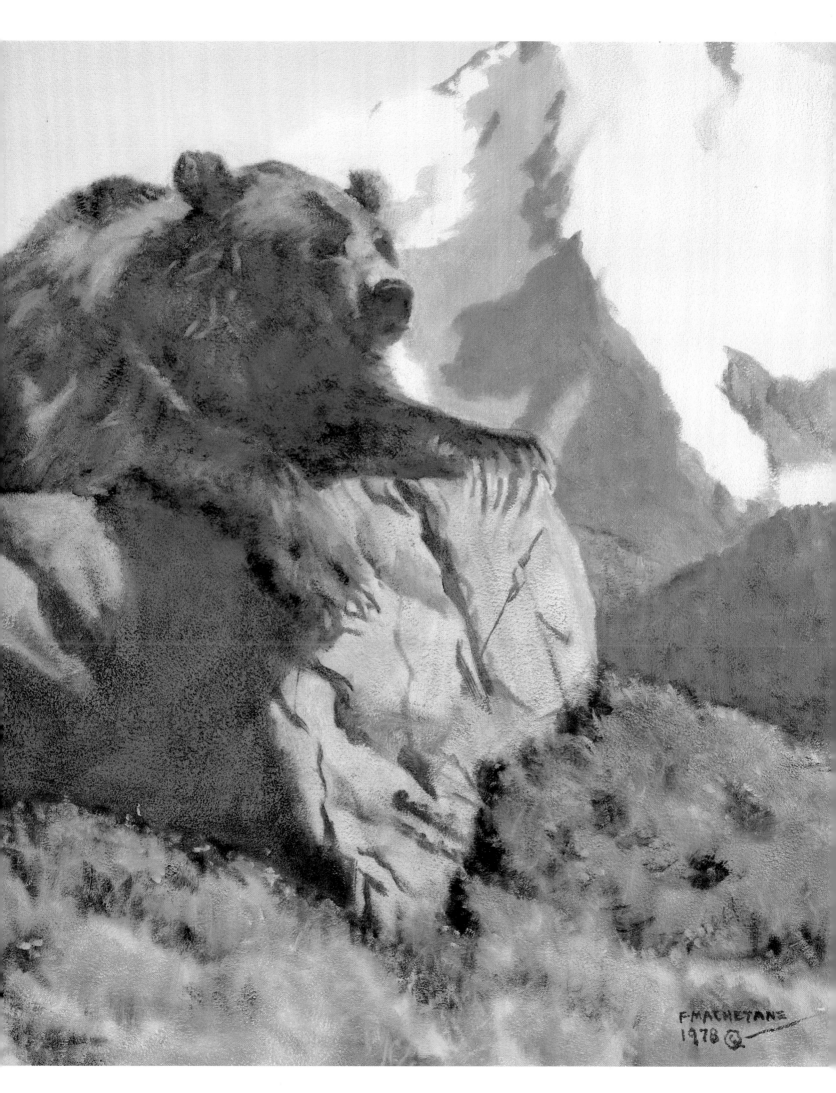

F.MACHETANZ
1978 ©

# STANLEY MELTZOFF

When Stanley Meltzoff dons his wet suit and plunges into ocean waters, he is joining two of the most durable strands of his life, which were long separated: his skill at diving into the deep sea, and his devotion to the art of painting.

Through the use of both skills, he portrays the drama of one of the world's last great wildernesses. Until this century, this wilderness was unknown. Now, with the development of diving equipment and underwater cameras, life beneath the seas is becoming increasingly accessible. Because snorkels and masks are commonplace today, and because millions have viewed Jacques Cousteau's films of life in the deep, Meltzoff limits himself to depicting "those animals which are too rare, too large, too swift, too shy, or too hidden by dim waters to be readily photographed." In this underwater art he crosses the boundary between that which is visible and that which is visionary. The limitations of underwater viewing are still tremendous. They include clouded waters, swift-moving animals, precious few minutes of time breathing oxygen from a tank, and dim light filtered through deep waters, all of which disturb perception where big fish live.

Yet it is Meltzoff's goal to bring his vision of that underwater world to canvas as an "illusionistic artist who considers a painting as a window through which one looks." He says, "I'm trying to give the viewers the feeling they see what I see, as though the viewer is behind my glass mask under the water." It is a task for which Meltzoff is well equipped by both education and experience.

Born in New York City in 1917, Meltzoff began drawing early in his childhood, spurred on by a cousin who was a trained academic artist. "He was my role model," says Meltzoff. "He painted a portrait of my father and me, and I grew up in an atmosphere in which art was looked upon as a socially approved way to make a living." Young Meltzoff was equally interested in many other things, including writing, which he did for a living even before becoming a successful illustrator. Chief among those other interests was

*Bluefin 1 — Orca and Tuna #1*
Oil over acrylic and gouache
34″ x 24″ (86 x 61 cm)

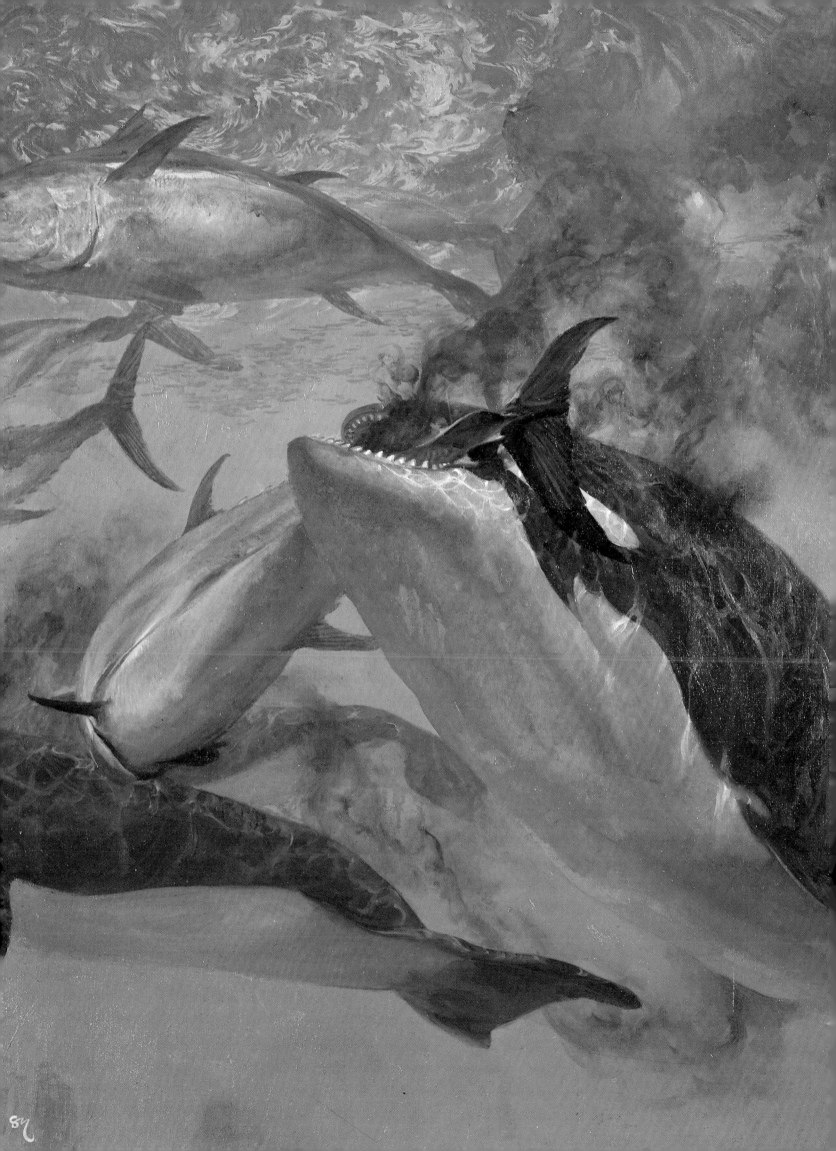

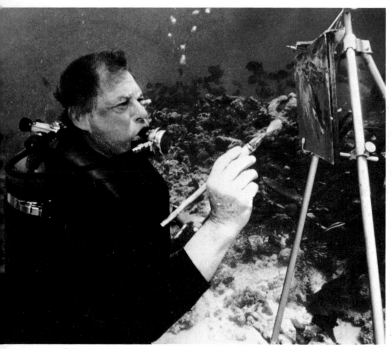

Stanley Meltzoff "painting" underwater.

the sea. His family took him to Belmar, New Jersey, on the Atlantic Ocean every summer from the time he was three. "I can remember looking through the clear Atlantic water, picking up seashells, seeing sea horses in the shallows. My summer life was always at the seaside, and that summer world lasted four months of every year. In my teens I set up a studio in New Jersey and did oils and aquatints. There was never any doubt that I was good at drawing and painting."

His early formal art education took place in both the public schools and colleges of New York City, Townsend Harris High School and later at CCNY. He began to study art history with Meyer Schapiro, the famous art historian, who was giving classes in Manhattan when Meltzoff was about sixteen. Further studies included the National Academy and the Art Students League, where he took classes in lithography with Will Barnett. As an undergraduate at the College of the City of New York, he majored in aesthetics and took a B.S. degree, then went on to New York University's graduate Institute of Fine Arts, where he earned a master's degree in art history, writing a master's thesis on "The Revival of Le Nain: A Study in the Changes of Taste in Art." At that point he was as interested in becoming a writer and critic as in being a painter. During World War II he was an art editor and writer for *Stars and Stripes* in Italy, doing maps, cartoons, illustrations, and stories.

After the war, Meltzoff decided that "I would rather do art than write about it. If it was important enough to write about, it was important and more satisfying to do it myself." While he was "doing art" as a free-lancer, Meltzoff also taught art history and studio art at City College and later at Pratt Institute.

Meltzoff married in 1952. Later, he and his wife, Alice, decided to move from New York City to the New Jersey coast with their two daughters, Sarah and Annie Laurie. Once more, Meltzoff was close to his childhood seashore. Now, instead of teaching, he expanded an already growing career as an illustrator to become a full-time free-lancer. In the years that followed, his illustrations appeared on the covers of *Scientific American* and in the pages of the *Saturday Evening Post*, *Life* magazine, *National Geographic*, *Field and Stream*, *Fortune*, and *Sports Illustrated*. The subject matter varied from an eight-page color history of Greece to emblematic still lifes for *Scientific American* covers. He also illustrated paperback books, some of which were about natural history. For those Meltzoff says he was influenced by the eighteenth-century paintings of Joseph Wright of Derby, England, who was one of the first to study science, and by another English painter of the same period, George Stubbs, who painted portraits of horses for a living and developed a new type of animal picture "full of Romantic feeling for the grandeur and violence of nature" (H. W. Janson, *History of Art*).

Says Meltzoff, "Stubbs and Wright painted the productive side of life instead of the great lords and ladies preferred by Gainsborough and Reynolds." Rubens, Tiepolo, Winslow Homer, Bellows, Eastman Johnson, Magritte, and

Top
*Blue Marlin 7—Double Header #1*
Oil over acrylic
22¾" x 27¾" (58 x 70 cm)
Collection of Mrs. Arthur Lamborn

Bottom
*Striper 1—Stripers on North
Tip Manasquan Inlet, October*
Oil over acrylic, 14½" x 32" (37 x 81 cm)
Meltzoff's first fish painting.

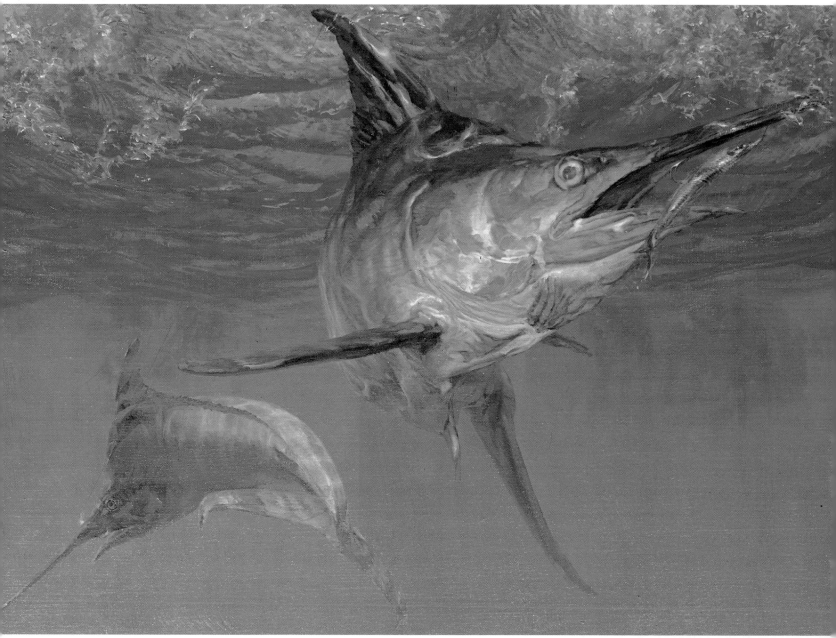

Balthus—all were influences to which Meltzoff claims a debt for his subsequent painterly style with underwater subjects.

These subjects, however, were merely his private preoccupation for the many years after World War II when Meltzoff was busy turning out commissioned illustrations. Simultaneously, deep-sea diving was coming of age. Shortly after World War II, underwater masks became available for general use. Meltzoff used them for spearfishing underwater and is one of the first to have taken striped bass. He also founded the first diving club of New Jersey and became an experienced skin diver and scuba diver. He holds diver's world records for bluefish and striped bass. For years, he estimates that he spent about 150 days a year hunting underseas on the New Jersey coast with no thought of making a painting of what he saw. Instead, he was learning firsthand about the undersea world, and about marine biology by reading both books and scientific papers. He became a founder of the American Littoral Society, made up of marine biologists and divers, and had still not painted a fish.

Yet all this experience was vital when he finally did begin to paint the underwater world. It was while he was doing illustrations for *Field and Stream* that he did his first fish painting for himself—a striped bass in Manasquan Inlet. The striped bass was later reproduced in a series by *Sports Illustrated*, and it was followed by paintings of tarpon and bluefish. Larger game fish followed when a friend, Steven Sloan, an international game fisherman and record holder, invited him to fish for blue marlin in the American Virgin Islands.

While several series of game fish were published in *Sports Illustrated*, Tom Lenk began to buy the originals for the collection of the Garcia Corporation, a manufacturer of fishing and sporting gear. Meltzoff's sketches and paintings were displayed at meetings of conservation groups, fishing conventions, and regional seaport museums. Exhibitions at art galleries soon followed.

He says of his now full-time devotion to painting underwater subjects: "If you can paint people well, animals are not so difficult." Meltzoff has never abandoned his early academic training and classic approach to oil painting, and he applies it to his underwater painting as well. There is one important difference for painting in the underwater atmosphere. He says, "You must also be capable of painting empty water. It's not blue, and you can't take a photograph of it. Another problem is that fish underwater move without reference to the horizon, or sky and earth." It is no wonder, then, that Meltzoff relates his work to Tiepolo's paintings on the ceilings of baroque European churches and palaces which show angels inhabiting similar boundless blues.

But there is a great difference between painting air and painting the water portrayed in Meltzoff's paintings. He says, "The problem of light filtered through water must be solved, to depict the difference between transparent water and the suspended solids." Meltzoff points out that "the

Top
*Tarpon 7—Tarpon at Looe Key*
Oil over acrylic, 26¼" x 53½" (37 x 136 cm)
Collection of Mr. John Whitney Payson

Bottom
*Shark 2—Fort Shark #2*
Oil over acrylic
17¼" x 47½" (44 x 121 cm)
Collection of Mr. Samuel Watson

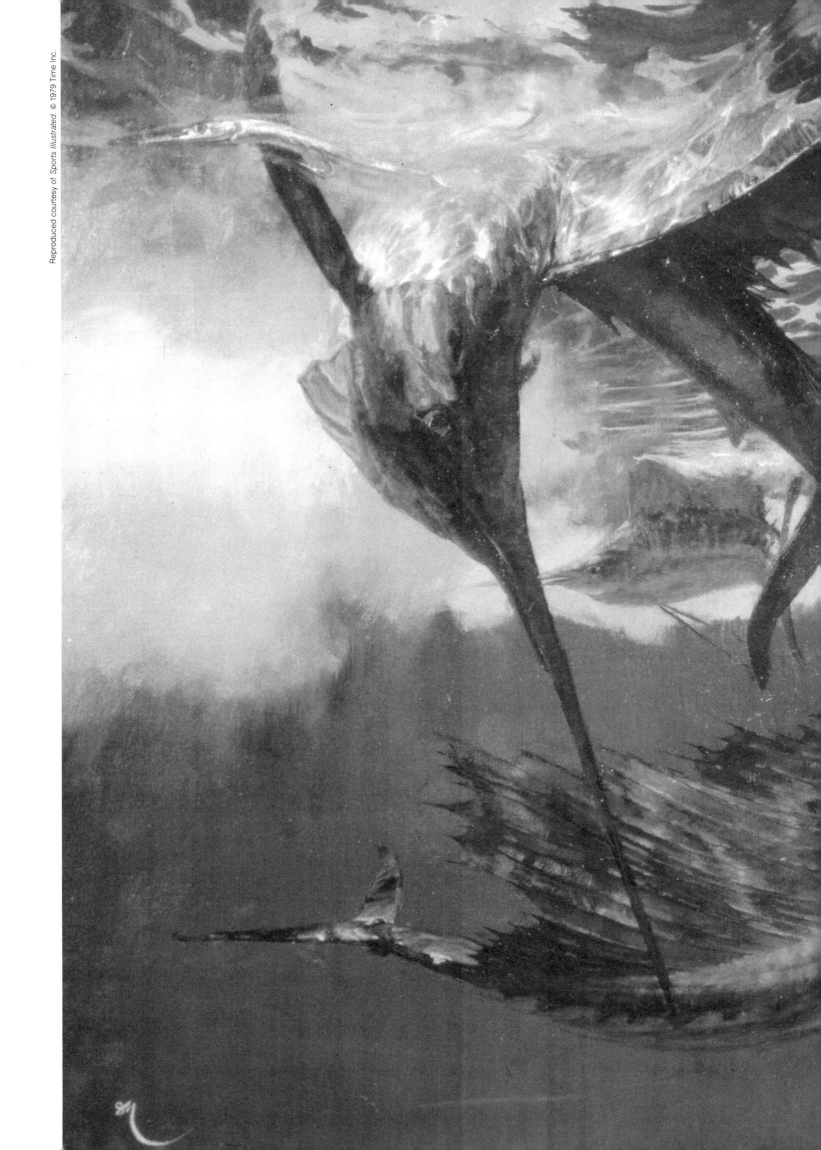

limit of visibility in the clearest water is less than two hundred feet. A hundred feet is considered excellent visibility, and twenty often makes do. The seascape of the underwater wilderness is unlike a landscape, since it has neither top nor bottom and no horizon. The stretch of visible solid bottom or undulating undersurface is never more than an acre or so in extent. Even when corals and kelp (which take the place of vegetation on land) are present, there is little to take the place of the clouds and skies which activate the landscape. Underwater space is a palpable emptiness with closed and yet indefinite limits. As soon as we leave the coastal shallows, nothing is visible in the seascape but the subsurface of the waves. Beneath that surface, all visibility is severely limited.''

Meltzoff points out that special things happen to light and color as they are transmitted through water, which are quite different from what happens when light is transmitted through air. "Atmosphere perspective takes place in distances of less than five feet. The theoretical visibility in water is one hundred fifty feet with the clearest possible water and light. But, since all light comes from above and drifts down through layers of water, the light is absolutely unfocused fifty feet below the surface.''

Until this century, nobody had even viewed underwater life at those depths. Fish were portrayed, if at all, as part of a still life on a dining table, dangling on the end of a fisherman's hook, or alive but out of their native water. "Hiroshige, the great Japanese artist, was the best fish artist before the present day,'' says Meltzoff. "He painted the fish off the coast of Japan. If you look at his work, you would do better than to look at a photograph, but it is not what you see when you look at fish underwater. He doesn't attempt to paint water, only its symbol. I believe that a wildlife painter now has to paint the light in that watery wilderness and suspend fish in that illumination. It is important to draw fish as realistic in detail as Hiroshige did, but then they must be seen illuminated by underwater light. For that, you need to be an expert painter and to know the special conditions underwater. How do you paint a wet fish underwater? It is not the same as painting a wet fish above water. You have to see it underwater to know the difference.''

In order to see that underwater illumination, Meltzoff dives continuously in the New Jersey Atlantic and up and down the New England coast, in the Bahamas, and in the Caribbean. He knows the Pacific waters less well. In addition to his scuba-diving gear, he is expert with the Nikonos underwater camera, lenses, and flash equipment which accompany most of his dives. His photographic arsenal includes thirty to forty cameras, one formerly owned by Man Ray. Meltzoff does all his own darkroom work as well.

A photograph of Stanley Meltzoff published in *Southwest Art* (p. 112) shows him several feet underwater with his scuba equipment and fins, kneeling before an easel with a canvas. Brush in hand, Meltzoff is presumably sketching the seascape firsthand. The title even says: "The artist, Stanley Meltzoff, field sketching in the waters off Belize, C.A. (1980).'' It is true enough that Meltzoff was diving in those

*Sailfish 11—Three Acrobats and Needlefish*
Oil over acrylic, 23½" x 23½" (60 x 60 cm)
Genesee Country Museum

waters at that time, but never had it been possible for any artist to sketch under those conditions. "It was meant as a joke," says Meltzoff. At the same time, it is at least symbolic of the kind of depiction of underwater life for which Meltzoff is striving—to show that world as it is.

There are many varieties of life beneath many seas, and Meltzoff looks for his subject matter among all species of fish. Of the big-game fish, he has done series of paintings of bluefin tuna, bluefish, sailfish, white marlin, blue marlin, and swordfish. "The problem," he says, "is to do something different for each animal, yet keep it true to each species with its individual attitudes and groupings. Each picture should be different from the others. I have done nearly two hundred pictures of fish, covering at least forty species. I ask myself, 'What is typical of that animal?' Those in the open ocean are quite different from shore animals. For example, bonefish have mirrors all over their bodies. Since they live in very shallow water, the mirrors serve as their camouflage." (They hunt, as well as escape danger, by being invisible.)

Meltzoff gets his ideas for a painting from direct observation, but also, he says, "I talk a lot to fishermen, anglers and divers who tell me their stories." One of his paintings of a tuna eating a puffer fish came to his attention when Captain Jack Lance "called me to come and see it." He also dives as much as possible to "see what I can see." The world underwater is a constant source of wonder and delight to Meltzoff. "I find everything is interesting to look at. Everyone should go with wide-open eyes and be astonished, and I paint for those who do as well as for those who can't."

When the time comes to decide what to depict, Meltzoff limits his scope to the subjects and activities that cannot easily be photographed. One of his least photographable subjects was the 1-inch (25-mm) photoblepharon. These tiny sea creatures have bags under their eyes containing microorganisms. They live in schools, opening and closing the lids over the bags as a way of signaling to the rest of the school and attracting food. A scientist and a photographer had studied these little animals at night, trying to photograph the light blinking from their eyes without success. Then *National Geographic* magazine, in desperation, asked Meltzoff to represent the phenomenon. This, perhaps, is the most extreme example of an unphotographable underwater species.

Yet, it is true that photography is of the greatest importance to the wildlife artist because, says Meltzoff, "those photos taken from life become the 'sketch' from which the artist refers for his finished work. You can't sit down and sketch a moving fish from life." He also feels that for what he is trying to do, which is to depict fish in their natural habitats, sketching them in an aquarium makes no sense whatsoever. Nor does he get much from viewing stuffed fish; however, he says, "I often pose dead models and can learn a lot from frozen small fish—for example, the details of a school of fish."

For that reason, Meltzoff spends a great part of his time exploring the underseas, both to view the fish and to see their habitats—the color of the water, the configuration of the life chain such as the reefs, the sand, and the un-

*Sailfish 19—The Master and His Sailfish*
Oil over acrylic, 20" x 30" (51 x 76 cm)
Collection of Mr. John Rybovich

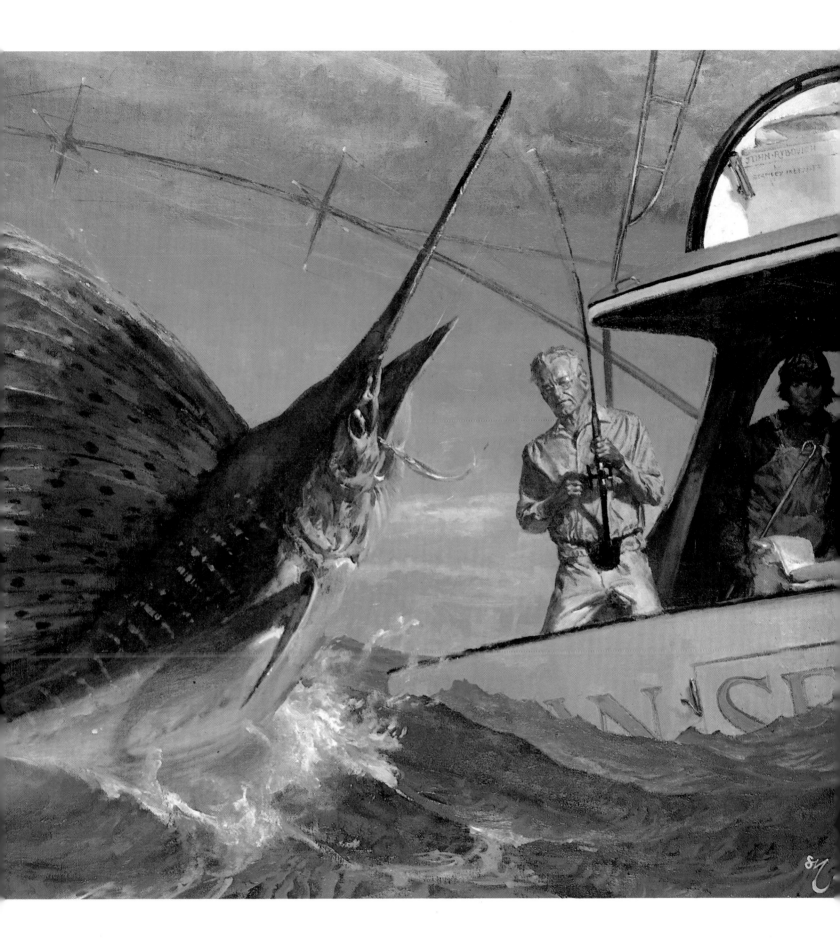

dersurface of the water. When he makes these trips, in addition to his cameras, he carries a small notebook. After diving, he says, "I make notes. For example, they might be about what I see a white marlin do, or I make notes about colors. Occasionally I make a compositional scribble."

By now he has a large collection of these notebooks, all marked for places and dates. One of them from January 1978, for instance, concerns a trip for research on sailfish. He listed possible subjects: "Finning with teasers" recollects the use of artificial bait to bring fish to the boat. "Two deep at the baits; leap and tail from the water" describes the action of two sailfish. "Sails balling the bait" is meant to remind the artist how sailfish sail around the bait fish and herd them into a ball.

He says, "I must be in the water with the live fish at some point. If I can't see it free, I'll get the fish hooked and tethered on a line, then I'll go overboard and swim with the fish and with my camera. It's all very fast and complex. I'm swimming one way and taking photos of the fish going the other way. If a fish dies, I take it to shallow water and suspend it in the water. Then I can do whatever I want, such as taking photos in various positions. I can put it in the proper light and depth I want in the water and swim around it at every depth and distance. The photos are not good by themselves because it's clearly a rigged fish, sagging from its supports. But the pictures serve my purposes for reference. Sometimes I take a fish on land and put it in a freezer, then pick it up in my truck or van. I can pose the fish on land or even 'fly' the fish from the ceiling of my studio. While it's somewhat stiff from cold, this works well. But a limp fish is no good this way."

Many of his notes also include discussions of the water. "Five-foot waves, for example. My notes will ask, 'How do they look from underneath?' I'll wait for a day with that kind of water and take photos of that. Some fish live in a particular landscape, or rather seascape. When I was doing tuna in the Atlantic, I went to Bimini to find a seascape, and while underwater there, I imagined the tuna which I had seen nearby in passage on their regular migrations. I look for seascapes appropriate for this passage. I take photos of a lot of seascapes. I can lie on the bottom and see if the seascape 'works' for a picture. In water I can suspend myself at any depth, which is significant for the light, and see the appearance or absence of the surface of the water at that depth."

In addition to fieldwork, photography, and note taking, the artist also makes use of published materials for accurate details of fish anatomy and habitat. He is fortunate in living near the Sandy Hook Marine Laboratory, which has a large library. "Libraries are especially good for anatomy. It's important to know such details as the number of rows of scales on a particular fish. I try never to violate accuracy, although I may not paint every scale. I must not get something really wrong. Fortunately, there are thousands of reference tools on anatomy of fish used by biologists in many languages, and I use these a lot."

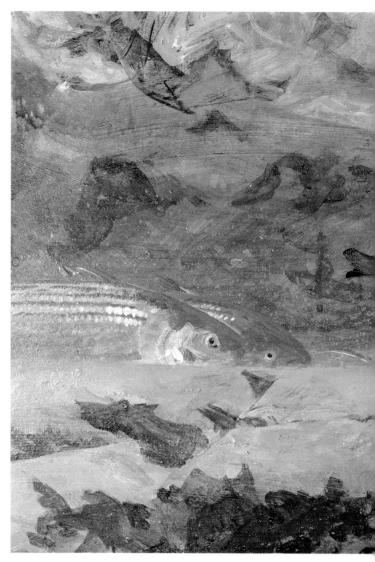

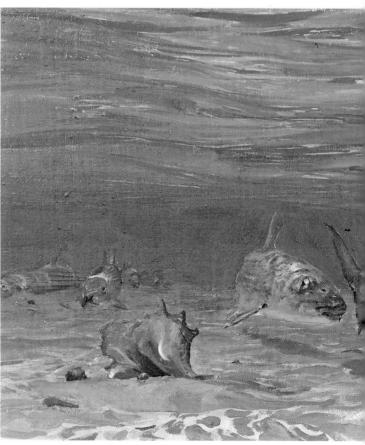

Top
*Striper 9—Eighth Avenue, Asbury,*
*Stripers in the Surf Line*
Oil sketch, 11½" x 16½" (29 x 42 cm)

Bottom
*Bonefish 12a—*
*On the Flats, Bones and Permit*
Oil sketch
Private collection

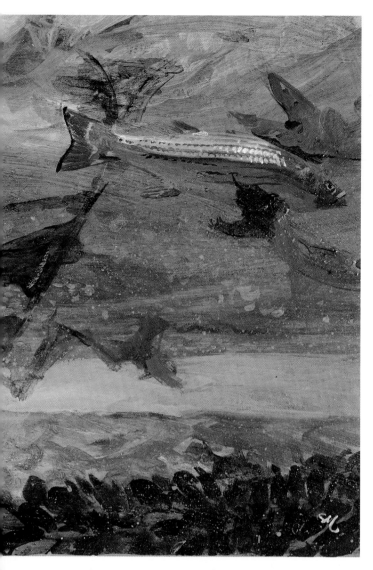

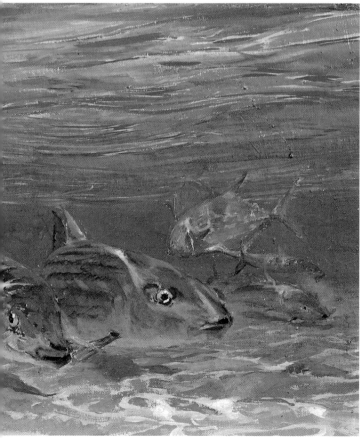

Meltzoff does not do separate paintings for settings. "The hardest thing is to understand what the water looks like from underneath." He cautions, "Remember that the only thing you can do with photography is to match it as opposed to making what you know should be there. What you invent may be different from a photograph, and perhaps not even as good, so if you can photograph something, do so. I paint what can't be photographed, yet I must use what I have photographed in order to paint the final scene illusionistically, and still express my own feelings along with facts. It is pointless to use photos made by someone else except for a detail you may have missed in the appearance of a fish."

He says, "Illusionistic painters must be the masters of both crafts—photography and painting—with the photograph replacing the sketch as the source of primary data, refreshing your memory of how the subject looked originally and how you were feeling at the time. Photos in some ways are better than sketchbooks for keeping a moment-by-moment record of what you see. When you see your photos, you can tell if you missed something and then go back if need be. Time underwater is vital. Only a camera can record time in parts of a second, so a photo stops action, letting you see what the human eye can't see without its aid.

"Today photography is the currency of vision, and whatever you do by hand has to live up to the photograph's accuracy as a minimum. But if you're making a picture, you have to know the real thing as well as see it. Experiencing, perceiving, and knowing have to be put together to make a picture with the aid of the recording of the photograph. Since you can't sketch underwater, your photo is your record and gives you choices among all the possibilities of seascapes, other fish, and light. The photograph has already solved the problem of representation on a two-dimensional plane, so matching becomes a simpler process.

"But," he warns, "if all you do is copy a photograph, the result will not be of more interest than the original photograph. To the extent that you get past matching the record, you are making a picture that includes your feelings and your knowledge." Meltzoff uses 35mm Kodachrome color film, which he feels provides sufficient detail. He does not believe that color accuracy is too important, because all color is filtered by blue. He works from color slides, which, he says, "you can't match in pigment because they are made of light. Instead, you match the disposition of forms and ask yourself, 'How can this color of light be matched in the reflection of a pigment?' I put into my painted images what I can imagine, but can't really see, even in a photograph. For that I use every pigment going."

When working on a painting in the studio, Meltzoff follows a fairly regular progression. First he refers to the words in his notebook and his photograph; then he does a compositional diagram. He says, "When I have all the information I need, I make a small painting to explore the problem, usually an eight-by-ten- or twelve-by-sixteen-inch [20½-by-25½- or 30½-by-40½-cm] on canvas. This will be a full little painting. I may make several of these paintings as studies." The sketch paintings are done in oil over gouache. When the artist decides how he wants the finished painting

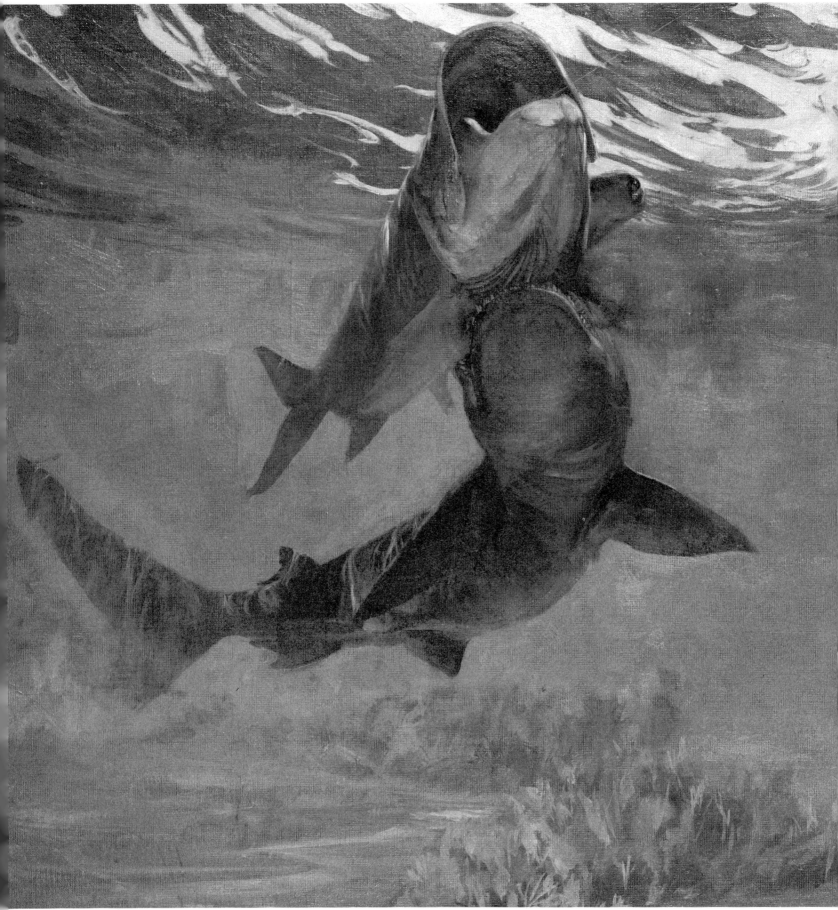

to look, he mounts linen canvas on both sides of a Duraply panel to prevent warping. After priming with gesso, Meltzoff does an underpainting in gouache or acrylic. He likes the water medium for its speed. His overpainting is done in oil. "The reason this works," he says, "is that you divide the labor—form is defined in the underpainting while in the overpainting the artist controls color and illuminant values. It is possible to work rapidly and change easily if you want to restart."

He allows the notation of the underpainting to remain visible through the vigorous overpainting in order to keep the picture "looking painterly." Brushstrokes are visible only when useful, such as for the effects of the overhead light and its direction. "Once I've painted the water with blues, which are lighter near the surface and darker below—that's a lot of blue paint used fairly thickly—then I may sometimes take a big brush, perhaps a foot across, like a wallpaper brush, and score the wet paint with brush marks as controls of illumination. I do this occasionally in the background to indicate light rays, being careful not to do it where light rays hit fins. There I use thick paint to call attention to the fin by a single brush mark—to give movement to the fish by the trace of my motion in painting."

Of color he says, "Since underwater is a blue world, the differences of the blues and blue greens are very important. Mixing pigment makes values darker, but water is always moving, reflecting and transmitting light, more vivid in hue and higher in value than anything above water. It is necessary to use pigments which are themselves different hues—all higher. All blue pigments are useful—cobalt, thalo, manganese, ultramarine, Prussian, Antwerp blue. The greens I use are Winsor green, Winsor emerald, viridian and cobalt green, cobalt deep green, and cobalt turquoise as a glazing color and for scumbling." For the rest he uses a full range of pigments. The colors are laid out on Meltzoff's palette, a 2-by-4-foot (61-by-122-cm) glass-surfaced tabletop, plus a smaller palette 1½ by 3 feet (46 by 91½ cm). His medium is a classic combination: sun-thickened linseed oil, damar varnish, and turpentine. "If I have a particular blue range, I keep exact notes on mixtures and keep the paints I've mixed on six-by-six-inch [15-by-15-cm] tiles which will keep underwater in a pan for weeks. It is extremely important to maintain exact values and hues. Since the range of color is so limited, I have to be more precise. I can't violate cues to vision or the illusion breaks apart."

In addition to the blues and greens, Meltzoff likes the Naples yellow made by Rowney and Permalba white permanent pigment. "All pigments must be the right hue, but some must be transparent and others opaque. I can't use a mixture of opaque colors for transparent, or vice versa."

Meltzoff works in sizes ranging from 20 by 36 to 32 by 56 inches (51 by 91½ to 81 by 142 cm). Most of his canvases are horizontal, but his compositions are varied. He says, "Fish are moving, but there is no clear horizon, so my composition is more a baroque interweaving into space like the baroque ceiling paintings and frescoes of Tiepolo and Rubens."

The artist and art historian feels strongly about the need

*Tarpon 1—Between the Hammerhead and the Boat*
Oil over acrylic, 26¼" x 36" (67 x 91 cm)

for painterly skills and wide knowledge being brought to painting wildlife. His own background as diver and classical painter makes him insightful about problems of painting beneath the water. In an article in *Southwest Art* (November 1980) he wrote: "Painters of land animals or birds rightly strive for clarity and precision of detail; painters of fish must take into consideration how the biological forms of sea animals dissolve into the illuminant water. Clarity actually muddies the view of underwater life, and the emotional mode—that special straining against the limits of perception—sets the mental framework of the underwater painter.

"To endow wildlife with human emotions," said Meltzoff, "the underwater painter must make use of the underwave patterns of light and foam. These underwave patterns take the place of thunderclouds, raging surf, sunset calms, or shafts of moonbeams through drifting clouds which assist a landscape painter in setting the narrative or symbolic tone for the protagonists. The color given to the water naturally, by the bottom or by the matter suspended in it, tells us not only the water depth, but its location, season, weather, and the type of animal life able to survive in it."

He concluded the article: "The greatest danger to painters of underwater wildlife is keeping up one's courage in the face of inevitable failure. Fish, burning in the wilderness light, destroy caution or premonition of failure, and the senses, drunk with strange and barely explicable perceptions, fade into uncertain memories. The underwater artist can preserve only with difficulty that moment of personal vision so fleeting and deceptive that it ranks closer to the visionary than to the recordable fact."

To achieve that personal and mystical vision, Meltzoff can give the aspiring underwater artist no better advice than to "learn your craft and know your wildlife in its surroundings. You must know this all firsthand, and you can't use someone else's photographs of it. After that, your own imagination will make your picture your own original contribution to art."

Meltzoff works at his own original contributions in a studio near the New Jersey Atlantic shore on a spit of land between the Shrewsbury and Navesink rivers where the artist is able to dive and observe underwater life close to his doorstep. Twenty-five minutes away is the Atlantic Ocean and the area between Sandy Hook and Manasquan Inlet, which constitute "the northern and southernmost terminals of my normal diving range."

The white clapboard house has been added on to since 1825, when it was first built. Meltzoff's additions are a workshop, studio, storage space, and darkroom. "The place fits me like the shell of a conch," he says. "Everything is where I've put it."

The one-story studio building has interior work space of 25 by 30 feet (7½ by 9 m), with a 13½-foot (4-m) ceiling, high enough and large enough to "fly" fish and handle large objects brought in and removed through double doors, salvaged from a demolished brownstone in Brooklyn, leading to a terrace and the driveway. Those objects may include

*Shark 8—Homing into the Rookery*
Oil over acrylic, 34" x 24" (86 x 61 cm)

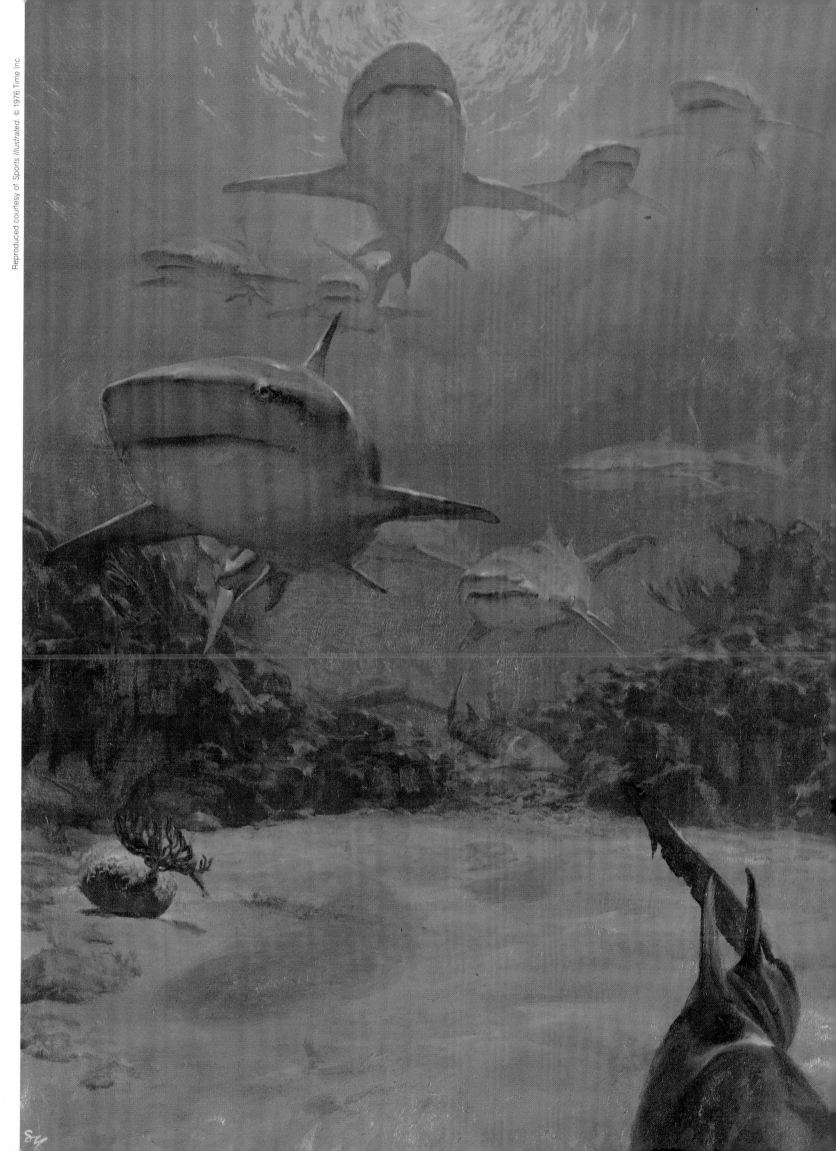

large fish and quantities of ice for preserving them. Concrete floors make it simple to hose the studio down after the watery, slippery "subjects" are no longer needed. And, because all the furniture is on wheels—tabouret, easel, slide projector, chairs—it is simple to push them aside when the hosing down takes place.

North light enters through windows and large skylights, augmented by color- and temperature-corrected incandescent and fluorescent lights in the walls and ceiling. "With the use of both these kinds of light bulbs," says Meltzoff, "I can paint in the same colors both day and night." Walls made of Homasote make it possible for the artist to tack up roughs, proofs, and photographs for selection.

Photographs of the artist, his wife and children, friends, and other artists are memorabilia with which Meltzoff is surrounded. Parts of his unique collection of palettes, brushes, and paint rags represent such artists as Munch, Eakins, Boucher, Sisley, Seurat, and many others. Says the artist, "This collection is called the Meltzoff Reliquarium."

Next to the studio is the artist's darkroom, a 12-by-16-foot (3½-by-5-m) space, 13 feet (4 m) high, with ample room for developing and enlarging photographs as well as storing prints and paintings. The room contains his camera gear and a large stainless-steel sink for everything from washing brushes and photography to mixing gesso. In a separate building, Meltzoff's woodworking shop is equipped for making the variety of needed items such as his own painting panels or rigs for "posing" a school of small bait fish in his studio. At one time he made his own frames there as well.

On the wall near the doors of his studio, Meltzoff's spearfishing gear is ready for use. Nearby, his parrot, Xochi, cries encouragement. On another wall is Meltzoff's first painting of a fish underwater—a striped bass from the nearby Manasquan Inlet, painted in 1960 for the artist's own pleasure. He says, "It took me ten more years to understand that I could do others like it for the public."

In the years since then, Meltzoff's underwater paintings have been shown in galleries from New York (where he is represented by the Sportsman's Edge), to Florida and points west. They and his prints are eagerly bought by collectors, many of whom are big-game fishermen, and other admirers of his dramatically portrayed visions of the newly revealed mysteries of life under the seas.

*Sailfish 16—Double Header Aboard, Three in the Wash*
Oil over acrylic, 17½" x 29½" (44 x 75 cm)

# ROGER TORY PETERSON

Roger Tory Peterson is the creator, author, and illustrator of what has been called "the most influential bird book of this century. Since it was first published in 1934, every generation of bird watchers has been schooled by it, and its author has become the most famous ornithologist alive." Thus said Joseph Kastner in an article in the *New York Times* (April 15, 1979) when the book's most recent update was announced.

Peterson's *Field Guide to the Birds of Eastern North America* has also become the handbook of wildlife artists and an inspiration for conservationists. Since its beginning, the *Field Guide* has sold in the millions.

The honors that have been bestowed upon the creator include the United States Medal of Freedom presented by President Carter, as well as gold medals and awards from many organizations here and abroad. He has received eleven honorary doctoral degrees from universities. Ten of the degrees are for science or the humanities. The eleventh, from the University of Hartford, is an honorary doctoral degree in fine arts. "This means much to me," says Peterson, "because I have always considered my career to be basically that of an artist.

"My first interest in birds occurred simultaneously with my first interest in drawing when my seventh-grade teacher, Blanche Hornbeck, in my native city of Jamestown, New York, had us drawing birds." Peterson was eleven years old when Ms. Hornbeck formed a Junior Audubon Club, which Peterson joined and where he attempted his first bird drawings, copied from colored leaflets distributed by the National Audubon Society.

Until then he had filled the margins of his textbooks with doodling drawings and copies of photographs shown in the books. "I flunked history for that reason," he recalls. "In fact, I was the school nonconformist. Lucille Ball was the school dropout. But they think well of both of us in Jamestown today."

*Golden Eagle*
Watercolor and acrylic
40″ x 30″ (102 x 76 cm)
Private collection

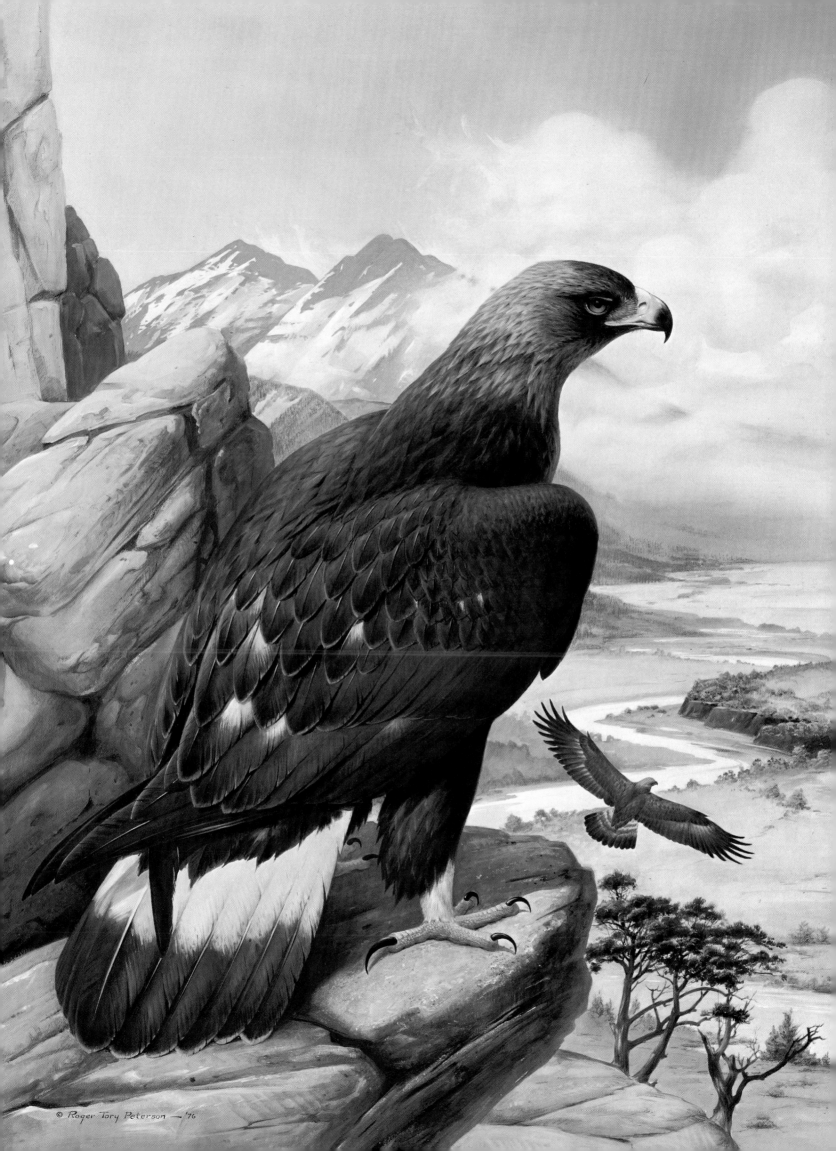

© Roger Tory Peterson — '76

Today in Jamestown, there is a Roger Tory Peterson Nature Center and plans for a projected Roger Tory Peterson Institute. But the former nonconformist found his course only after Ms. Hornbeck pointed the way. After that first drawing of a blue jay (copied from a Louis Agassiz Fuertes colorplate), Peterson became increasingly absorbed in drawing, eventually including butterflies among the birds. Soon he had decided he wanted to be either a biologist or an artist. High school in Jamestown offered good art courses; "I excelled at mechanical drawing and design. But I argued with the biology teacher and got poor grades in that subject. I wasn't much good in English, either, except for poetry, and I was terrible at shop. But in mechanical drawing and history of art, I was the best in the school. After graduation at the age of sixteen, I had the choice of a job as a draftsman or as a furniture decorator. Furniture decorating seemed more fun. Soon I was decorating liquor cabinets with Oriental designs. My boss thought enough of my work to suggest I go to New York City for art education, and I took his advice."

At the age of seventeen, Peterson attended a convention of the American Ornithologists' Union in New York. While there he managed to show some of his drawings to the revered Fuertes, who rewarded him with encouragement and a red sable brush as a memento. "I never cleaned the bit of white paint I found in the hairs," said Peterson. "That brush was the stuff of which dreams are made."

In New York Peterson worked part time at decorating furniture while attending classes at the Art Students League. "I studied with John Sloan, who influenced my use of color. But Kimon Nicolaides was the most influential teacher I ever had." After two years at the League he was admitted to the National Academy of Design. "When I switched from the League to the Academy, it was because I felt the realistic academic approach was best for a naturalist." Peterson studied at the Academy for three years, continuing to decorate furniture to support himself, "until the Great Depression came," he says. "Then I went back to Jamestown. In 1931 I got a job teaching art and natural history at the Rivers School, a boys' prep school in Brookline, Massachusetts.

"It was then, during the depth of the Depression in 1933, that I completed my first *Field Guide to Birds,* a project suggested to me by my friend Bill Vogt, first editor of *Audubon* magazine, a pioneer conservationist, and author of the best-selling *Road to Survival.*

"Four New York publishers turned down the *Field Guide.* Then Houghton Mifflin in Boston decided to take a chance on it, but in a very small edition in case it didn't sell." The edition of two thousand sold out in a few days, and the rest became history.

Says Peterson, "Originally I thought I might become a commercial artist with wildlife as a sideline, because I never expected to be able to make a living at painting wildlife. Yet I always had felt the need to be outdoors and to take trips. I can't help painting wildlife."

In painting birds, Peterson believes that the greatest problem is that so many birds are patterned to blend into their environment for protection. "The painter attempts to do just the opposite, to show the contrast of the bird against the background. Even Fuertes had trouble with this. Because

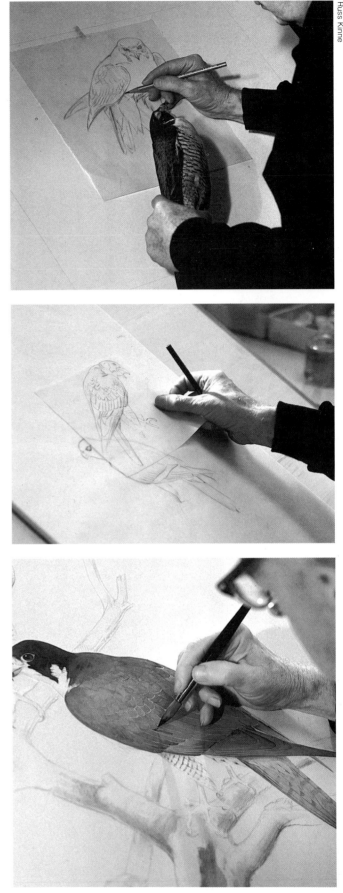

*Peregrine Falcon*
Watercolor and acrylic, 30¾" x 24½" (78 x 62 cm)
Private collection

Field sketches come first for Peterson, but he also examines study skins to get specific proportions and details of the birds in his paintings. Heads are particularly important—he may draw one several times before deciding which one to use. He makes dozens of drawings of the birds on tracing paper, cuts them out, and assembles them to determine the final composition. When he is ready to paint, he builds up washes slowly in the traditional English watercolor method. Later, he may use acrylic washes over the watercolor.

© Roger Tory Peterson -'77

©Roger Tory Peterson '74

birds fit so well into the environment, you could wind up with zero. One can paint either objectively or impressionistically, with light and shadow, or more intellectually, delineating what you know is there but may not see. That was Audubon's method. Delineation can be very good, if really accurate, but it is not necessarily good painting. There are two extremes in realistic painting: impressionistic and intellectual. I'm a hybrid. I don't do ultra detail. Right now, my style is going in the direction it should have gone in the first place—to the painterly, three-dimensional, and away from the schematic drawings of my field guides. Lately I've done more Audubon-type paintings—delineating the bird on an open white background. Incidentally," says Peterson, who has just completed a large book on Audubon, "when Audubon put in backgrounds to his birds, many were done by his apprentices. One of the best was Joe Mason, a fourteen-year-old kid."

Of his own current work with backgrounds he says, "My style is going toward corner-to-corner, environmental, painterly painting." Pointing to a painting of grouse against a background of leaves and ferns, he says, "I can only judge one of my own paintings two years later. I'd like to work on several paintings at one time in different stages. My style has not reached where I want it to go. I'd like it to go more in the direction of Robert Bateman's work." Peterson recently wrote the foreword to a book on Bateman's art.

It is his plates in the field guides that have made him famous. Peterson explains that he evolved the simple system for identifying birds by discovering that most species can be identified by two or three unmistakable marks. "It was my own approach," he says, "based on visual rather than technical descriptions. I believed it could be done with all birds."

From this educational approach to showing birds, Peterson now would like to appeal to a more advanced audience for the art of bird painting. "Each bird is different," he says, "and what I look for is the basic stance or 'gestalt' of a species. For this it's necessary to go out and look at a lot of birds. For some species, zoos are good." His painting of a snowy owl was partly done in a zoo in Copenhagen. "The rest of it was from what I know about this owl." That knowledge comes from a lifetime of studying birds. "Back in my student days," he says, "I went to the Bronx Zoo on payday when fewer people were there. I'd sketch some of the same birds over and over again, especially the great horned owl and the shoebill stork, because they would stay still.

"But most birds won't stand still, and I discovered that one must develop a very good memory, nearly photographic in fact. At times I have used living models such as an injured bird that is being cared for. I go both to zoos and into the field. Zoos are marvelous because they have some birds you can't see otherwise. No matter the model, I always check the details with an actual specimen. I borrow many of my specimens from the American Museum of Natural History in New York."

Left
*Great Horned Owl*
Watercolor and acrylic
34" x 26" (86 x 66 cm)
Private collection

Above
*Snowy Owl*
Watercolor and acrylic
40" x 30" (102 x 76 cm)
Private collection

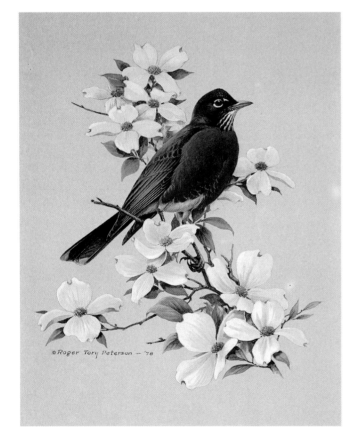

In the field Peterson makes good use of powerful binoculars for those fleeting and memorable glimpses. "I use ten-power and even twelve. Fortunately I have very steady hands. I'm going to acquire a Questar, usually used for astronomical purposes. It will pull a shorebird or gull nearly into your lap. I never stint on equipment."

On the other hand, Peterson learned never to rely upon taxidermy, although he does use study skins of birds. "Taxidermists make mistakes," he says. "But mounted specimens sometimes can be helpful for such things as foreshortening. This is particularly so when drawing mammals. Modeling is also good for learning anatomy."

In search of his birds, Peterson has traveled to every continent of the world. He has even visited all of them in one year's time, including the Antarctic. "I like to spend four months of every year in the field," he says. "I've been in the Antarctic fifteen times. I should be painting a lot of penguins." In fact, he is known among birders as the "King Penguin."

While in the field, Peterson does a great deal of photography, particularly of habitats—settings, branches, water, and special settings for weather. "I do a lot with my camera or a quick pencil sketch," he says. With the pencil sketch he uses a chart of color values, coded by numbers. Peterson and his wife, Virginia, now spend two months of every winter in Florida or some other suitable place. "I sketch there with a color box," he says.

Of the thousands of photographs he takes, Peterson says, "I never copy from them. They are only split-second records of momentary things. Sketches are more suggestive of what the eventual picture might be. With a sketch you can get rid of the clutter of a photograph; the sketch really shows more the essence of the subject. But photos are important as memory jogs." Peterson uses Nikons, owning seven of them, and two Hasselblads as well. "I must have a hundred thousand transparencies, ten thousand of penguins alone," he says. "Even a poor one may spark an idea. They may show how a foot is held, a beak is turned, and so on. Peterson himself has taken every one of the photographs he keeps on file. "I never use another's photograph, only my own transparencies. But I don't paint directly from them." The photographs and the materials in his large library on natural science all "go into the computer of my brain. I want to know the works of other artists, but I never copy them. I don't want to risk repeating their mistakes."

Peterson works in a studio near his home in Connecticut. The studio building contains two individual workrooms, one for his wife, Virginia, who created all the maps showing the ranges of species in the 1980 updated *Field Guide to the Birds.* Formerly, as a research chemist, she helped the Coast Guard develop infrared spectroscopy methods for identifying oil

Top
*Mockingbird*
Watercolor and acrylic
21" x 17" (53 x 43 cm)
Private collection

Bottom
*Robin*
Watercolor and acrylic
19" x 16½" (48 x 42 cm)
Private collection

Right
*Rose-Breasted Grosbeak*
Watercolor and acrylic
22½" x 19¼" (57 x 49 cm)
Private collection

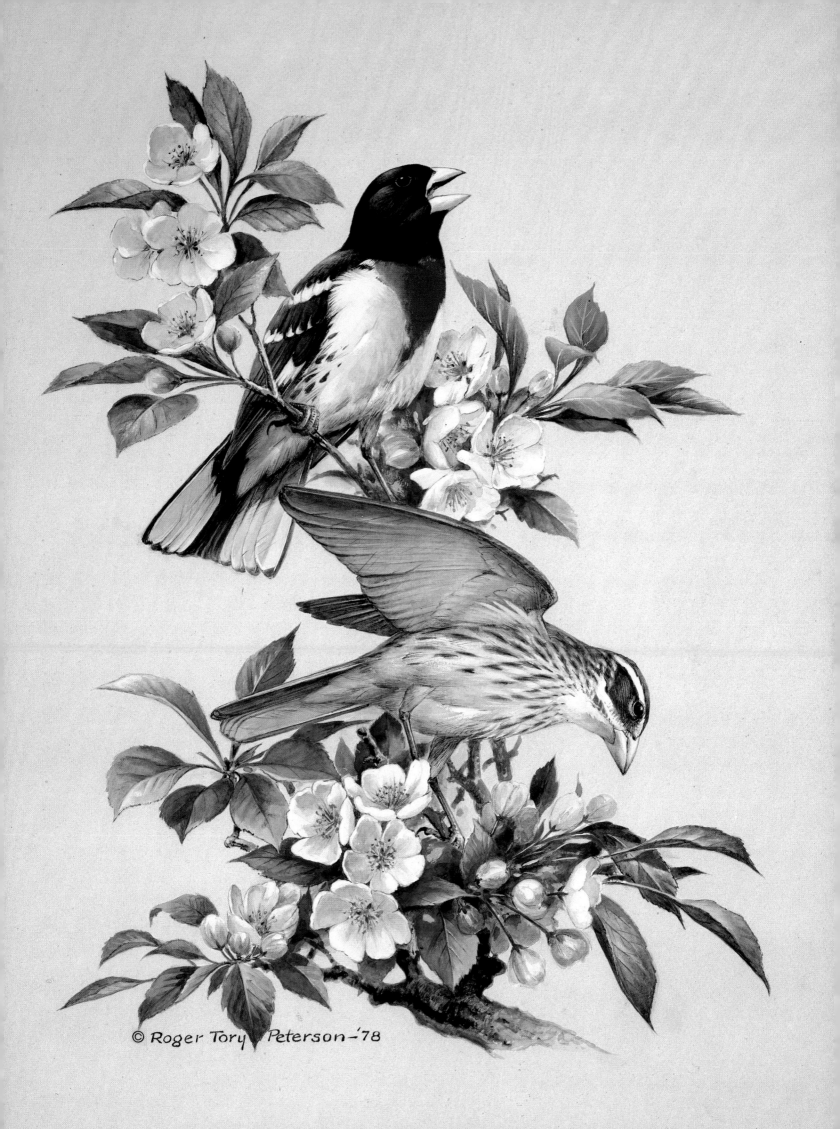

© Roger Tory Peterson-'78

spills. Her maps have helped make the third updated edition since the original 1934 classic such an innovative addition to the knowledge of birding.

In Peterson's own spacious, well-lighted studio, large windows face north and south with a skylight overhead. "I don't really need north light," he says. "I just need maximum light and make use of fluorescents as well." His new easel is a swivel model that converts to a drawing table. On it are tissues with drawings of egrets, pelicans, and other Florida-based birds. To the right is his tabouret with his watercolors and acrylics, sorted by color. Jars hold large bristle brushes and smaller sables, along with some synthetics with which he likes to experiment. "I'm always experimenting," he says, pointing out the large flat brushes and the tiny, extremely fine ones.

In a separate closet, shelves hold Masonite boards; papers are in carefully labeled built-in drawers. Photograph files in the studio are in the process of being set up according to a new system of quick retrieval with the help of Peterson's assistants, Chuck Schulze and Kerry Pado. Files hold all birds sorted by species, photographs of habitats, and folders of scrap material cut from magazines and other sources. Bird files are color-keyed: green for North American, red for foreign. Says Peterson, "I also want to do mammals—polar bears, zebras—but I'm always tempted to put a bird in the composition." Near the double studios is a good darkroom and an Artograph, used for scaling Peterson's drawings to

Below
*Ruffed Grouse*
Watercolor and acrylic
32″ x 38″ (81 x 97 cm)
Collection of the New Britain
Museum of American Art

Right
*Ring-Necked Pheasant*
Watercolor and acrylic
27″ x 38½″ (69 x 98 cm)
Private collection

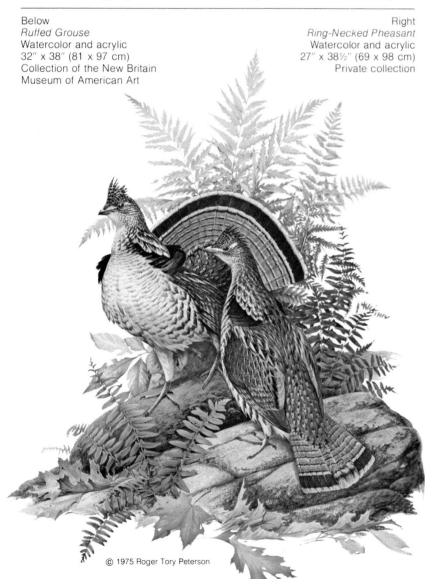

© 1975 Roger Tory Peterson

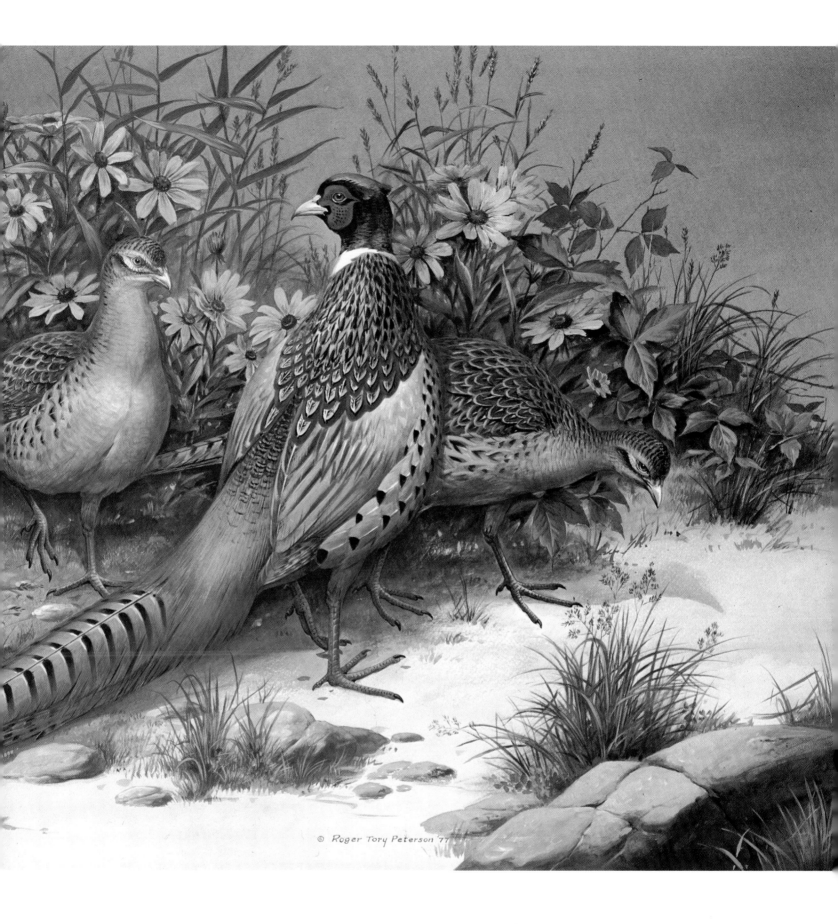

© Roger Tory Peterson '77

© Roger Tory Peterson — '73

size. Peterson formerly did his own enlarging and developing. On the walls hang clear plastic envelopes, reminders that Peterson's life is closely concerned with editing and publishing his famous *Field Guides*. The envelopes hold pages from his books in the process of being updated, page by page.

Over the years Peterson has made several 16mm movies for lecturing and film presentations. Some of the films provide ideas for paintings as well. One film is on East Africa; another is the ABC film on Peterson, called *Birdman*, written by his friend the naturalist Roger Caras. In a series of drawers he keeps a collection of study skins of birds—quail, hawks, sandpipers, plovers. One loggerhead shrike skin is labeled "1881, Rosewood, Florida." Many of the specimens were collected more than one hundred years ago. "I have permission to keep these skins," he says, "and I can always go to the American Museum of Natural History to borrow others."

Another series of drawers is filled with Peterson's slides, filed by species—golden eagles, eagles of Europe, and several drawers full of penguins taken by the King Penguin himself. Peterson remarks that his wife, Ginnie, "is known as the 'Wood Thrush,' because she sings well and must keep out of the sun."

Looking at the files and equipment for maintaining organization, Peterson remarks, "Most artists, including myself, may seem disorganized, but their work is one of complete organization." He is hoping to get his own files so well organized that his plans for updating two or more of his books, plus his desire to write at least five new ones, can proceed without interruption.

When he works on a painting, Peterson often uses his slides as references for preliminary drawings in pencil on tracing paper. They are mostly in outline to establish patterns and develop a concept. "Sometimes I do thirty or forty sketches of one subject. Then I'll cut out the drawings with scissors and form the design. But it may not be to size, so I'll trace them off and enlarge them or make them smaller mechanically. Then I proceed to perfect the drawing. I used to work on Whatman board, but now I work on Masonite coated with three or four applications of gesso. This is a newly developed medium for me. It is possible that I will do future paintings entirely in acrylics. I can always redo a passage. I may overpaint with oil over the acrylic to make it 'juicier.'

"Now I'm mostly using acrylics. You can do so many things with acrylics. They dry the same color as when wet. All my recent paintings have been in watercolor or gouache with a little acrylic. I might isolate a shadow with acrylic medium and then give it a glaze. More and more I'm working with all three—transparent watercolor, gouache, and acrylic. I'm not a direct watercolorist. I like to build

Left
*Barn Swallow*
Watercolor and acrylic
20" x 20" (51 x 51 cm)
Collection of Mrs. Edmund McGibbon

Top
*Scarlet Tanager*
Watercolor and acrylic
22" x 18" (56 x 46 cm)
Private collection

Bottom
*Bluebird*
Watercolor and acrylic
19" x 16½" (48 x 42 cm)
Private collection

Left
*Flicker*
Watercolor and acrylic
18″ x 18″ (46 x 46 cm)
Collection of Mr. Edward H. Tabb

Below
*Puffin*
Watercolor and acrylic
22″ x 33″ (56 x 84 cm)
Private collection

Right
*Baltimore Oriole*
Watercolor and acrylic
18″ x 18″ (46 x 46 cm)
Collection of Mr. Jack E. Moermond

Bottom right
*Roadrunner*
Watercolor and acrylic
26¼″ x 35″ (67 x 89 cm)
Collection of Philip Morris Co.

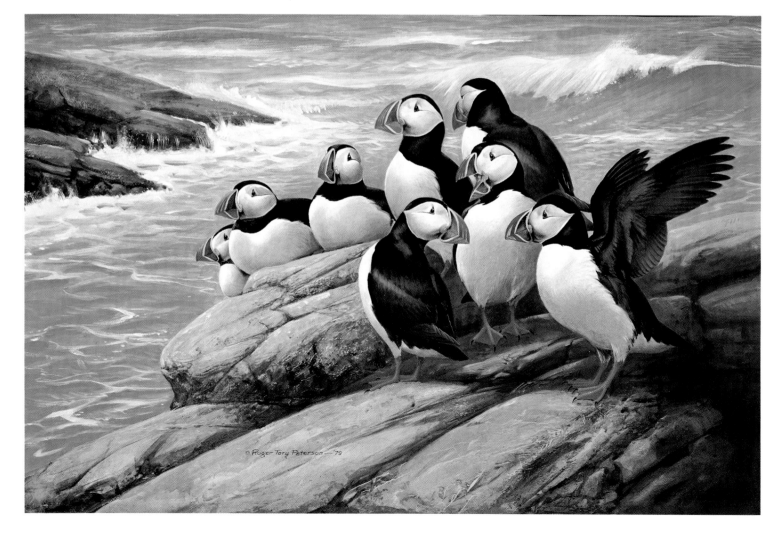

things up, wash by wash, in the old English style." Many of his early sketches in the field were done solely in transparent watercolor. "It's quick, but the final painting is always watercolor and acrylics. I plan to try oil over acrylics. I'm still looking for the perfect combination.

"I don't have a basic palette," Peterson says, "so I put out at least a dozen colors and mix them, and then overpaint. A bright red will be underpainted with yellow, as I do with the scarlet tanagers. I'm still working on new ways to use color."

His compositions are undergoing experimentation as well. "I'm becoming more and more asymmetrical. In the past, my main subject was usually on one side of center or the other, looking into the picture. Now I'm striving more for basic patterns and abstract design. I try to start with a good concept. The subject is always dominant, like all Audubonesque portraiture, but there is always design to it."

One of his paintings of a group of quail is on the wall. Of it Peterson says, "There are five quail. The fact that quail group themselves in a tight form saved the painting."

Peterson's years as a naturalist and artist have brought him ever more zest to continue in new directions. His fascination with wildlife as a subject for art appears to be just beginning, although he has been working at it for most of his long life. His advice to others interested in the pursuit of wildlife art is based upon his own experiences. He says, "Go into commercial art if need be and paint wildlife on the side, or work as a preparator in a museum. But if you go the academic route in the biological sciences, that may prove to be a trap. I know several natural scientists who would have become successful artists, but never got free of the academic rat race. If you must make a living, have more than one string to your bow. Learn the techniques of art in all subjects."

Peterson himself plans to live until at least 110 in order to realize some of his ambitions relating to publishing and painting. He says, "People think of me as a biologist and a birder. I like to think of myself as an artist and a teacher who uses visual methods." He is particularly proud of having been the teacher singled out by one student, former U.S. Attorney General Elliot Richardson. Richardson selected Peterson as the 1974 recipient of the Golden Key Award, an honor given each year by the country's educators to the teacher who helped shape the career of one of the nation's leading citizens. Said Richardson of Peterson: "He gave me my senses—the eye, the ear, the hand."

*Blue Jays*
Watercolor and acrylic, 22" x 28" (56 x 71 cm)
Private collection

# MAYNARD REECE

A lifetime wildlife artist, Maynard Reece began his career before World War II and has since collected more awards than perhaps any other known wildlife painter. Yet now, after more than forty years of studying and painting waterfowl, among other subjects, Reece still begins every fall season with a trip to Hudson's Bay to watch migrating ducks and geese. "I watch them," he says, "all the way down to Louisiana and Texas, traveling by car and plane from September to January."

With sketch box, binoculars, and camera, Reece spends more than half his time in the field in pursuit of perfection. For him that perfection belongs to nature. He says, "I'm trying to put a part of nature together, and put it together so that people will respect it."

It is partly because people have begun to respect imperiled nature more that Maynard Reece's faithful depictions of its vanishing beauty have been acclaimed, collected, exhibited, reproduced, and awarded no fewer than five Federal Duck Stamp prizes, the most ever won by any artist. Reece has traveled to the Arctic and Antarctic, to Europe, Hawaii, New Zealand, Australia, and Africa. Yet his paintings reflect most of all his early childhood environment in Iowa, where he was born in Arnolds Park, the son of a Quaker minister, and where at the age of eleven he began drawing ducks and deer. "Northwest Iowa was one of the big waterfowl migratory areas of the country," says Reece. "In those days the whole of the area was marshlands and wetlands. Later they were drained by the farmers, so now there is only a fragment left of that once teeming wildlife habitat."

As an aspiring young artist, Reece had no opportunity for formal study. "I went to rural schools with no art classes," he says. "My seventh-grade teacher saw I had interest and talent, and she showed me what watercolors are and how to use colors. She was my first teacher." Following the fortunes of his minister father from one small town to another, Reece attended high schools without the benefit of further art training, except his own observations and constant sketching and painting. After graduating from high school, he worked

Above right
Preliminary sketches
for *Dark Sky—Ruffed Grouse*

Right
*Dark Sky—Ruffed Grouse*
Oil, 24" x 36" (61 x 91 cm)
Collection of Mrs. Maynard Reece

144

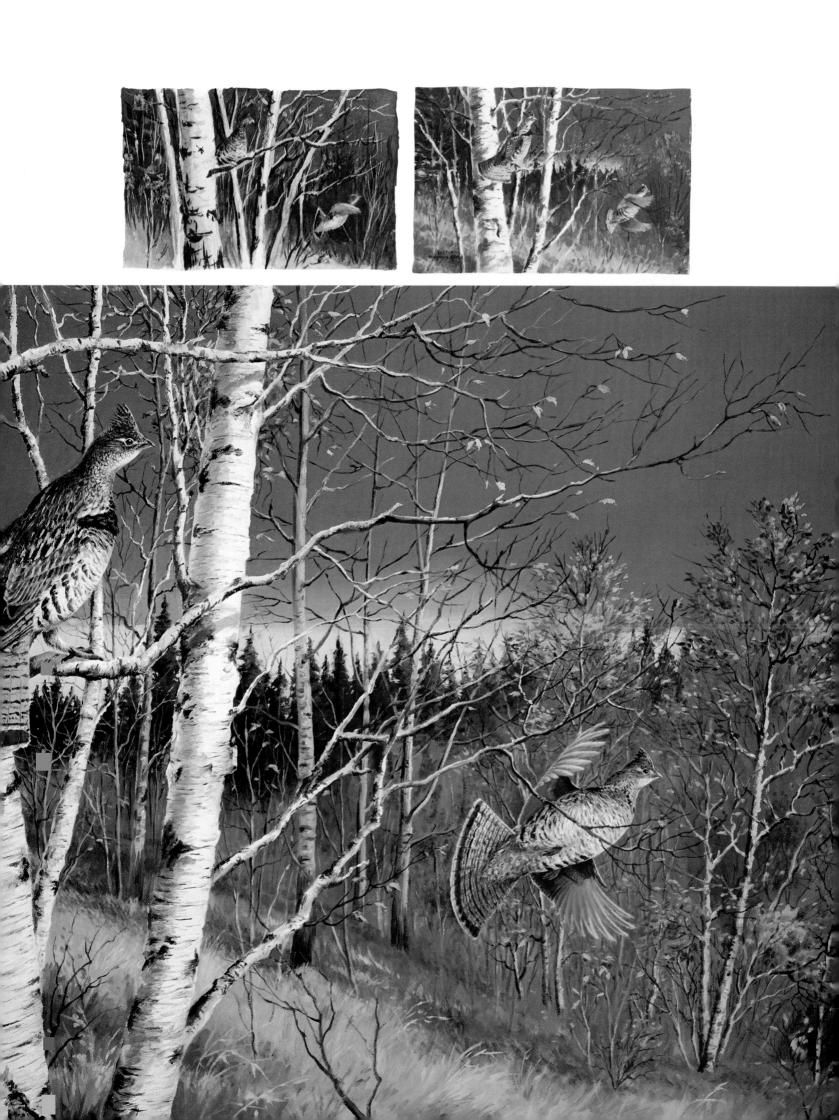

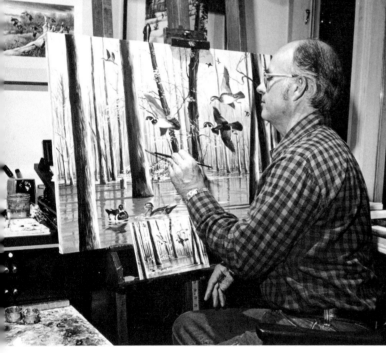

Top
Reece sketching in the field,
using the wooden sketch box
given him by James Perry Wilson.

Bottom
Reece painting in his studio,
using a field sketch as reference.

Opposite
*Early Spring—Wild Turkeys*
Oil, 24" x 36" (61 x 91 cm)
Private collection

Reece first pencils in the outlines of trees, birds, horizon line, and
hills. He then paints the birds, paying little attention to detail; at
this stage he is merely establishing the black look of the toms and
the brown of the hens. Next he blocks in the background, except for
the trees; they are roughed in at the next stage to create the silhouette
pattern. Reece then adds the limbs, twigs, and smaller trees, to
give the feeling of heavy cover, and adds more detail to the birds.
Finally, he paints the flowers, dead leaves, critical details on the birds,
small twigs, and a few green leaves. He balances the color values,
keeping the strong early-sunlight contrast between light and shadow.

in the Iowa Museum of Natural History in Des Moines and
while there met one of the major influences of his early art
career in the person of J. N. "Ding" Darling, the renowned
political cartoonist. Darling encouraged Reece and urged
him to continue daily sketching and drawing as the best way
to hone his skills. Then Reece landed a job with Meredith
Publishing in Des Moines, where he also learned the secrets
of commercial art, including paste-up, spot drawing, and
airbrushing.

"I was learning as I worked. The art director took me in
hand and tutored me." Meredith Publishing owned *Better
Homes and Gardens, Successful Farming,* and Prentice-Hall, a
book publisher, but after two years as a commercial artist,
Reece decided against publishing as a career.

Instead, he went back to the Iowa Museum, this time as
staff artist and assistant museum director. "There I was
working with men who were experts in the field. The state
library was housed there, and I absorbed all the books about
zoology and biology. You need a solid background in science
somewhere," he says, "and that's where I got it." He began
doing some free-lance art, mostly, but not only, natural
history. "You can get in the front door or the back door, but
you have to get training somewhere—in both natural history
and art. You must somehow know the intimate habits of
wildlife. I was always interested in painting wildlife. At the
museum I learned taxidermy and began to study in the
field." His first book of watercolor painting and scratchboard
drawings, *Waterfowl in Iowa,* was published in 1943.

Even his service in the army during World War II provided
opportunities for his art and for studying animals. In 1943 he
was stationed in Sacramento, California, and spent his spare
time sketching the wild birds that flew in. "I would sketch
them while they were feeding or drinking, resting and
swimming. I also sketched at the zoo in San Francisco and
other zoos, but I've always preferred to do fieldwork with
wild animals. Zoo animals don't look quite the same as those
in the wild. Some of the tamer birds get too fat. If you can't
get out to see wild animals, zoo or stuffed animals are next
best—but with stuffed animals, you are at the mercy of the
taxidermist's mistakes. I can tell at one glance whether
someone has painted from life, stuffed, or frozen. Inciden-
tally, a frozen animal is next best to a freshly killed one
because its limbs are still flexible."

After a year in Sacramento, where Reece did visual train-
ing aids for the Army Signal Corps with hand lettering that
"was wonderful discipline for steadying the hand," he was
transferred to the Signal Corps in Red Bank, New Jersey, for
six months of training before being shipped overseas. While
in Red Bank he spent every weekend of leave in New York
City at the American Museum of Natural History, where he
met Francis Lee Jaques, noted background painter of the
museum's famed dioramas; artist James Perry Wilson; and
ornithologist Dr. James Chapin and Dr. Cushman Murphy.
"They were an outstanding group of well-known natural
scientists and they took me under their wing," recalls Reece.

The fledgling artist then took off for England and France to
spend the rest of the war sketching and learning about
wildlife art. Reece says, "I didn't want the war or the army to
keep me from learning my craft. I sketched every chance I
got in London's game markets and in the field in Scotland. I

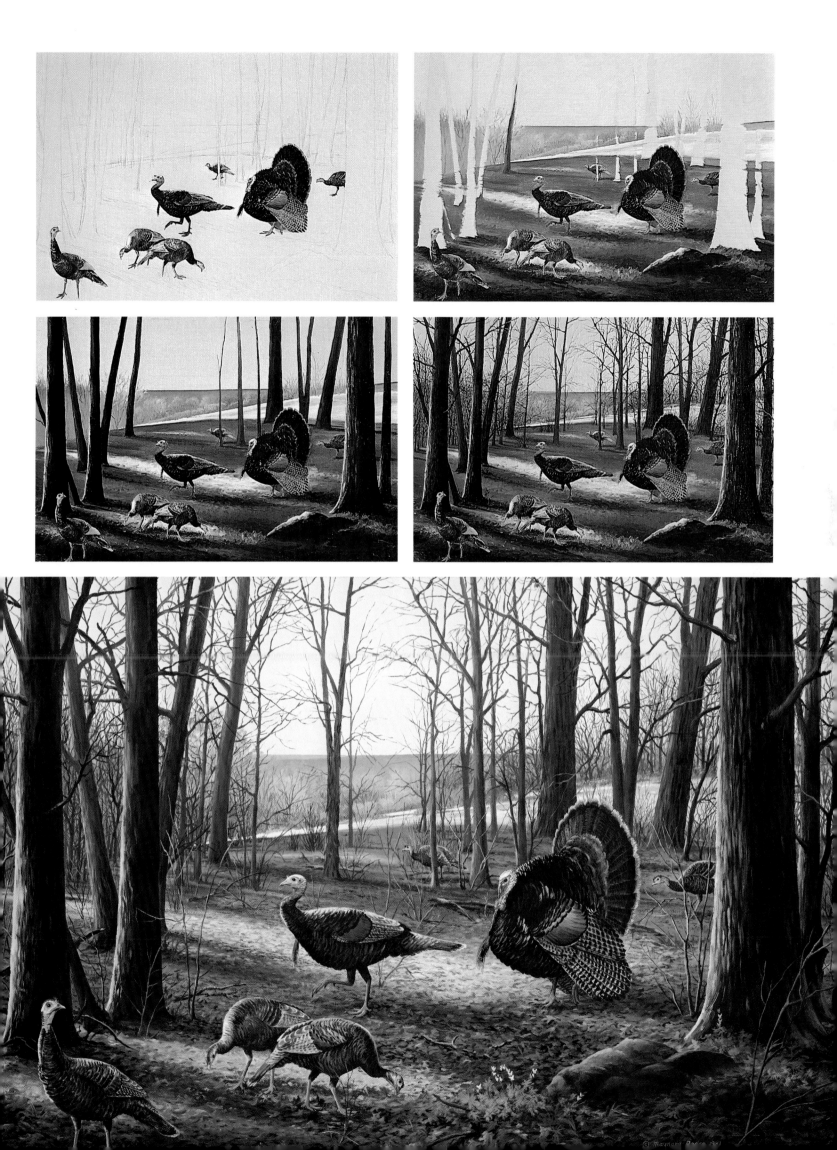

had sketchbooks filled with black-and-white drawings of game, of oxen and carts, and of buildings." His sketching was interrupted finally by training for infantry duty at the front. But before he could put it to use, the European victory had been won and Reece returned to his native Iowa and his job at the Des Moines museum.

Shortly thereafter, Reece met and married his wife, June, an art major and designer. Reece reminisces about their early married days: "I was working for ninety dollars a month and we were paying forty-five dollars a month for our apartment. June worked, too, and sewed all her own clothes." In addition to his job, Reece worked late into the nights at free-lance assignments. By 1948 he won the first Federal Duck Stamp Contest, and by 1950 his free-lance career was so successful that he felt he could devote full time to it. His former employer, Meredith Publications, became one of his major clients, and he did illustrations for *Successful Farming* and *Better Homes and Gardens.* He also did work for *Outdoor Life* and *Sports Afield.* His love of fishing led to illustrating a book for the Iowa Conservation Commission, *Iowa Fish and Fishing,* as well as *Waterfowl in Iowa.* Reece also traveled to New York for assignments from the *Saturday Evening Post*

Reference sketch of the head of a sandhill crane

and to Washington, D.C., where he met Roger Tory Peterson, who was then art director of the National Wildlife Federation. Besides doing illustrations for the magazine, Reece also received commissions from Peterson to do illustrations for wildlife stamps.

During this period he worked entirely in watercolors, chiefly gouache, and used the airbrush for some of his backgrounds. He won his second Duck Stamp Contest in 1951, after which more free-lance assignments culminated in a major one from *Life* magazine, then in its heyday of popularity and prestige. "I did a series of fish classifications for *Life*," says Reece. "In 1955 I did 'Fresh Water Fish,' then in 1957, 'Salt Water Fish.' I gave up all my other work to do that, and it was a big mistake. By the time the two years were over, other publications considered me to be a *Life* artist and would not give me work. I never permitted myself to be exclusive with anyone after that."

After a brief time, however, the other publications returned and Reece did illustrations for *Sports Illustrated* and *Ducks Unlimited.* "I was making a living, but I was also learning about natural science, about plants and animals." He had done botany studies for *Successful Farming* and for

Top
*Rough Water—Canvasbacks*
Oil, 24" x 36" (61 x 91 cm)
Collection of Mrs. Maynard Reece

Bottom
*The Sentinel—Whitetail Deer*
Oil, 24" x 36" (61 x 91 cm)
Collection of Mr. Mark Reece

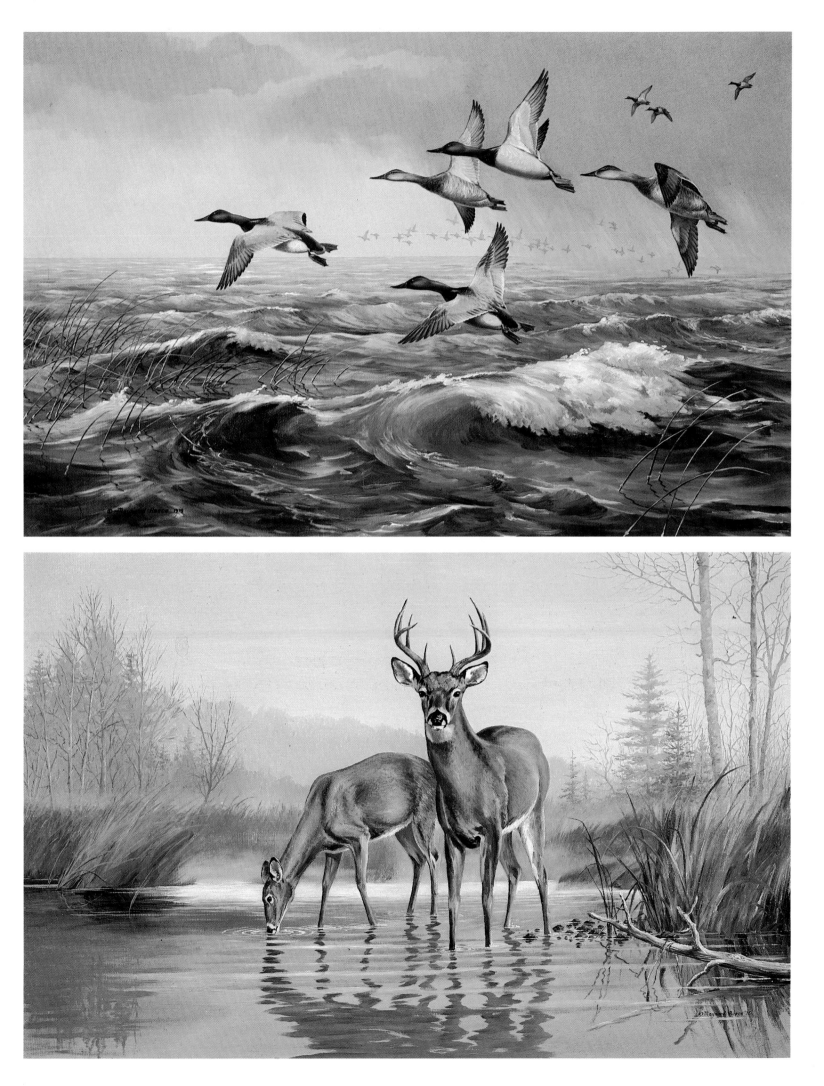

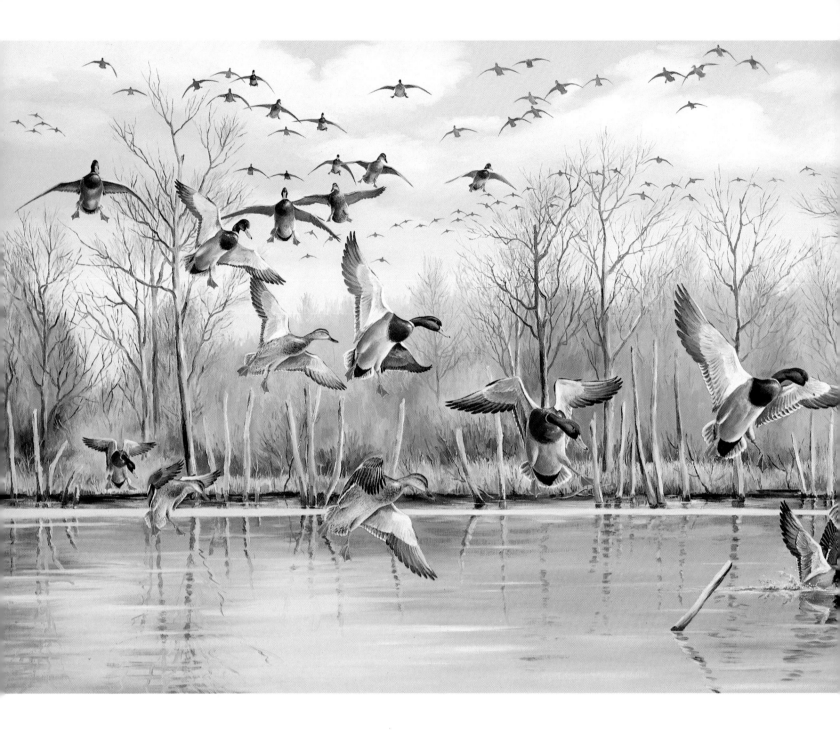

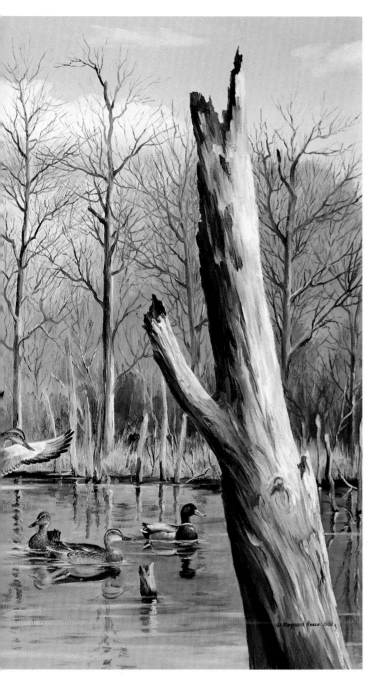

*Country Gentleman.* "I did a lot of plant things, so now when I put plants in wild waterfowl paintings, I really know them. To me, it is all part of my one aim, which is to become a good artist. To me, Winslow Homer is one of the greatest, and I especially like the power of his marine scenes. Rosa Bonheur's *Horse Fair* never ceases to amaze me for the anatomy and the lighting."

In the early 1960s, the country became interested more than ever in conservation of wildlife, and the great demand for fine prints of wildlife art began. "All at once," says Reece, "I couldn't keep up with the demand."

In 1959 Reece and his wife bought wild timberland acres several miles from the center of Des Moines and cleared the land for a stunning hillside house and studio, designed by a modern architect and decorated by June Reece. The couple's two sons had been born in 1953 and 1955, and the house was designed to accommodate the close-knit family in comfort, allowing Reece a separate area for his work that was at the same time in close touch with the rest of the house. Facing due north, the studio is a long, narrow work place about 8 by 22 feet (2½ by 7 m). The built-in table faces 256 square feet (24 m²) of double-height window looking out on timber where squirrels, moles, and birds provide the action. Designed for Reece's left-handedness, his drawing table is at the narrow end of the room. Behind the window is the balcony, atop which is the family living room. The 16-foot (5-m) wall leading up to the balcony—living room is filled with Reece's paintings and functions as a viewing gallery. Beneath the 12-foot (3½-m)-long studio table is a tabouret. Ample storage facilities are built in along the rear wall, where everything is within easy reach, including file drawers filled with study skins of birds and animals collected by Reece, who has a special permit from the museum to do so. "They are not the usual stuffed animals," he says. "They are only stuffed with cotton. I prepare the skins myself. It's a form of collecting reference material. The skins are readily available for instant reference for color and markings of feathers and fur."

For all that Reece is best known for his paintings of waterfowl and other animals, he says, "I'm basically a scenic artist. I'm as interested in habitat as in birds. I'd enjoy painting if I never had a bird in the picture." He has now reached the enviable position of being able to do just about as he pleases. "I do very little illustration," he says. "Mostly I sell my original paintings or my prints through Mill Pond Press, except for an occasional magazine cover, such as for *National Wildlife.* Even though I can paint what I want now, I still feel it must be truthful to nature. But it is also true that now the public will accept more sophisticated approaches to wildlife art. I try to learn from all good artists, including abstract ones. After all, good design is the basis of all good painting and is important to all art. I've spent a tremendous amount of time in the Louvre in Paris. I love studying the play of light and the dramatic use of light and shadow. You can learn a lot from in-depth study of museum masters. You'd be dumb not to take advantage of the things these people have done." Reece was especially inspired by the

---

Top
*Diamond Island—Mallards*
Oil, 34" x 66" (86 x 168 cm)
Private collection

Bottom
Reference sketches
of the head and foot
of a mallard

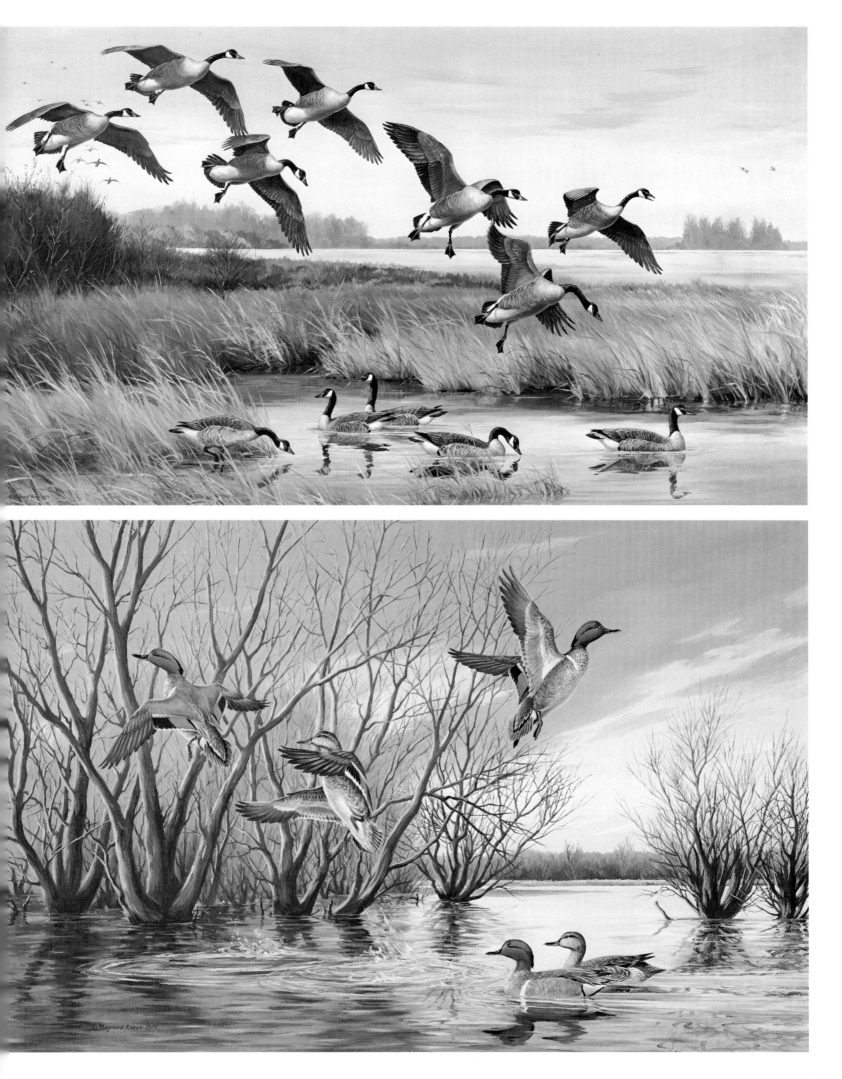

work of Michelangelo and of Rubens. Of Rembrandt he says, "I've gotten a lot of good from studying his use of light and shadow. It can be adapted to the study of marshes as you wouldn't believe! Because of my interest in lighting, I spend more than half my time in the field looking for unusual contrasts of lighting in nature."

The problem of lighting is to Reece one of the most important in wildlife painting. For many artists who begin rendering faithful representations of animals for scientific journals, the next step into full-scale landscape-with-animal paintings presents the challenge of dealing with local color. Says Reece, "You work with local color—the color of a feather is the color of the feather—but if you work atmosphere in a landscape with dramatic lighting conditions, say with red and yellow highlights, then how far do you go with color? Do you keep it to the color it would be in a north light, or do you change the color to reflect the reality of outdoor lighting? You have to make that decision. And that's the problem."

Concerning his evolution from scientific illustrator, Reece says, "I did a lot of detail. Now, as I go along, I try to eliminate detail. After all, it's not the criterion—it's a means to an end. I'm not literally painting feather for feather. You don't really see every feather. You don't see every hair in a mammal. I'm after the thing as a whole. I go for the light and for the shadow and the mass."

Painting waterfowl in natural habitats provides abundant opportunity for this artist to experiment with design and with light and shadow. He claims that he paints waterfowl mostly because he loves water so much. "I can spend my time solving problems of moods of water, storms, sun, and reflections." Most of his ideas come from spending time outdoors observing nature, whether it's driving through Nebraska in the setting sun, or walking by chance by a couple of trees that he has passed for years. "I walked by two trees in the fall of the year for the past five years. Then, one year, I noticed the snow on them and slightly different lighting. I thought, 'Why not do a painting of quail with those trees?' It hadn't been done before. I wondered why I had not noticed it until now." The result was one of his more dramatic paintings, *Winter Covey, Bobwhites,* a 36-by-60-inch (91½-by-152½-cm) oil he completed in 1978. Dark skies suggested an entire series based upon his observations of a dark sky with light against it.

Observation of landscape and dramatic lighting sparks most of his ideas for paintings. "I look for the setting first," he says, "then look for the animal that would likely be there. I have great respect for nature, and I don't want to cheat or misrepresent, so I would never put the wrong bird in a habitat just because the color would be right. Certain birds are best in certain color schemes, and I decide which birds

Top
*The Quiet Place—Canada Geese*
Oil, 36" x 60" (91 x 152 cm)
Private collection

Bottom
*Sunrise—Green-Winged Teal*
Oil, 24" x 36" (61 x 91 cm)

Right
Reference sketches of ducks

153

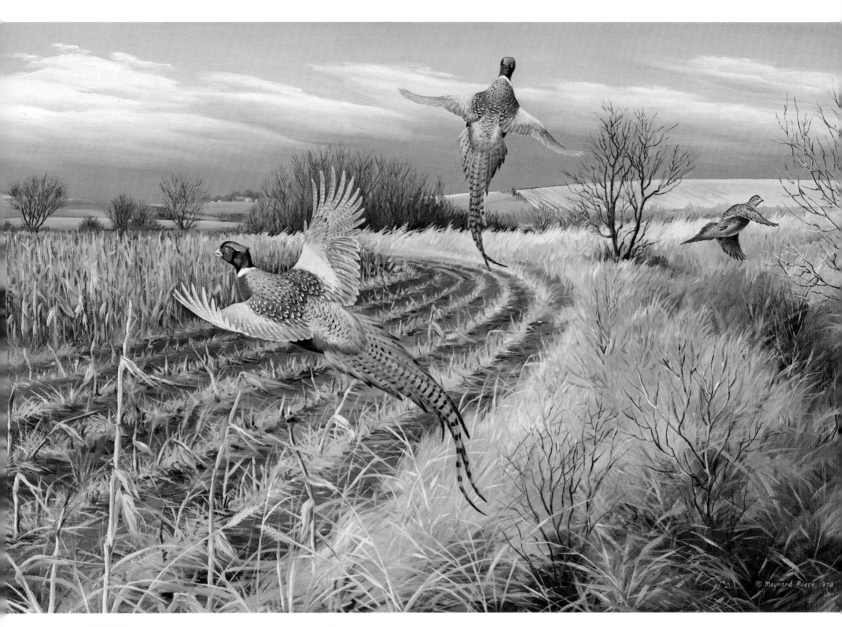

William N. Hopkins

will work best with which scenes. For example, canvasback ducks with white underbellies look wonderful against dark skies, or the mallard ducks which have a flash of white under their wings. I get very intimate with characteristics of each animal. But, above all, habitat governs selection of the appropriate animal. Although I start with the animal, my paintings are more habitat than animal. If I start with a mallard, I know they fit several habitats, so I decide which one I want. But some ducks are to be found only in one habitat. Sea ducks are seen only on the ocean; others are found only in marshes; still others, in large bodies of fresh water. The ducks are adapted to their habitats. Puddle ducks, which feed by tipping up in shallow waters, are surface feeders and are found in shallow-water areas, whereas diving ducks can go into deeper waters.

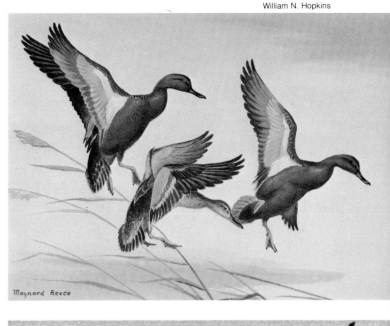

"It is important to know the intimate habits of birds. The ways they land depend on wind conditions. Birds landing in heavy timber must generate a lot of action in head, tail, and wings to land upright since there's no wind resistance in timber to work with. In open marsh, with adequate wind, they can coast in with hardly any body or wing movement. It's important to know that waterfowl always land against the wind. People can tell when an artist is not knowledgeable about their favorite animals. It is important to know that some ducks can dodge through timber whereas others are less maneuverable so would never be seen in heavily wooded areas. You learn that wood ducks have broad wings to help them maneuver in their woodland environment, whereas mallards cannot manage that well, and you would never put a canvasback in a wooded area. They are strong, fast fliers, but have hardly any tail for maneuvering. They are more like jets, whereas the wood duck is more like a helicopter, able to fly at forty miles an hour directly into wood holes, braking instantly. Each species has different characteristics and life-styles.

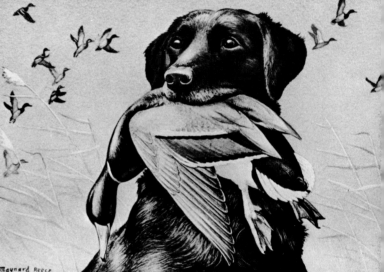

"Accuracy is most important. You don't paint seven fingers on a human hand. It's just as important to know the individual shapes, proportions, and colors of each species of waterfowl." Reece also relies upon printed materials for accurate information. "I have a better library of natural-history books than the library does," he says. "I use reference books to learn the range the birds have so I'll know if I'm going to see a bird in a particular spot."

When Reece makes his annual migration to study the habitats of waterfowl, he takes along his binoculars ("I use six- to seven-power; eight is too strong") and his high-speed Leicaflex camera with telephoto lens to study birds in motion, including their wing movements and the way their muscles show. He says, "I never use the photos for copying purposes. The high-speed camera shows things you can't see with your eye, and I only paint what can be seen with the unaided human eye. The photos are used for details of

Top
*Pheasant Cover*
Oil, 24" x 36" (61 x 91 cm)
Private collection

Bottom left
Preliminary sketch for *Pheasant Cover*

Bottom right
Reference sketches of the head
of a ring-necked pheasant

Top
Duck Stamp design, 1971

Bottom
Duck Stamp design, 1959

species, plants, trees, movement of water, and facilitate the recording of bits of material for reference, such as the shape of a leaf or weed. I don't sketch from the photographs. They are aids and reference material. My work is a composite of photos and sketches done over a period of thirty or forty years.''

Reece values his sketches in the field far above his photographs. For years he has taken with him, to every part of the world, the small wooden sketch box given him by James Perry Wilson back in the days of World War II. In it he carries his oil paints, medium, and brushes, plus 8-by-10-inch (20½-by-25½-cm) canvas boards which fit cunningly into the slots made in the cover of the compact carrying case. He also carries a small box of watercolors and brushes.

With these simple tools he can record the new things he sees every year during the migration period. ''That's when most of my ideas occur, and most of my paintings are of the migration time of year. It's when one sees activity among upland birds—pheasant, quail, grouse, wild turkey.'' One of his paintings of deer was done in the snow-covered driveway of his cabin north of Grand Rapids, Minnesota, where the family spends Christmas every year.

For many years Reece and his family have divided their time between Des Moines and Minnesota, where they also spent summers in addition to Christmas. Reece has a studio in each dwelling and recently added a third studio to his itinerary when he and his wife bought a condominium north of Palm Beach, Florida, for the winter months.

Wherever he goes, however, his finished paintings are all based upon his observations, photographs, sketches, and knowledge of the appropriate habitats of each animal he depicts. He says, ''I may decide to put grouse on a birch tree, but because it is known that grouse feed off aspens or poplar trees, I will paint 'popples' in the background, or people would know the grouse would never be there. Pulpwood trees are also good habitats for grouse. The quail in south Georgia is the same bird with the same habits as the more northern quail. The goal is to remain scientifically accurate, using artistic latitude only within the range of truth about the range of the birds and animals.''

His sketches from far afield are kept close at hand for ready reference. He likes to show his oil sketches of icebergs in the Antarctic. ''These are things I can't get from photographs,'' he says. The turquoise, cobalt, and ultramarine are brilliant. ''Photos don't pick up the refraction of light going through glacial ice. The camera can't get the shading.'' Another sketch is of the Arctic on the north coast of Alaska showing tundra, the lousewort flower, and two swans. A scene of eider ducks shows them nesting in driftwood; another is of Sabine gulls on the Arctic tundra. They are painted thin and painted quickly to catch the gesture and the hues of the moment. Sketches of African acacia trees with weaver nests and termite hills jostle sketches of Egyptian geese with papyrus plants posed against the background of the pyramids, and a Kenyan crocodile is revealed in delicate watercolors.

Reece says, ''I rely on my sketches and a great deal on my memory of observations in the field. Fortunately, I have a nearly photographic memory, but sketching further implants a subject in the memory.

Pencil sketches

"Sometimes it is important to get the details of an animal as quickly as possible." For this, his sketches of bird bills and feet are especially important. "These are the parts of animals which dry out quickly in a dead specimen, and the colors fade rapidly. One of the great skills is to get something with very little to go on. You dig into your research materials, into your experience and your memory, when something is wanted and you don't have time to do a lot of field research. For that my files are invaluable. One sketch I did of a mole in my garden was used thirty years later." Reece's files of his photographic slides, scrap materials, and sketches are all carefully stored and indexed. Among his scrap files, he has one solely of pheasants; his photographs are filed by locale.

It is from these reference materials that Reece does his paintings—not in the field, but in his studio. The top of his specially built 18-inch (46-cm) square wooden tabouret functions as a palette, and the drawers beneath hold paints, medium, and brushes. An array of Grumbacher's Finest oil paints fills the top drawer; acrylics are on the bottom. On his palette are ultramarine, cobalt blue, and cerulean blue for the variety of his skies. He uses thalo green because "it's the only green that will make the iridescent color on a mallard's head. It's the only green I use as it comes from the tube; I mix all my other greens." Cadmium yellow, he feels, is compatible with all other colors, so he does not make use of chrome or lemon yellow. Cadmium orange and cadmium red light are used for all his red tones, and alizarin for the pinks and purples. Earth tones are Naples yellow, yellow ochre light, raw sienna, burnt sienna, and burnt umber, used for painting habitats, including dead wood and trees. "I gray down my colors with their opposite colors," he says, "and use ivory black very sparingly. Most often I use ultramarine blue and umber for the blacks." For his white he prefers Permalba white. He uses his palette knife only to mix his paints, not to put paint on the canvas, and his medium is straight linseed oil. "I never use turpentine," he says, "because my wife is allergic to it and I find I can get by without using it at all. I varnish only after a painting is finished, and I use Rembrandt retouching varnish made by Talens. This was recommended to me by an expert restorer as a finish varnish that doesn't turn yellow. I spray it on with an airbrush."

His painting brushes are flat bristles and round sables, among them Japanese-made synthetic sable brushes, Arttico, which he claims outlast natural sables. "They wear like iron," he says, "keep a sharp point, and I'm very happy with them." For his drawings on tracing paper, he uses Conté crayon grease pencils, preferring them to charcoal.

Reece follows a time-honored progression in his painting of a full-scale picture, beginning with a thumbnail sketch in watercolor for speed. Painted on Whatman board, the thumbnails are tiny, 2 by 3 or 1¼ by 2¼ inches (5 by 7½ or 3 by 6 cm) in size. He may do two or three of these, each a little different, until he is satisfied, thinking mostly of design all the while. From these he proceeds to an 8-by-10-inch or 6½-by-10-inch (20½-by-25½-cm or 16½-by-25½-cm) in oil on canvas board, concentrating on color. Between his thumbnail sketch and the 8-by-10, he makes pencil sketches of the subjects on tracing paper which he transfers to the canvas board. For the finished painting, he uses linen canvas that he stretches himself. When he addresses himself

to the large linen canvas, he goes back to his tracing paper to work out larger-size composition. Usually this is not exactly the same as the original tracings. He says, "I'm always switching birds around as I think necessary. By the time I get to the large canvas, most of my problems are solved on the tracing paper and the eight-by-ten oil." Although the tracing paper used for the 8-by-10 is done to size for the larger canvas, he does not trace from the paper to the canvas. Instead, he copies in sections from the tracing paper and refers to the 8-by-10 for color, roughing in first the birds, then the background, constantly changing the composition until he finally commits himself to the large canvas. He says, "This minimizes a lot of changing and overpainting. I'll do that even years later if a finished painting seems to need it."

His goal is constantly to keep growing and changing, so Reece likes to experiment with unusual compositions. "I don't want to be typed and get in a rut," he says. Sometimes he follows the compositions of western artists who often show the habitat in the foreground with the subject high in the picture. Other times he reverses the proportion. His ducks may fly over the water against a low horizon of clouds and sky, or they may fly high in the sky, with a lot of habitat visible.

"I consistently try not to be too consistent, and I strive for variety. Mostly," he says, "I play with color more than line. I look for dramatic contrasts like the white birch tree against a dark sky."

Consistent hard work is the lot of the artist who wants to push his talent to its limits, and Reece's advice to aspiring wildlife artists is to anticipate hard work and constant change. He says, "The wonderful thing about art is that you never get there—there's always a new plateau."

He likes to quote his early mentor, "Ding" Darling, who said to him, "If you religiously make five or six sketches every day for five years, you will become an artist." Reece believes that one would learn to draw that way and would build up enthusiasm. But he also believes it is important to know the anatomy of animals, their habits, and the environments they live in. "The more intimate you become with animals, the better you can paint them. I have feelings for the freedom—awe and respect and compassion for nature. I spend most of my time outdoors. Everything I paint comes from there, so why shouldn't I spend my time there? I'm convinced nature has been as good a color expert as any other, that nature has woven beauty and superb design. I'm just trying to dig it out and put it on canvas. You can capture that beauty with lighting effects, but remember, nature doesn't jar you with even the gaudiest sunset because the light it casts makes all colors compatible. Only man can jar if he tries to paint those same colors. In nature, bright colors don't last long. Most of the time you see restful colors with only fleeting flashes of brightness. I get away from bright local colors and get my colors into the atmosphere of light from nature."

Maynard Reece's own particular vision of "light from nature" owes its colors to those of the Iowa landscape where

Top
*Winter Covey—Bobwhites*
Oil, 36" x 60" (91 x 152 cm)
Private collection

Bottom
Reference sketch
of a mole

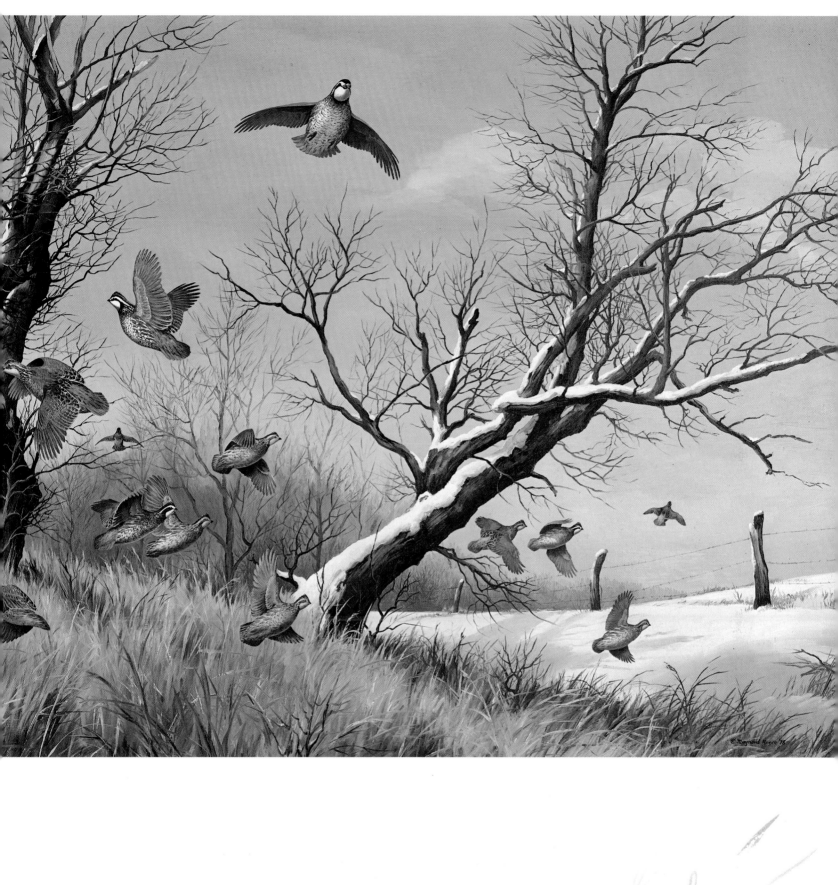

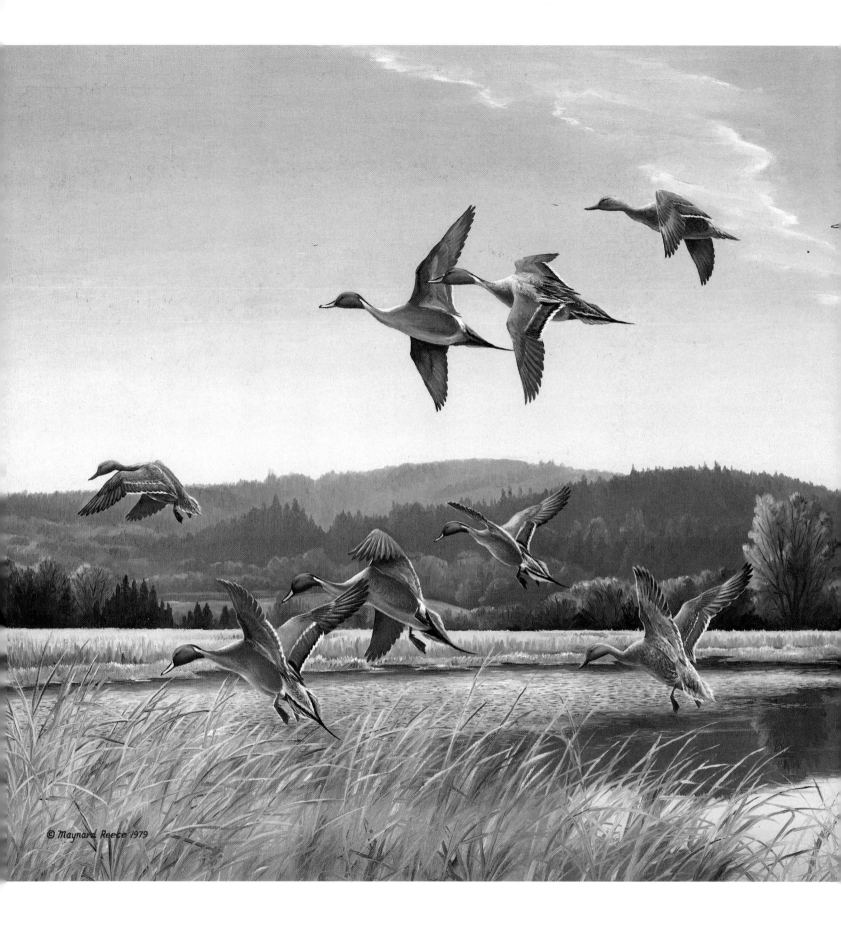

© Maynard Reece 1979

160

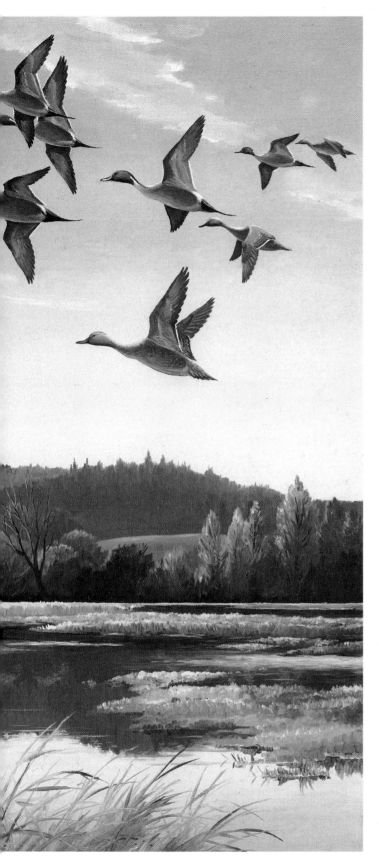

he has made his home, where spacious skies light an equally expansive landscape of flat prairie and gently rolling hills, punctuated by the lakes and ponds congenial to waterfowl. It is a gentle light varied by natural events such as the darks of evening and the occasional storms of the seasons. It is no wonder that the city of Des Moines has honored its portrayer with enthusiastic reception of his work, evident in city buildings such as the Iowa Des Moines National Bank, where three of Reece's large paintings of waterfowl hang on the walls of the imposing boardroom opposite a collection of Limoges porcelains made in France and painted by Reece.

Newer buildings with innovative architecture are similarly decorated with one or another of Reece's typical paintings of the surrounding area. At the Methodist Hospital Plaza in the city, a prominent physician has assembled an outstanding collection of wildlife art which hangs in his large suite of offices. Over the years Reece helped the doctor choose from among the best work of American wildlife artists, including his own.

Along one of the main shopping streets of Des Moines, a new art gallery carries the name of Maynard Reece. Dedicated to the exhibition and sale of wildlife art, the gallery is owned and operated by Brad Reece, Maynard's younger son, who is also a wildlife artist and frame maker. The gallery carries the works of all the Reeces as well as that of other wildlife painters and sculptors, plus limited-edition prints which have brought the works of these painters to thousands of collectors for whom the acquisition of originals might be prohibitively expensive.

Both of the Reece sons, Brad and Mark, have authored prints, and both have won Iowa Duck Stamp competitions. But while Brad has chosen to carry on the traditions of wildlife art in the gallery, Mark is a medical doctor aspiring to use his artistic talents for plastic surgery someday.

Honored in his native region, Reece has also been recognized nationally with awards ranging from the *Ducks Unlimited* 1973 Artist of the Year Award, the Certificate of Merit from the Art Directors Club of New York and its Award of Distinctive Merit, as well as the five Federal Duck Stamp Awards.

An ardent conservationist, Reece was made honorary president of the Izaak Walton League of America for 1974–75. He was the first chairman of Iowa's Governor's Committee for Conservation of Outdoor Resources and is a member of the Fishing Hall of Fame as well as a past board member of the Outdoor Writers Association of America. For *Ducks Unlimited,* of which Reece is an honorary trustee, Reece and his wife designed the camouflage gear worn by outdoor enthusiasts throughout the country.

"I always knew I wanted to be a wildlife artist," says Maynard Reece. Work toward that goal has made for this artist a whole lifetime of activity with his family—work, study, pleasure, and honor in the society of his time.

*The Valley—Pintails*
Oil, 24″ x 36″ (61 x 91 cm)
Private collection

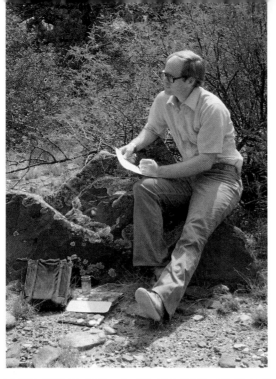

# NICHOLAS WILSON

*". . . Clear blue sky, Arizona sun*
*Are the obvious things to which so many come.*
*But, more subtle shades of beauty lie*
*In your seemingly hostile lullaby. . . .*

*Laura Wilson, from "Desert Song–II"*

The animals and landscape of the great Arizona-Sonora Desert provide the "subtle shades of beauty" Nicholas Wilson paints. Those animals are his neighbors as well as the subjects for his "living still-life" gouaches, painted in a self-invented technique akin to sculpture, which is another of Wilson's talents.

Wilson and his poet wife, Laura, live in the midst of one of the most varied landscapes in the country. Although it is called a desert, the area from Phoenix to Payson, where they have their house and studio, rises two thousand feet straight up into the Superstition and Mazatzal mountains—an eighty-mile region that comprises seven different life zones, each with its different flora and fauna.

As he drives through them, Wilson enumerates: desert scrub, desert grassland, oak woodland and chapparal, oak-pine woodland, Ponderosa pine forest, Douglas fir forest, Engelmann spruce forest. Here is the home of the famous saguaro cactus, plus an astonishing array of desert plants, bushes, and flowers, culminating in the Alpine-like evergreen area of Payson, where Nicholas and Laura live with their two young sons, Elliott and Stefan.

Wilson has only to drive for about an hour to find the backgrounds suited to nearly all the animals inhabiting this desert range—Gambel's quail, roadrunners, red-tailed hawks, turkey vultures and coyotes, raccoons, cougars, bighorn sheep, mountain lions, black bear, bobcats, and the kit and gray foxes. "I like to paint things I see," says Wilson.

*Ocelot*
Gouache, 30″ x 20″ (76 x 51 cm)
Private collection

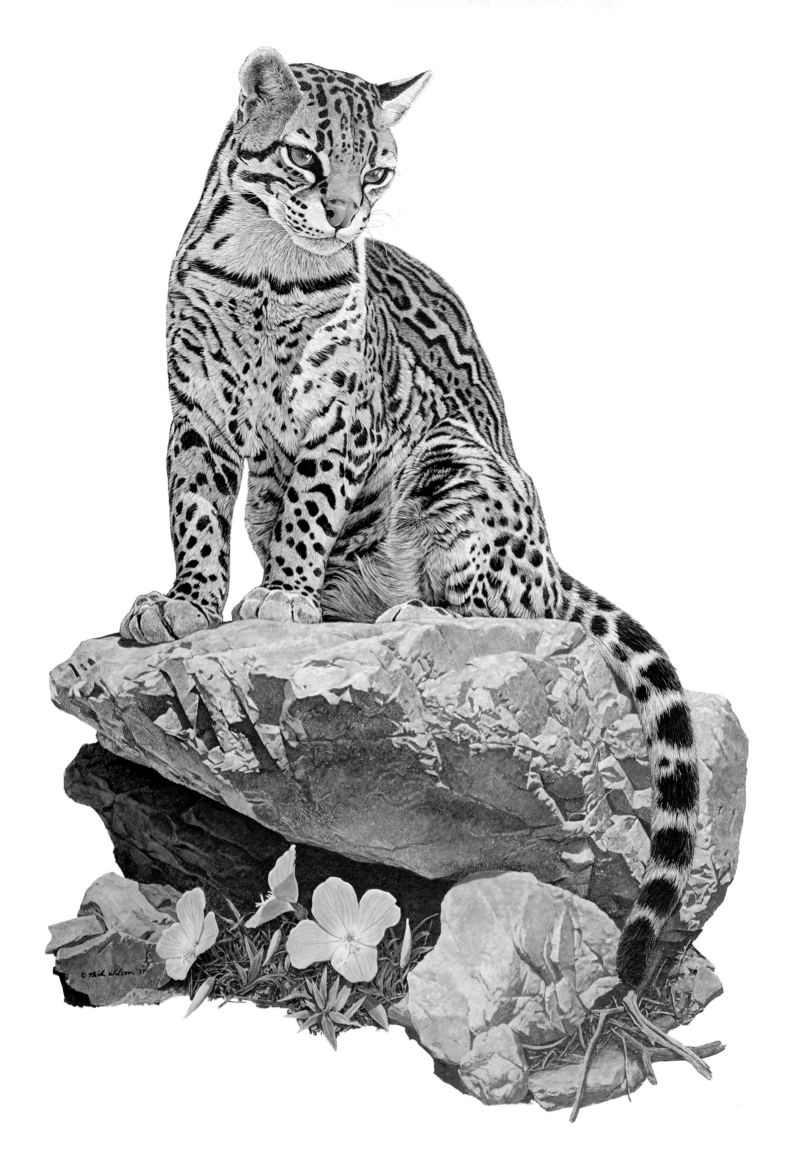

"They happen to be in Arizona. And what carries me through to the end of a painting is my attachment to that particular tree, that rock, and that animal."

Nick Wilson was born in the different landscape of Seattle, Washington, surrounded by art produced by a painter grandfather and a mother who is now a professional porcelain-doll maker in California. One of his aunts had also been a painter. Wilson soon moved, however, when at age two he developed asthma, and the family took him to live in Reno, Nevada, where he grew up.

He remembers drawing tropical landscapes while still in kindergarten. "I used to wait for my older brother who finished classes later than I did," Wilson says. "The teacher used to sit me down with crayons and manila paper just to keep me quiet while I was waiting. I drew from my imagination."

Although he always had art materials available at home, he had no formal art training beyond that offered in the regular art classes of junior high school and high school. But he began to be praised for his art, beginning with his fourth-grade teacher, followed by his sixth-grade teacher, who "kept everything I did for herself."

"I always copied things from schoolbooks," says Wilson. Of his love of animals, he says, "I distinctly remember a woodchuck crossing a road while I was in the family car. I made my mother stop so I could find it. I never did, but I still remember it as being one of the most desirable of things in my life. I also collected insects, and I still like to do that. Butterflies are my favorites." Vacations spent in the Puget Sound area developed an appreciation of the sea life found at low tide.

During high school Wilson worked part time as a ski instructor in Nevada, an occupation he continued after graduation for a total of eight years. He also found work as a frame maker. He continued to paint on his own, chiefly animal portraits. Gradually his artwork began to attract attention, and he was given a free-lance job to illustrate a manual on chukar partridges for the Nevada Department of Fish and Game. "That was my first professional commission," says Wilson.

"After the book was published," he says, "I was offered a job at the Arizona-Sonora Desert Museum in Tucson as curator of exhibits. That was in 1970. I was twenty-three, and I had no idea what a curator was." But soon he was painting and sculpting on his own, and creating his own exhibits. "I did the art," says Wilson, "and others would do the lettering. I became the staff artist and learned a lot about animals while I was experimenting with art."

The museum was an ideal place, because animals native to the area are kept chiefly in outdoor habitats as similar as possible to the kind in which they naturally dwell. Wilson was encouraged by the museum's general curator, Robert Craig, who had first offered him the job after seeing some of his book illustrations. Further encouragement came from the museum's director, Mervin Larson, who offered art criticism along with his enthusiasm.

Soon Wilson's large portraits of the animals at the Desert Museum began to sell. They were also reproduced as posters, which are still sold in the museum's gift shop, visited by collectors from all over the country. Even then he described

Wilson's preliminary work for this painting, *Riparian Glider,* includes quick pencil sketches and color studies in watercolor or oil; he also takes photographs for reference. First he establishes the animal's position and size within the picture area with pencil, then reinforces the drawing with brush and ink. He quickly lays down the dominant colors and values with a large bristle brush. He focuses next on the grass, then the raccoon. He paints the animal first with a wash mixed of umber and black; then he begins to scratch out the fur. He applies light washes of color to tint the white scratches, then scratches out more "hair." As he progresses, Wilson adds color to the hair with glazes as well as by scrubbing it on with a bristle brush. Finally, he paints the eyes and nose, overlaps the raccoon with a few blades of grass, and adds the butterfly as the finishing touch.

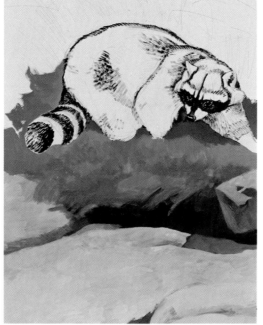
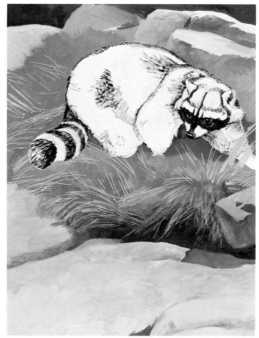
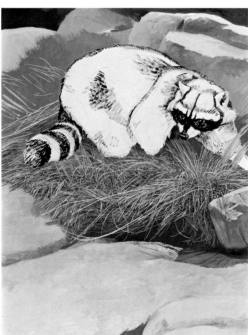
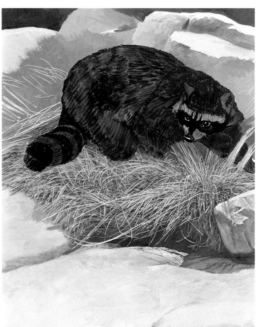
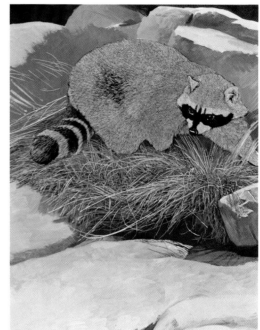
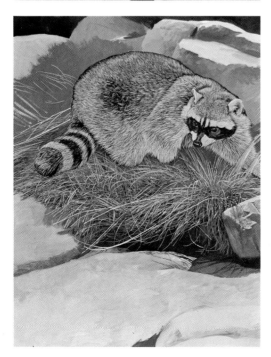
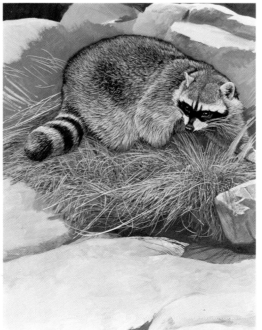
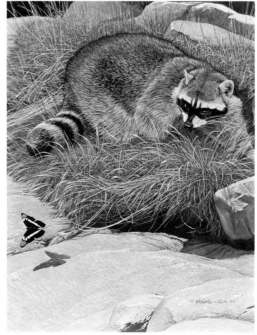

his work as "semi-still life" and refused to do action paintings of animals.

In an interview that appeared in the *Tucson Daily Citizen*'s weekend magazine edition in 1976, he said, "So many artists paint these creatures in action—fighting and attacking. People think of a mountain lion as chewing something for dinner, as a predator. I don't like this. I don't emphasize this side of their nature, although it is there. I want to show a different view of the animals—their casual, passive times."

He also prefers to show them close up and in great detail, with special emphasis on the three-dimensional textures of feathers and fur. In order to achieve such detail, Wilson began early to experiment with new techniques. He says, "I began doing scratchboard paintings on chalk-coated cardboard. They would fall apart under watercolor. I was trying to find good materials I could scratch into for the details that you can't paint." Eventually he developed a ground of lacquer paint formulated with a flattener of diatomaceous earth, used for swimming-pool filters. "It makes a dull, brittle surface," says Wilson. "I'm not really a scratchboard painter. Instead, I would say I'm doing gouache paintings, scratching out the details in feathers and hair."

Andrew Wyeth is Wilson's favorite painter, and from the beginning he has adhered to realistic art with an added admiration for the kind of fantasy in realism exemplified by Salvador Dali. Above all, Wilson is devoted to painting and sculpting wildlife for "the beauty in natural design, in textures of wood and stone, in the effects of light."

He attributes his intense concentration on natural objects to his childhood. "I was alone a lot," he recalls. "And during those periods I enjoyed looking at flowers, seeds, bugs, and collecting things from nature. I was never a competitive athlete." The single sport in which he excelled was itself a solitary one. Skiing, he muses, "is not a slow person's sport. But I must have gotten speed out of my system through my skiing, because now I move so slowly that my colleagues at the Desert Museum used to tell me I was teasing the vultures flying overhead who couldn't be sure I was alive."

It is with slow, careful concentration that Wilson accomplishes enormous amounts of work, using observation in the field, photography, sketching, and finally painting for his finished pictures of animals in their natural settings. These days, those settings and those animals are within a short distance of Wilson's house in the Ponderosa pine area of Payson.

Now he walks in the mountains to find backgrounds for the native animals. During his days at the Desert Museum, he learned to photograph the animals in many different poses as they roamed their enclosures. On one occasion, he remembers, he posed a tortoise on top of a coffee can. While the turtle tried in vain to walk away, Wilson managed to do a complete painting of it from life. It was one of the few times, however, that he found a way to make a wild animal "stand still" long enough for a portrait. For that reason, Wilson has long since become a highly competent photographer and

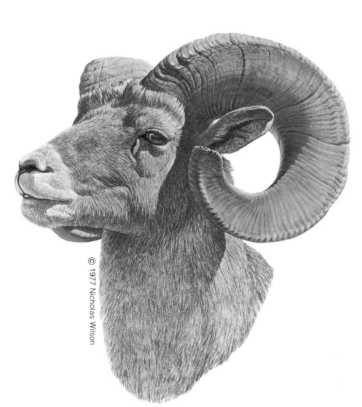

Above
*Bighorn Sheep*
Gouache, 14" x 14" (36 x 36 cm)
Private collection

Right
*Farmer's Adversary*
Gouache, 16" x 28" (41 x 71 cm)
Private collection

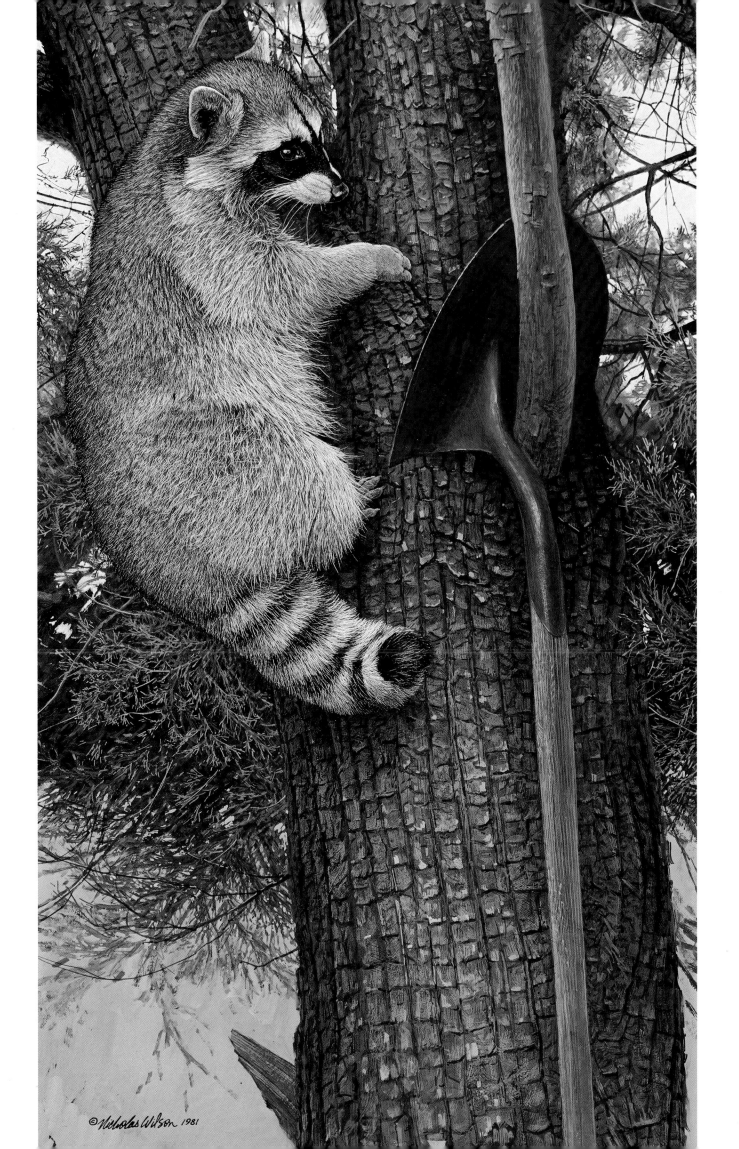

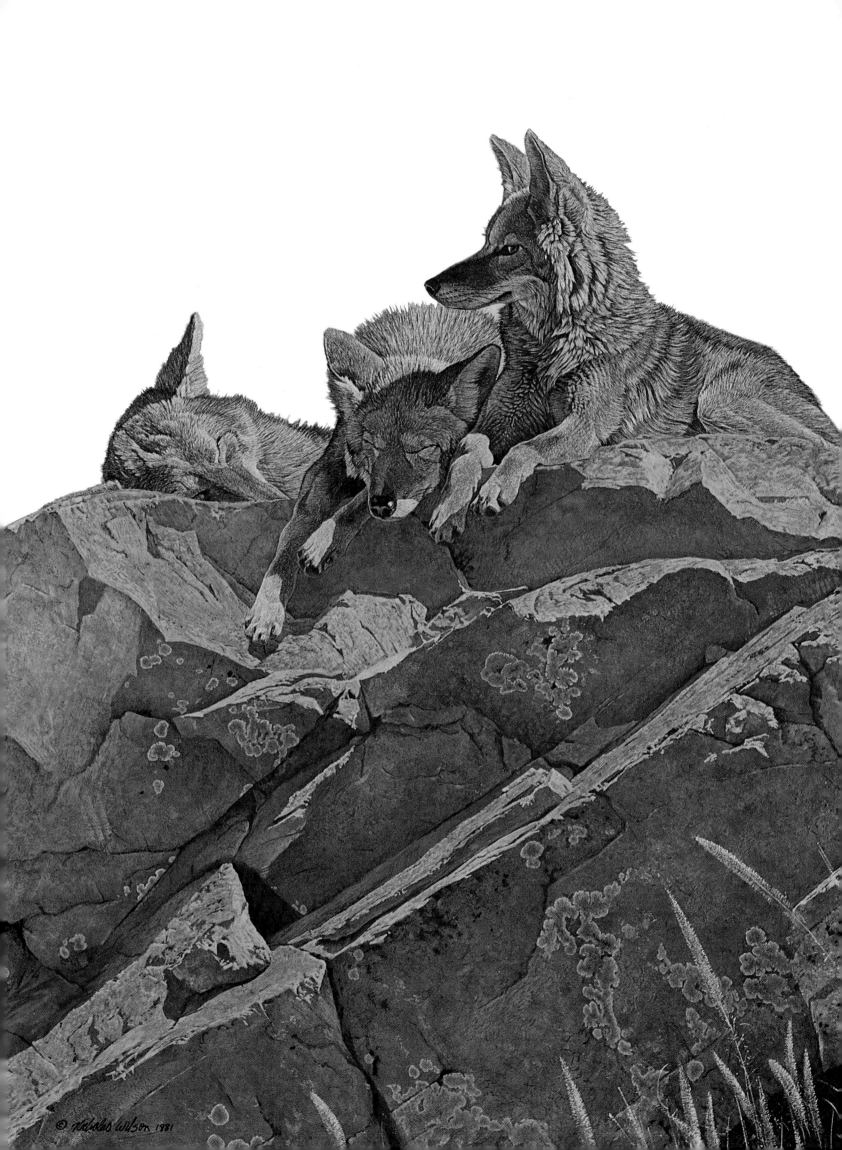

© Nicholas Wilson 1981

does his own darkroom work as well. He uses only black-and-white photographs as the basis for his paintings and takes separate photographs of his subjects and the backgrounds, using them for the sketches that he does later in his studio.

His Konica Autoreflex 35mm camera goes with him on his walks through the mountains as he looks for rock formations, tree stumps, and flowers. "I'll visualize an animal on that rock or stump," he says. "One walk will bring twelve or fifteen ideas, then I have to choose. Most of the settings come from near my home, and that's why I moved up here."

When it comes to deciding exactly what to paint, Wilson says, "I get some pretty good ideas just before I go to sleep. Then I get up and write them down so I can go to sleep." For more tangible sources of picture ideas, Wilson says, "I have a file of photographs I have taken and I can choose among them. Sometimes I say to myself, 'I want to do a painting of a rabbit.' I go through my file of rabbit photos. Then I'll take a walk to look for a setting for that rabbit."

A walk with Wilson up the hill behind his house and studio takes one over red rocks, through a thicket of dead trees and flowering cactus, to a view of a valley with a picturesque pond and waterfowl skimming its surface. If there are no rabbits or other wildlife to be seen, there are plentiful flora and rocks for settings. On occasion Wilson is able to take a photograph of a wild animal such as a cougar or a bobcat on the run, but actually it is seeing them, rather than being able to capture them in photographs or sketches, that brings the knowledge of how they look in the wild.

"Even though you can only glimpse them in the wild," says Wilson, "you can see what makes them different from zoo animals. You can tell when zoo animals are fat, underexercised, and you have to correct for that when you are using a zoo animal as the basis for a picture." Wilson says further, "The reason I specialize in this state's animals is that I see them all the time in the wild."

Wilson, nevertheless, has traveled extensively to areas famous for the variety and quantity of their wildlife, such as Alaska, Canada, Africa, and Mexico, mostly observing, photographing, and sketching in pencil on a sketch pad. In Africa, he says, "I was impressed with all the huge mammals, but mostly I collected butterflies. I like to be able to get my hands on things, the small, brightly colored things I can touch."

Best of all, he likes to work in his own surroundings and in his own studio, located on the lower level of the house which is situated in a grove of trees on a hillside. The studio windows face into trees and bushes on one side of the 20-by-30-foot (6-by-9-m) room. Opposite the windows, Wilson works alternately at a drawing table for the close details and at the stand-up easel next to it where he works on the larger areas of a painting. His picture files and library are shelved on the walls; a stereo set and records are handy for musical accompaniment to his work. Warm and cool fluorescent bulbs provide the working light.

The library consists of books such as those on the habitats of the Arizona animals and the *National Geographic* book *Wild*

*Summer A.M.—Coyotes*
Gouache, 24" x 30" (61 x 76 cm)
Private collection

*Animals of North America.* "I use the books only for occasional reference," says Wilson. "Usually I prefer not to use them at all, but once in a while I will make color comparisons from them." Wilson likes his studio to be separate but near the rest of his household and family. "It's sort of like going to an office every day," he says with a grin.

It is also like going to a sculpture studio and a graphics workroom, because Wilson's studio contains an etching press and sculpting materials, armatures, and clay. Often he makes clay models of the animals he is painting and poses them in natural settings for photography sessions. He also makes clay sculptures, from which he makes his own molds for later casting in bronze. A raccoon worked in clay was the subject of a new mold-making project Wilson has begun to experiment with for a porcelain cast.

On a couch near the windows are spread out sketches for a painting in progress. There are rough sketches in pencil of a rocky outcrop which will become the background for a painting of scaled quail. Notes made on sketches serve as reminders. "I call them placement sketches," says Wilson. A photograph Wilson took of two quail lies beside the pencil sketch of the birds. The notes say, "Bird, stone gray. Rocks, burnt orange." "Warm shadow—pinkish gray" describes the reflected light on the side of the rock.

Wilson says, "I photographed the setting and developed it in my darkroom. From the photo I do a second pencil sketch, then I do an entire composition from the black-and-white photographs. Usually I take photos of the animal and the setting separately. When I come home, I develop all the prints and sketch the entire composition from them. I depend on photos for both my sketches and my paintings. It is a composite painting from separately photographed elements. These quail were photographed at the Phoenix Zoo, but the rock was photographed near here."

Using pencil for speed and ease of blocking out contrasts, he works out the preliminary sketch on his sketch pad. Wilson then proceeds to the next step, which is to cut visualizing tissue the same size as the projected painting. He outlines the elements of his composition on the tissue in pencil, turns it over, and redraws the lines. He then places this over his board and transfers it. "I then go directly into painting," says Wilson. "I have to know exactly where things are going. That's why I like a slow pace. It allows me to do all those things which take concentration and patience. Whatever I do, I give it a lot of thought and picture it from beginning to end before I start. That's true of every painting I do. I see it all framed and hanging on the wall before I even start. All the spontaneity has to occur before I begin to paint."

Both his approach to his subjects and his technique make this kind of steady concentration necessary. Wilson says, "I like a triangular composition and put the animal in it as on a stage. Because of my technique, I usually choose a furry animal, with medium-length fur. I never do smooth-hair animals or paint them from too great a distance so that you can't see the details of the fur. I like the animals to look alert, head high above the shoulders, and I try to keep everything in the picture within a distance of ten feet or less. I like the contrasts of fur against hard substances like rock and tree bark. Then I like to use insects or flowers as highlights. Most

of my compositions are right to left or left to right. They may form a triangle, an oval, or go from one side to the other. Most of all I like to draw the viewer's eye to the animal as the main subject. The animal usually occupies a third of the picture space. I see the main masses like rock, tree limbs, or stumps as the underlying structure that gives weight and solidity. My animals are always up front."

Those "up-front animals," posed as if on a stage, are painted in gouache on Wilson's specially prepared and cut scratchboard, with his own formula of lacquer and diatomaceous earth as ground. He prefers 18-by-24-inch or 24-by-30-inch (46-by-61-cm or 61-by-76-cm) sizes. "I like to use gouache not only because of the colors," says Wilson, "but because it dries quickly and because I can pound it in with a bristle brush. It's brittle enough that I can scratch into it. I can make soft glazes, and I can make it thick or thin. When I do a rock or a tree, I use big bristle brushes and stab paint on for texture." For the finer details, Wilson prefers Grumbacher's no. 6 watercolor brushes. His palette is a butcher's tray, and his sons' baby-food jars hold water.

The colors of his palette reflect the warm earth tones of the Arizona terrain. Tubes of Winsor & Newton gouaches are labeled raw umber, burnt umber, raw sienna, burnt sienna, olive green, and Chinese orange. "In most cases I add white and lamp black to my colors." For his flowers he also uses lemon yellow and magenta. "I keep the primary colors handy," he says, "but I don't use them much. These are the warm colors of Arizona. I've never done a cool painting except for one—a cover for *National Wildlife* magazine which was a cool painting of a rabbit in snow. I prefer colors from the tube rather than having to mix the main colors."

Gouache, however, is ideal for Wilson's own brand of scratching in the details of feathers and fur. For these details, instead of brushes, his tool is a scratchboard knife, periodically sharpened during the process. Scratching out the lines that impart three-dimensionality to Wilson's animals is a long, laborious job. When the color is applied, Wilson says, "I use Krylon spray fixative which must be sprayed very lightly. When I make a glaze, I use a drop of wetting agent, such as Kodak Photo-Flo, mixed into the paint, and then a wash which is spread evenly over the fixative." To explain the process further, Wilson says, "Fur is a good example. After I've scratched out an area to get the look of depth in fur, I tone in the scratches with a wash of brown. I can go back and scratch the same area and tone it down with half as much. This gives two-tone colors of hair or fur. I can scratch out more and use highlights. That gives a three-step depth. Each area is scratched. There is no color except a glaze. Then I apply the washes. I have to be more concerned about design of hair and fur than other artists with this method.

"The initial wash that goes down on the subject begins the thin buildup of washes. Each wash has to be fixed before it's worked on. The fixative must go on very thinly because it builds up as one works. I developed this technique because I wanted to get the depth that is obtainable with the original scratchboard technique. But that only works with black and white, where the scratching cuts through black to reveal

*Above It All—Chipmunk*
Gouache, 12″ x 18″ (31 x 46 cm)
Private collection

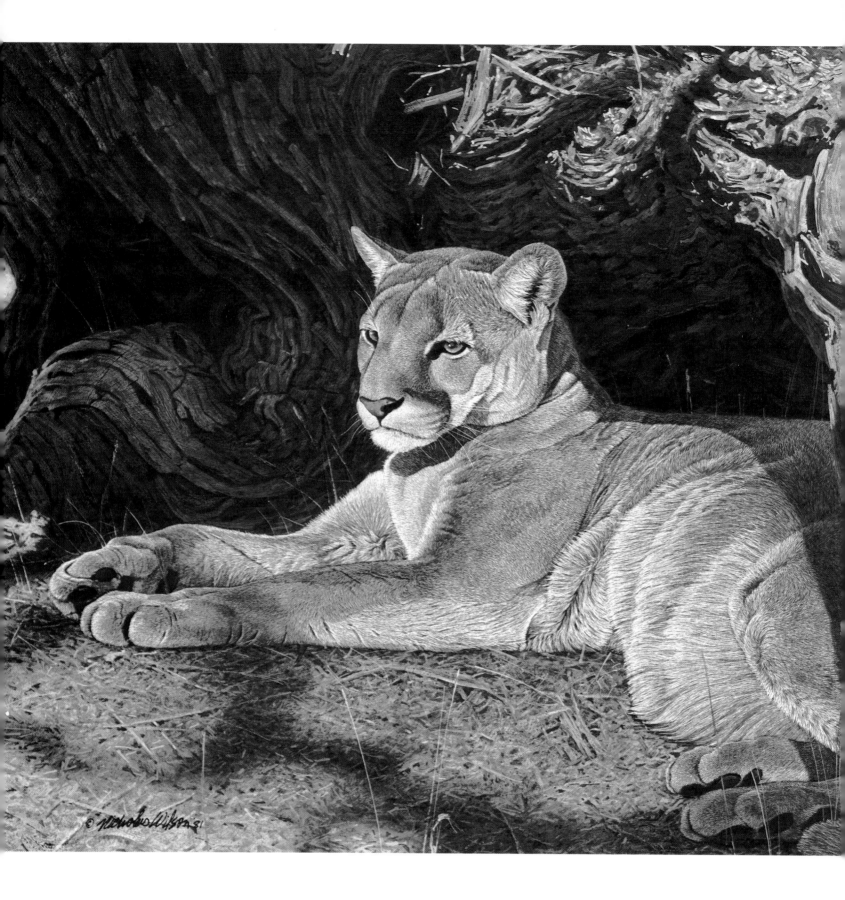

white lines. I have tried it with colored inks, but it looked terrible.'' His discovery of the combination of the proper ground with gouache has worked well for him.

In fact, it worked so well that Wilson left his job with the Desert Museum and moved to Payson to devote full time to his paintings, sculpture, etchings, and stone lithography. His work is sold on a regular basis through the Settler's West Gallery in Tucson, Arizona, and the Carson Gallery of American Art in Denver, Colorado. Some of his paintings have been reproduced in limited editions of prints distributed by Mill Pond Press (204 S. Nassau Street, Venice, Florida 33595).

Although his style began as vignettes of animals against a white background, Wilson says, ''Vignettes are going out of style. Ten years ago they were all the rage. Now people want a more comprehensive statement of the wild. They want to know what this animal is doing and where it's coming from. That means pinpointing its habitat. I'm working with this concept now.''

Wilson holds the treasure of the wild dear to his heart, and he believes that as the world becomes more and more populated and pollution more rampant, wildlife will be pushed out and will become more valuable. ''You can get out less and less to see it on your own.'' He believes, sorrowfully, that this is an irreversible trend.

Nick Wilson also believes that wildlife art is ''a holding onto what is fleeting by.'' For that reason he also thinks the art has a secure future as people try to recapture what they themselves have destroyed. If for no other reason, therefore, wildlife art will continue to be sought and bought.

For those who aspire to become wildlife artists, Wilson advises: ''I think every artist should have a plan. I believe in thinking out an entire painting from the beginning to the end. I think this is necessary for realistic painting. I would say an artist should deal with local animals. I am more emotionally attached to the animals I'm familiar with, and I think that being emotional about a subject is necessary to do a good job.'' He also believes that there is a lot of room for inventiveness and explorations of new techniques to be applied to wildlife painting. His own contribution to technique, the scratching he uses for fur and feathers, is just one example of the many possibilities that could be applied to the painting of wildlife.

*Hot Afternoon—Mountain Lion*
Gouache, 16" x 24" (41 x 61 cm)
Private collection

# INDEX

Edited by Barbara Wood
Designed by Bob Fillie
Graphic production by Hector Campbell
Text set in 11-point Palatino